Spaceshots and Snapshots of Projects Mercury and Gemini

Spaceshots & Snapshots of Projects
MERCURY
& GEMINI

A Rare Photographic History

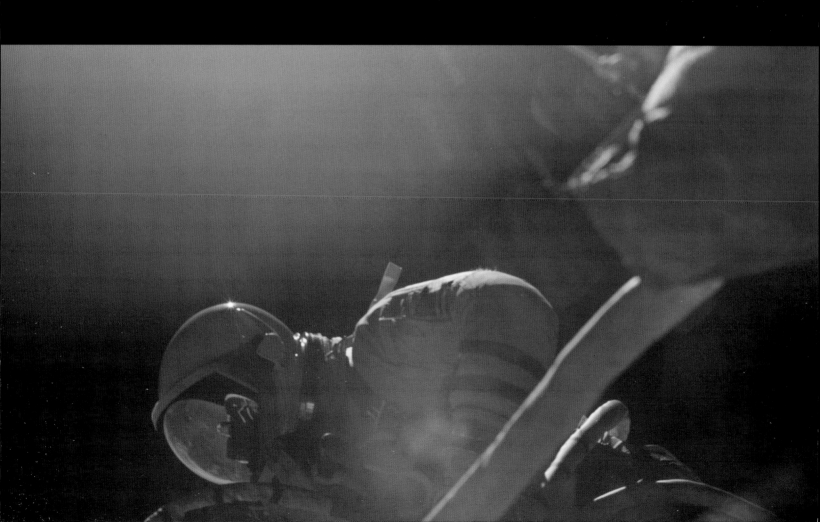

Library of Congress Cataloging-in-Publication Data

Bisney, John, 1954–
 Spaceshots and snapshots of Projects Mercury and Gemini : a rare
photographic history / by John Bisney and J. L. Pickering.
 pages cm
Includes bibliographical references.
ISBN 978-0-8263-5261-3 (cloth : alk. paper)
 1. Project Mercury (U.S.)—History.
 2. Project Gemini (U.S.)—History.
 3. Astronautics—United States—Pictorial works.
 4. Space photography—United States.
 I. Pickering, J. L., 1957–
 II. Title.
 TL789.8.U6M425 2015
 629.45′4—dc23
 2014024288
Cover photograph courtesy of NASA
Designed by Lila Sanchez
Composed in Adobe Garamond Pro 11/13.5
Display type is Americana and Optima

Contents

Foreword

Lt. Gen. Thomas P. Stafford, USAF (Ret.)
Gemini VI-A, Gemini IX, Apollo 10, Apollo-Soyuz Test Project

This book and *Moonshots and Snapshots of Project Apollo* (UNM Press, 2015) document a unique era, both in American history and in my life. The Space Race was the most visible of the Cold War competitions between the United States and the Soviet Union, and to the citizens of both countries, the most inspiring.

When I graduated from the United States Naval Academy in 1952, US forces were engaged in South Korea, fighting the North Koreans and the Chinese, with support from the Soviet Union. Twenty-three years later, I commanded the Apollo mission that docked with a Soviet spacecraft, symbolically bringing the Space Race to a close.

The most significant event in between, of course, was the 1969 Apollo 11 moon landing, the culmination of an enormous national effort to achieve President Kennedy's goal and maintain our engineering and technology lead over the Soviets.

I was fortunate enough to fly on four of the thirty-one space missions documented in these books and was involved in most of the rest, so they are almost like yearbooks of my experiences with NASA. I hope you will both gain a greater understanding of the facilities and systems on the ground that we depended on, as well as the men and women who made it all possible.

The facilities we used during Gemini now seem somewhat spartan, but that's part of the texture this unique book provides. It gives a good sense of what it was like to spend many days at Cape Canaveral or in Houston; and when you weren't at either place, you were aboard an aircraft, spacecraft, or naval vessel!

I was privileged to be one of twenty-two Apollo astronauts to visit the moon. Looking through those chapters, I'm still struck by the size and scale of the program, from the Vehicle Assembly Building and the Saturn V to the massive network of contractors across the country that built it all and the worldwide coordination and cooperation it required.

Our in-flight photography shows the true beauty of the earth and moon from space, something we never got tired of enjoying. I remember commenting during Apollo-Soyuz Test Project (ASTP) that because our Earth

orbital altitude was about forty miles lower than during my Gemini flights, it was possible to see far more detail on the ground.

I had not seen many of the photos in these books before or heard some of the stories, so I appreciate the efforts of the authors, whom I have known for many years. Their research into the NASA repositories and other sources takes you behind the scenes and gives you a better appreciation for the enormous size of the undertaking.

I'm especially grateful for the recognition given to all the men and women on the ground who were responsible for our successes and learned from our failures. In these pages, you'll meet some of the most talented and dedicated people I have ever known; a few I had long forgotten, but most I will never forget.

Finally, it brought back many memories of the "can do" attitude we once had in our space program and the fun we often had along the way. I look at these photos and ask myself, "Who are those young guys and what were they thinking?" At the time, I knew on some level it was the greatest adventure in the history of humanity. To this day, I believe it still is and will be until we send astronauts beyond the moon and into the solar system. Until then, we can only imagine those snapshots.

Preface

John Bisney
Bethesda, Maryland

J. L. Pickering and I have been space-flight enthusiasts since we were elementary school baby boomers thrilled by the Mercury astronauts as they took on the Soviet Union's cosmonauts in the "space battles" of the Cold War's Space Race. We made our parents take us to the Johnson Space Center (J. L.) or the Kennedy Space Center (me) as kids, and we both wrote to NASA asking for photos and information.

In the intervening years, our interest in and love for this era only deepened. J. L. turned his boyhood hobby into a lifelong passion, accumulating what is possibly the largest private library of high-quality photos of the early US manned space program. He assembled this collection, numbering well over one hundred thousand high-quality images (and growing), over more than forty years from public and private sources, including through unprecedented access to NASA photo archives thanks to certain understanding public affairs staff. Other great sources included fellow collectors, retired NASA and news photographers, auction houses, and even eBay.

Today, he is often contacted by authors, historians, astronauts, and even NASA as the go-to source for hard-to-find images, and his website, retrospaceimages.com, offers compilations of rare high-resolution photos from each flight well into the Space Shuttle program.

My family moved to St. Petersburg, Florida, in 1965, and I saw my first rocket launch the following year from Cocoa Beach. Using connections through a local science education center, I attended most of the manned Apollo launches, including meeting President Nixon at Apollo 12. In 1975 J. L. and I were both at the Kennedy Space Center (KSC) Press Site for the ASTP launch. He was there stringing for his hometown newspaper and I was covering it for my college radio station, but we never met.

I became a national radio correspondent based in Washington, D.C., and was assigned to cover the space program from 1981 to 2011. J. L. and I finally connected in 1986 through exchanging letters as fellow collectors of insider space memorabilia and quickly became good friends.

During the 1980s and '90s, we frequently traveled to Cocoa Beach and Houston to meet and visit with the men and women, usually retired, who

were the heart and soul of our early manned space program, often timing our Florida trips around my shuttle coverage. We became especially close with Paul C. Donnelly (whom you will meet), the former KSC launch operations manager and a true pioneer who died in 2014 at age ninety.

We didn't realize it at the time, but our "vacations" were steadily laying the groundwork for this and *Moonshots and Snapshots*. Not only would J. L. often come home with a stack of new photos to keep (or scan and return), but we also heard wonderful stories about the people and events of the program that led us in new directions and gave us a greater appreciation for who did what and how.

About five years ago, we started kicking around ideas for a way to showcase some of the best photos in J. L.'s collection. We quickly settled on an obvious theme: a space book that only included images that had *never* been published. Of course, that would have been impossible since almost all of the photos taken during the flights by the crewmen are known and available today online. Still, we knew they represented a fraction of the material in his collection.

Thanks to the openness of the United States' civilian space program, there was certainly no shortage of photos taken during its pioneering years by hundreds of photographers working for NASA, aerospace contractors, the news media, and tourists, but relatively few ended up being published.

There are good reasons for this. Perhaps the biggest is that some photos are simply better than others. Over the years, an informal consensus developed as to which images best represent each of the thirty-two missions during what is now considered the "golden era" (or at least the first era) of US manned space flight from 1961 to 1975. As a result, when authors needed to illustrate a space book, they drew from the pool of easily available images they knew would be familiar to the reader or couldn't be left out.

The other main reason is that, until the Internet, the only outlets for NASA's photos were newspapers, magazines, and books. The first two, of course, had only so much space; with such limited demand, NASA had no incentive to release more than perhaps one hundred photos for each flight—certainly until the Apollo program. And, while books could include many more photos, those published in the years since inexorably dipped into only the same small group of "greatest hits" images and often were of relatively poor quality. Tens of thousands of others still regrettably languish in NASA photo archives—now stored away at massive federal warehouses.

Our goals, then, became to illustrate our early manned space program much more comprehensively than had been done before, using rare images, providing rich details in the captions, and adding some Cold War context. We hope the result will please both casual and hard-core followers of the US space program.

I mentioned I *thought* I had an extensive knowledge of the subject, but researching this effort provided me with a real education and an entirely new understanding of the magnitude of what, in retrospect, seems an almost astonishing plan, even in the face of the Soviet challenge: the public and private sector working together with public backing to *repeatedly* send people to the moon and back within ten years. The degree of planning, coordination, communication and logistics to pull it off in the age of typewriters and telephones is truly astonishing, and I hope these captions give you a good sense of that.

I also hope you enjoy these books as much as we did putting them together, and that you gain a new appreciation for what America can—and did—do.

Acknowledgments

The People in Our Grandstand

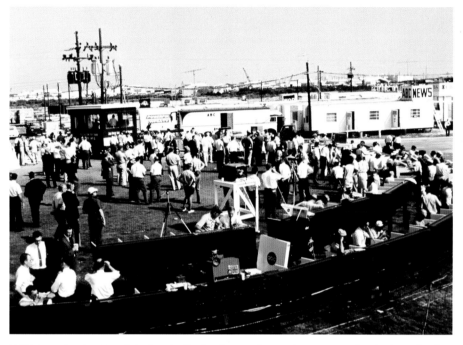

With broadcast-network trailers in the background, reporters prepare for the launch of Gemini IV on June 3, 1965, at Press Site 2 on Cape Canaveral.

J. L. Pickering

A few people need special recognition, beginning with the late Herb Desind. Herb was an amazing high school science teacher at Laurel High School in Laurel, Maryland, and was a very enthusiastic supporter of space exploration. I give him much credit for getting me started with photo collecting and opening some important doors. Herb passed away in the early 1990s before the Internet; no one would have loved the instant exchange of images more than Herb.

Mark and Tom Usciak have been tireless in their support. The brothers from Pennsylvania opened their personal photo vaults from the Apollo days, and some appear in this book. Tom runs his own photo lab (Greenfield Photographic Services) in Lancaster, Pennsylvania, and has been more than generous in producing numerous sets of proof page layouts. Mark has been there whenever needed to provide technical support regarding the images themselves.

I also give special thanks to my friend Ed Hengeveld in the Netherlands. Ed is the only person I know who shares my high level of appreciation and excitement for all types of early NASA imagery. He is proof that two heads are better than one when it comes to vintage NASA-photo acquisition, organization, and restoration. Ed also was an invaluable proofreader on this project.

We also thank Mike Gentry at the Johnson Space Center for taking the time to dig out some special images used here. Mike was with the Houston center for more than forty years and built up some great relationships with NASA personnel over the years. His connections were a valuable source of information for us.

An additional thank-you to the University of New Mexico Press for believing in this project. It can be difficult convincing a publisher that you have new material to share from an era that has long passed. A thank-you is also extended to Jeff Soulliere for his help in laying the groundwork that led us to UNM Press.

A final thank-you to my wife, Susan, for allowing me to run all over the country on "space vacations," and then spending endless hours at home with my wonderful scanners. Hopefully, this work will make some of my time away seem worthwhile.

John and I also wish to gratefully thank the following individuals, without whose help this effort would not have been complete:

Jay Barbree	Gerry Montague
Alan Bean	Lola Morrow
Tammy Summers Bucher	Dee O'Hara
John Byram	Margaret Persinger
Norm Carlson	Don Phillips
Gene Cernan	Gwen Pittman
Skip Chauvin	James Ragusa
Wes Chesser	Morgan Raines
Lou Chinal	Al Rochford
Laura Shepard Churchley	Louie Roquefort
Reid Collins	Jody Russell
Paul Donnelly	Bob Sieck
Cal Fowler	Lee Starrick
Mark Gray	Kris Carpenter Stoever
Ed Harrison	John Stonesifer
Ken Havekotte	Larry Summers
Jim Hawk	Kipp Teague
A. R. Hogan	Jacques Tiziou
John Johnson	John Tribe
Joel Kastowitz	Jim Visser
Chris Kraft	Don Willis
Sy Liebergot	Leigh Wilson
H. H. Luetjen	Ron Woods

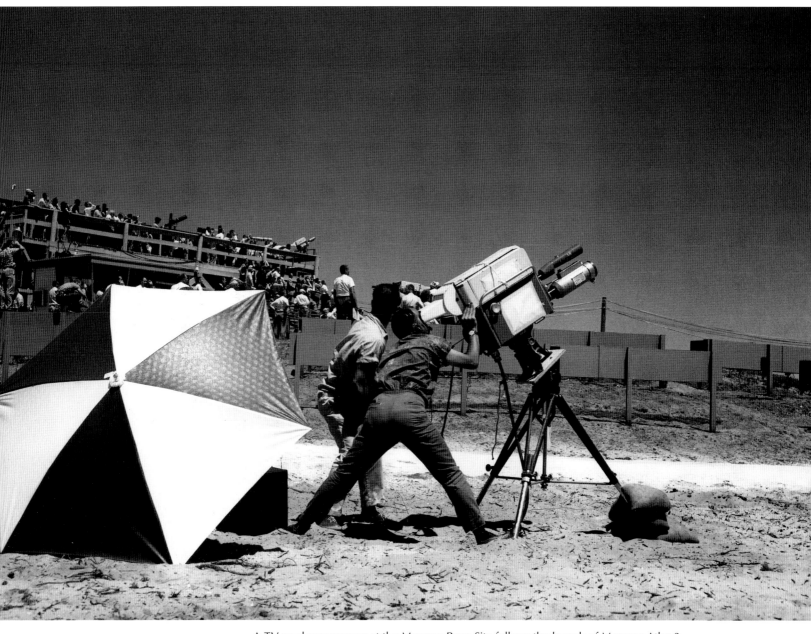

A TV pool cameraman at the Mercury Press Site follows the launch of Mercury-Atlas 3, an unmanned test, from LC-14 at 11:15 a.m. (EST) on April 25, 1961. Forty seconds later, the booster was destroyed by the range safety officer after it failed to stay on trajectory. The Mercury spacecraft separated, however, and was recovered. America's first astronaut would be launched ten days later. Note the improvised tilt mechanism for the RCA TK-11 black-and-white camera and its turret telephoto lenses.

Introduction

John Bisney

This project is, in many ways, the result of an abundance of riches. Thanks to J. L. Pickering's photo collection, it became quite apparent to me many years ago that he had a stunning luxury afforded to very few—if any—space enthusiasts: the ability, half a century later, to "see" in detail much more than was available to the public of what went on in day-to-day activities during the first fifteen years of America's manned space program. He was constantly showing me amazing images.

His source material is in many forms. For this book, vintage NASA 8 x 10 and 4 x 5 (black-and-white and color) prints provided the largest percentage of images, but 4 x 5 color transparencies and 35mm slides, negatives, and contact sheets were also used. J. L. scanned each using Epson and Nikon equipment.

We then decided to give this work another distinction. Not only would it consist of rare photos, but we would devote a chapter to each mission from Projects Mercury and Gemini. We're not aware of any other photo books that have done so; for example, all ten Gemini flights are typically lumped into one chapter (or less). We have often been disappointed that some missions have never received the proper credit for the essential roles they played in America's Space Race victory, and we wanted to give them more exposure.

Deciding which images to use from among the hundreds—if not thousands—available from each flight was not easy, but our process was fairly simple: J. L. selected about fifty photos that he knew to be rare or never published and sent them to me in sequence, presenting the mission in almost storyboard fashion. I then chose those I felt had exceptional visual, engineering, or human-interest appeal, often bearing in mind our snapshot theme. We also tried to provide a complete understanding of all the events and processes before and after the missions; we occasionally switched out a photo to maintain the flight's narrative. In a few instances, J. L. came up with an even higher-quality or more unusual image to substitute.

We can't claim every photo here is unpublished, but the great majority are. Almost all the others are at least uncommon. We did incorporate our publisher's suggestion to begin each chapter with what we came to call the mission's "iconic photo"—the image most associated with the flight in other publications and media—to give readers a well-known visual reference.

Sprinkled among the photos is an assortment of access badges and primarily "insider" memorabilia—much of it from NASA's Manned Flight Awareness program and our personal collections. Each chapter also begins with that flight's crew emblem, a practice that didn't begin until Gemini V. For Project Mercury, we use embroidered versions of the spacecraft's exterior art, and we show embroidered versions of the Gemini missions that did not have final crew emblem art.

The detailed captions, which tell the stories behind these remarkable photos, represent a significant accomplishment as well. To help bring as much context as possible to the images, we had two goals for our captions: to be accurate and to go far beyond previous space-photo books.

J. L. has stunned me many times by pointing out erroneous captions in many well-known space books—after all, this is the guy who can glance at a photo of any Saturn launch and correctly identify it within seconds. Although we're not infallible, he and his worldwide network of fellow space-photo historians took great efforts to double- or triple-check facts, dates, and locations. To better appreciate J. L.'s work, it's important to note that some original glossy photos had *no* captions, and the dates for many others are not of when they were taken but rather when NASA released them—sometimes weeks later. In the rare instances where no date is given, we were simply unable to pinpoint it.

Now about that second goal (to go beyond previous books). I approached writing the captions from a subjective viewpoint: As someone with what I thought was extensive knowledge of the subject, what would I like to know about each photo? What was that object, or why was something happening at a certain time or place? I often will tell you where something or someone has been and where they're going. I tried to strike a balance between being overly technical and providing fresh insights for those with background knowledge, while weaving in the flavor of the Space Race. A word about times and distances: We used statute (land-based) miles for distances instead of nautical miles because the former is what most people are familiar with. We listed most times in Eastern Time for consistency.

I relied on my reporting skills to track down many details and became something of a detective in the process. This book would have been almost impossible to write before the Internet—especially without the ability to access newspaper archives and NASA and contractor technical documents, which proved invaluable.

For photos with original captions, the majority only provided the basics; rarely is much context provided, and, more regrettably, few people in the background are identified. The space agency had little reason to do so, but without the thousands of government and contractor workers on the ground, the program would have been impossible. We were committed to identifying as many of these dedicated people as possible, who might otherwise go unrecognized.

As the captions came together, we were delighted to realize how valuable our networking with space retirees had become. Thanks to e-mail (and snail mail), we found it easy to show the pictures to our experts, who eagerly answered our questions about the procedures and people involved. I tried to include a sense of their colorful personalities and some anecdotes that have never been told previously. We especially enjoy taking you behind the scenes at NASA and contractor facilities, and introducing you to the journalists who provided so much on-the-spot coverage.

Just as each mission had its own objectives, each also has its own characteristics photographically. J. L. will discuss each flight.

J. L. Pickering

A lthough there are plenty of color images from Project Mercury, the majority are black and white. And while NASA photographically covered astronauts at work quite well, *Life* magazine's contract covered these men at home with their families.

Of special note for MR-3 was drawing from hundreds of images from unpublished contact sheets I obtained from the family of long-time Cape Canaveral Public Affairs Officer Gaitha Cottee, which were shot on launch day.

Locating rare material for MR-4 has always been more of a challenge. I was able to obtain some seldom-seen blockhouse images from the collection of Mercury Test Conductor Paul Donnelly; the loss of the spacecraft after splashdown doomed any hopes of getting onboard images of Gus Grissom. In fact, the capsule was eventually retrieved from the ocean and pieces of the onboard film were sold as souvenirs.

Three months of launch delays for MA-6 provided ample time for NASA to bulk up the John Glenn photo files, and it was difficult to choose from so much great material. It was also the first time that postmission photo releases made up such a large percentage of overall mission photography, primarily the result of Vice President Lyndon Johnson going to Grand Turk, and then President John Kennedy meeting Glenn at the Cape.

NASA did a great job with all aspects of photography for MA-7. I was fortunate to have obtained some great images of the Cape Press Site from NASA photographer Alex Bosmeny's collection. We have used a few in this chapter. Bosmeny also provided some rare images of Scott Carpenter at Grand Turk after his mission.

By the time MA-8 rolled around, more attention was devoted to Earth photography. Astronaut Wally Schirra was provided with special training and modified camera equipment. Unfortunately, there was extensive cloud cover during the mission, and most of the photos ended up being overexposed.

MA-9 provided the first decent images of Earth. The fact that this was the first U.S mission to go beyond twenty-four hours also put a lot of attention on astronaut Gordon Cooper. He became a media darling for a bit, and the result was an abundance of news-media images from the Mercury finale.

For the ten manned flights of Project Gemini, the biggest overall disappointment is the lack of onboard images of the crewmen. Given their packed flight plans and cramped quarters, however, perhaps that should not be a surprise. Our Gemini chapters include a number of images from a group of a few thousand poorly stored NASA color 4 x 5 transparencies I purchased from a retired Cape worker in the 1990s. They cleaned up very well, thanks to modern photo-editing software.

Gemini 3 offered great images across the board, again with onboard crew photos lacking.

Gemini IV featured what many call the best spacewalk photos ever taken, and the iconic photo of the sequence is almost in the same league as Buzz Aldrin on the moon and *Earthrise* from Apollo 8.

While Jim McDivitt took some spectacular photos of Ed White, I always wished that White had been more successful photographing the spacecraft during his extravehicular activity (EVA). We have included some of the more seldom-seen EVA images in this chapter.

Gemini V was the first mission where the flight crew spent a considerable amount of time shooting images of Earth, and with spectacular results. The eight days in orbit allowed the crew to become very familiar with one another and with their camera equipment. Pete Conrad also provided the first "alternate" portrait, with more photo pranks to come from the Manned Spacecraft Center (MSC) studio. (Thanks to Don Willis for that image.)

The concurrent missions of Gemini VII and VI-A provided some of the defining images of the program and some of its best. Having two spacecraft in orbit together provided unique photography of each spacecraft—although the Gemini VII crew was much busier snapping photos than their compatriots aboard Gemini VI-A.

Gemini VIII's brief stay provided some great views of an Agena in orbit, but the mission abort cut the planned photography short.

The "angry alligator" Agena provided a beautiful photo subject for Gemini IX-A. The crew did a very good job of documenting just about all aspects of this flight. The only regret is that they did not get a few more good shots of Gene Cernan's EVA.

Gemini X's crew took superb images of their Agena before and after docking, but John Young (like Tom Stafford on GT-IX-A) failed to get any photos of Collins during his EVA. This remains the most difficult mission of any in this project to locate and acquire unique—"new"—pre- and postflight images of, with MR-4 a close second.

The Earth and spacecraft photography was amazing during Gemini XI.

Finally, as is often the case, the last mission in a program supplies the best overall material. On Gemini XII, Jim Lovell finally provided additional images of an astronaut EVA, Aldrin snapped the first space "selfie," and the Agena shots were probably the best.

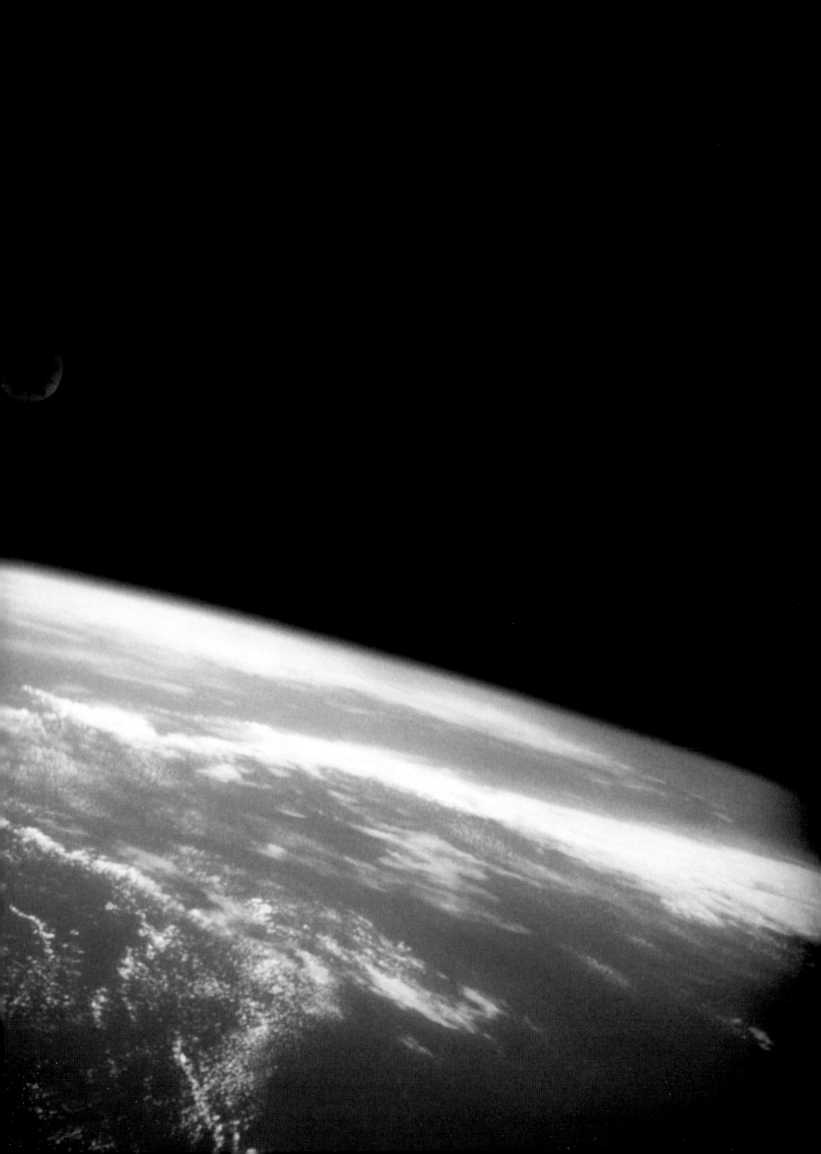

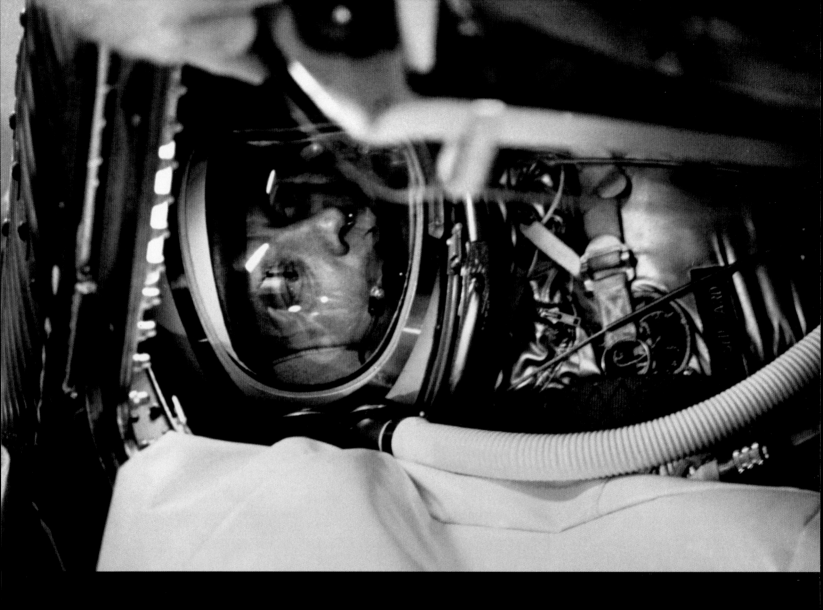

Alan Shepard on launch morning in *Freedom 7*. Visible in this photo are the edge of the instrument panel (*top*) and a white cover that protects the hatch edge (*bottom*). The hose from his helmet carries ventilation air exiting his space suit.

Mercury-Redstone 3

May 5, 1961

Launch: 9:34 a.m. (EST)

On April 12, 1961, the Soviet Union stunned the world by launching cosmonaut Yuri Gagarin on a one-orbit flight with no advance notice—the first human in space. Three weeks later, the United States lofted astronaut Alan B. Shepard Jr. 116 miles above Earth—about as high as Gagarin, but only about 300 miles out over the Atlantic Ocean, splashing down off the Bahamas. The fifteen-minute flight put the United States in the game of manned space flight but, to the American public, also disappointingly behind. Many worried that the Soviets, locked in a Cold War with the United States, had gained a dangerous military advantage.

Shepard's flight—the first manned launch of Project Mercury—was aboard a Mercury spacecraft launched by NASA on a modified Redstone missile from Launch Complex 5 (LC-5) at the Cape Canaveral Missile Test Annex, a US Air Force (USAF) facility on Florida's central Atlantic coast.

The flight was planned for May 2, but rainy weather forced delays until May 5. Although NASA officials had selected Shepard from among three of the seven Mercury astronauts weeks earlier, his choice wasn't disclosed until after the May 2 launch delay. More than 250 reporters from around the world were on hand, and although the hallmark of the US program—in contrast to the Soviet Union—was as open as possible, the White House was initially cautious about broadcasting the launch live in case of failure.

The primary goals were familiarizing a man with a brief but complete space-flight experience, evaluating his ability to perform useful functions, including controlling the spacecraft, and communicating with the ground. The final objective was studying the pilot's physiological reaction to space flight.

Photo from automatic Earth-sky Maurer 200G sequence camera with timer image superimposed in the upper left

Shepard could distinguish major landmasses using a periscope and make out coastlines, islands, and major lakes but had difficulty identifying cities. Lacking a window, Earth photos were taken by an automatic camera in the spacecraft's porthole. He also briefly tested small thrusters to adjust the capsule's position, unlike Gagarin.

After splashdown east of the Bahamas, Shepard egressed from the main hatch. He was pulled with a sling into a helicopter, which flew both the astronaut and *Freedom 7* to the aircraft carrier USS *Lake Champlain*. They were on board eleven minutes after splashdown.

The majority of NASA photos for MR-3 were black and white since newspapers did not have the capability to publish color pictures. Magazines did, however, and *Life* magazine was at the forefront through an exclusive (and controversial) contract with the astronauts' families.

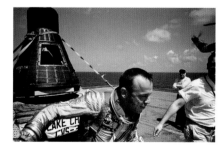

Aboard ship: 10:00 a.m. (EST)

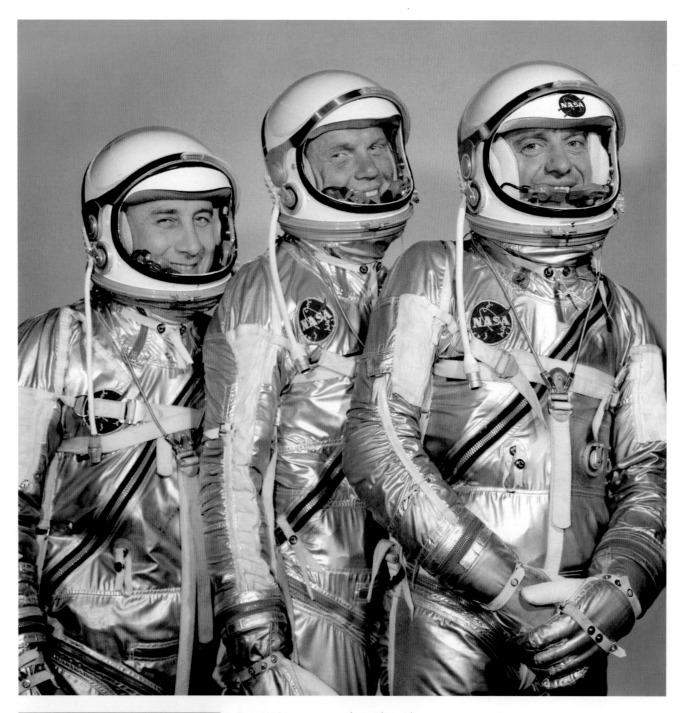

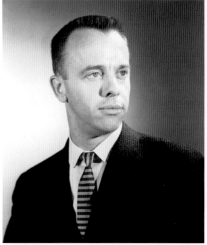

Top: NASA managers planned to select the first American in space from three of the seven Mercury astronauts. *Left to right*: Gus Grissom, John Glenn, and Shepard.

Left: The first NASA portrait of Shepard, released in 1959. He and six other military test pilots were chosen from more than five hundred applicants. They rarely appeared in uniform in keeping with the US Cold War emphasis on a peaceful space program.

Top: Shepard examines his space suit at B. F. Goodrich in Akron, Ohio, in 1960. The unidentified man holds a glove fitted for Warren J. North, who had the title of chief of Manned Satellites at NASA headquarters in Washington, D.C.

Right, left to right: Dr. William K. Douglas, Mercury flight surgeon; Glenn, Shepard's backup; Shepard; and Charles Mathews, Space Task Group Operations Division chief, at the final MR-3 preflight review meeting in Hangar S at Cape Canaveral Missile Test Annex.

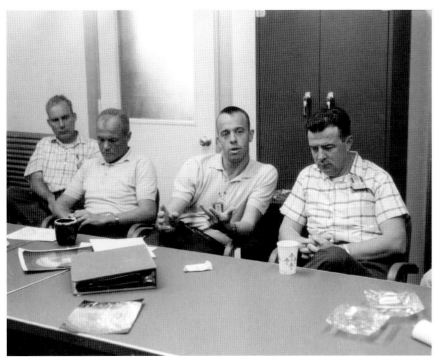

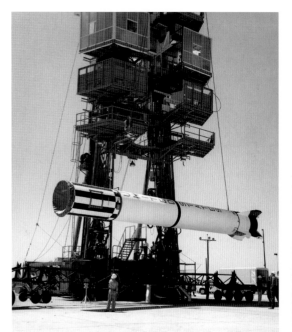

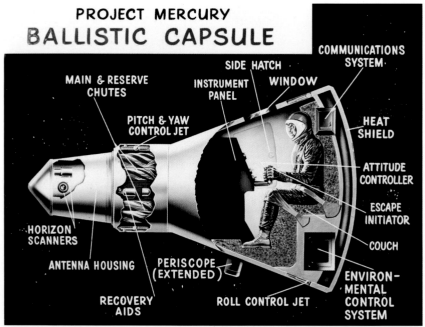

PROJECT MERCURY
BALLISTIC CAPSULE

MAIN & RESERVE CHUTES

SIDE HATCH

INSTRUMENT PANEL

WINDOW

COMMUNICATIONS SYSTEM

PITCH & YAW CONTROL JET

HEAT SHIELD

ATTITUDE CONTROLLER

ESCAPE INITIATOR

HORIZON SCANNERS

COUCH

ANTENNA HOUSING

PERISCOPE (EXTENDED)

ENVIRON-MENTAL CONTROL SYSTEM

RECOVERY AIDS

ROLL CONTROL JET

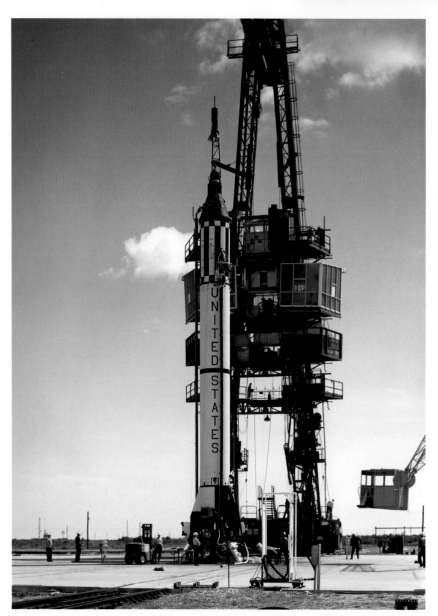

Top left: Suspended by cables, MR-3's Redstone booster is moved into position at LC-5 at Cape Canaveral on April 3, 1961. The Redstone, built by the Chrysler Corp. in Warren, Michigan, was the first large US ballistic missile and was deployed by the US Army in West Germany with nuclear warheads from 1958 to 1964 as part of NATO's Cold War defense of Western Europe.

Top right: NASA artwork from January 1960 shows the basic components of the Mercury spacecraft.

Left: A pad egress test at LC-5 in April 1961. Work platforms in the red gantry (which moved on rails) allowed access to the booster and spacecraft. The green fiberglass section, known as the white room, surrounded the Mercury spacecraft. It was enclosed after Hurricane Donna passed north of the Cape seven months earlier. The yellow cab of the Mobile Aerial Tower, or "cherry picker," at lower right would be used to remove the astronaut in case of emergency if the gantry had already been rolled back.

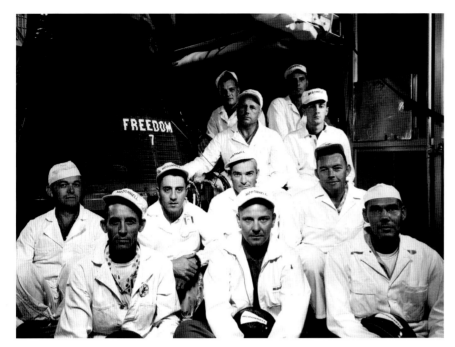

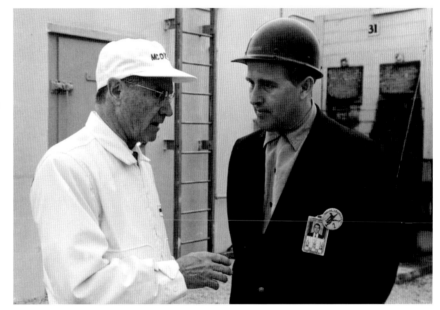

Top left: The second shift of McDonnell Aircraft workers pose with *Freedom 7* in the white room at LC-5 on April 28, 1961. Ed Sieblist, assistant foreman, is first-row center. McDonnell won the Mercury spacecraft contract over the Grumman Corp. in 1959 largely because the federal government knew Grumman would have its hands full with a number of critical US Navy projects.

Top right: Shepard before simulator training at Space Task Group facilities at Langley AFB, Virginia. The organization was the seed for what would become NASA's Houston center.

Right: James McDonnell, founder of McDonnell Aircraft, chats with Wernher von Braun, director of the Marshall Space Flight Center (MSFC) in Huntsville, Alabama, outside the LC-5 blockhouse on May 2, 1961, after Shepard's first launch attempt. Headquartered in St. Louis, Missouri, McDonnell was the principal supplier of fighter aircraft to the USAF and US Navy. Von Braun had developed rocket technology for Germany during World War II and was brought to the United States in 1945. He led the US Army's rocket development team at Redstone Arsenal, which designed the Redstone. MSFC, built nearby, opened in 1960.

Left: Douglas (*left*) enjoys a cigarette after breakfast at the Mercury medical facility at LC-3 with astronauts Glenn, Shepard, Deke Slayton, Gordon Cooper, and Grissom.

Bottom left: NASA suit technicians (officially known as "equipment specialists") Joe W. Schmitt (*left*) and Alan M. Rochford make adjustments to Shepard's space suit, No. M-22. Fabricated by B.F. Goodrich, the suits were based on the company's US Navy high-altitude Mark IV pressure suits.

Bottom right: McDonnell technician Guenter Wendt checks countdown procedures with Glenn inside the spacecraft early on launch morning at LC-5. Glenn's coiled headset cable stretches across the table.

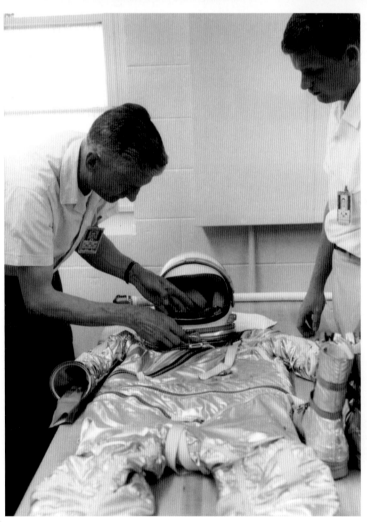

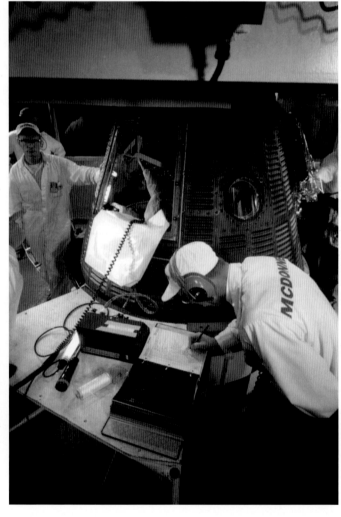

Chapter 1

Right: Dietician Jean McKay serves Shepard a steak and eggs breakfast in Hangar S around 1:50 a.m. (EST) on launch morning, while his backup, John Glenn, examines a set of coveralls. Several people ate the same meal as a control in case of a foodborne problem. Each Mercury astronaut stayed at the hangar's living quarters on the second floor for three days before his mission.

Bottom left: A final medical examination follows breakfast at 2:25 a.m. by Dr. Douglas (who also examined Glenn to clear him for flight if necessary). Shepard's biomedical harness is pictured (*top right*).

Bottom right: Shepard wears a set of cotton long johns under his pressure suit. He would don his helmet and leave for LC-5 at 4:00 a.m. on May 5.

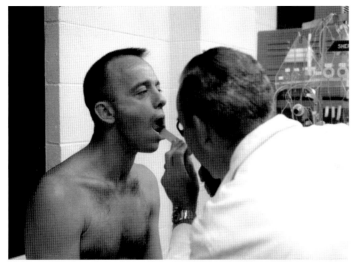

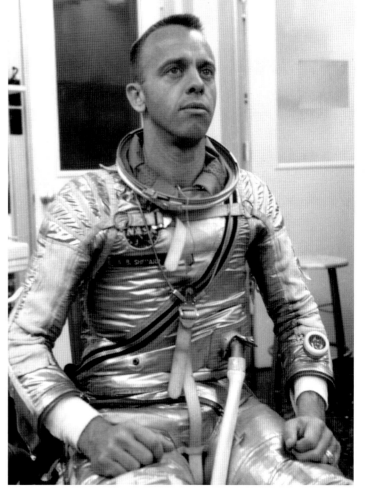

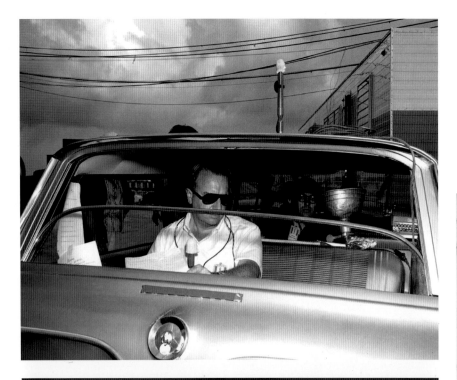

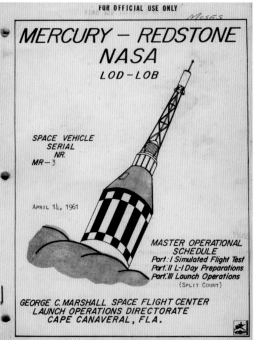

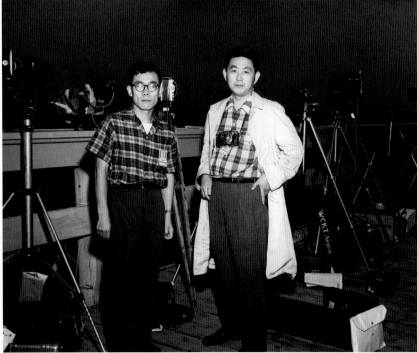

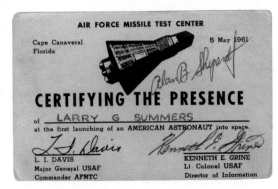

Top left: CBS News correspondent Walter Cronkite broadcasts from the back of a station wagon at the press viewing area less than two miles from LC-5. Producer Sandy Socolow (*behind*) served as a senior producer at CBS for thirty-two years (including as Cronkite's executive producer during his last four years as anchor). The car, a 1961 Chevrolet Nomad, provided Cronkite with on-the-spot mobility at the Cape. The make is taped over for on-air use.

Bottom left: Shiro Yasuda of Tokyo's *Yomiuri Shimbun* (*left*) and Akira Ogata of Japan Broadcasting Corp. were among reporters from around the world on hand on May 2, the original launch date. The flight was scrubbed that morning, however, by inclement weather. The equipment at right is from WCKT-TV, the NBC affiliate in Miami. The United States touted the openness of its civilian space launches as a contrast to the Soviet Union's extreme secrecy.

Top right: Clip-back button issued by NASA's Launch Operations Directorate (LOD) authorized access to the pad and blockhouse.

Center right: Cover of the Master Operational Schedule for MR-3. NASA's Marshall Center had first developed the Redstone as a US Army missile in 1952.

Bottom right: Larry Summers, Mercury's motion picture photographer, had Shepard later autograph this participant card.

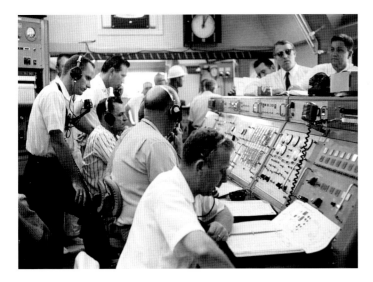

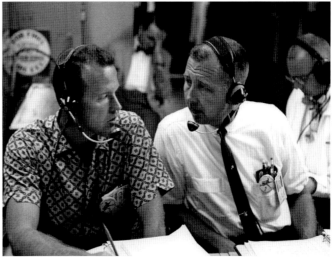

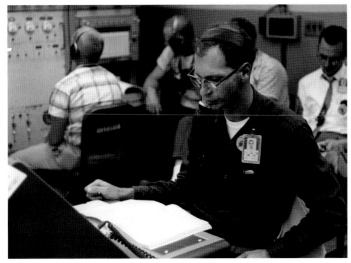

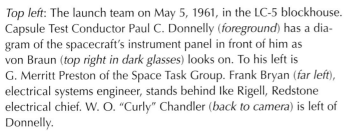

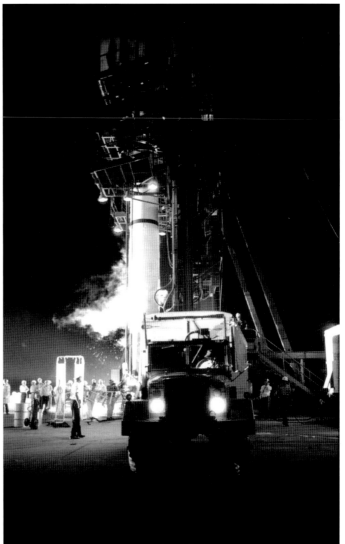

Top left: The launch team on May 5, 1961, in the LC-5 blockhouse. Capsule Test Conductor Paul C. Donnelly (*foreground*) has a diagram of the spacecraft's instrument panel in front of him as von Braun (*top right in dark glasses*) looks on. To his left is G. Merritt Preston of the Space Task Group. Frank Bryan (*far left*), electrical systems engineer, stands behind Ike Rigell, Redstone electrical chief. W. O. "Curly" Chandler (*back to camera*) is left of Donnelly.

Top right: Cooper (*left*) and H. H. Luetjen of McDonnell in the LC-5 blockhouse prior to launch on May 5.

Bottom left: NASA's Robert Moser goes over procedures in the blockhouse on launch morning. The ten-hour Mercury-Redstone countdown was spread over two days to reduce launch team fatigue. Moser was part of the team that launched the first US satellite, Explorer 1, in 1958 and remained with NASA through the Apollo program. At right is Emil Bertram, assistant to LOD Director Kurt Debus. Like von Braun, Debus was a former German rocket engineer brought to the United States at the end of World War II as part of Operation Paperclip.

Above: The trailer carrying Shepard arrives at Pad 5 in predawn darkness on May 5, 1961, as vapor vents from the Redstone's oxidizer tank, which had been filled with super-cold liquid oxygen (LOX) several hours earlier.

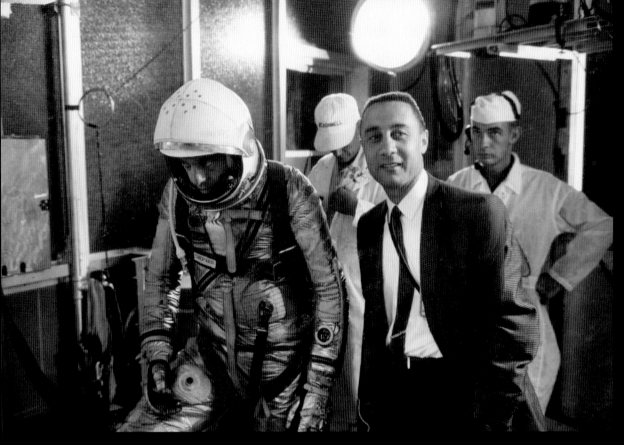

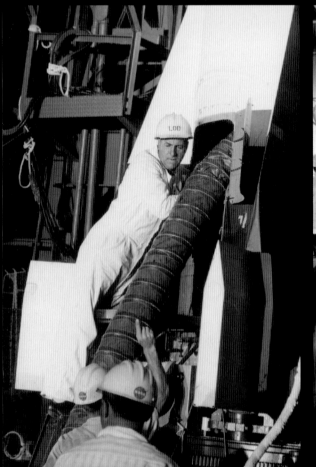

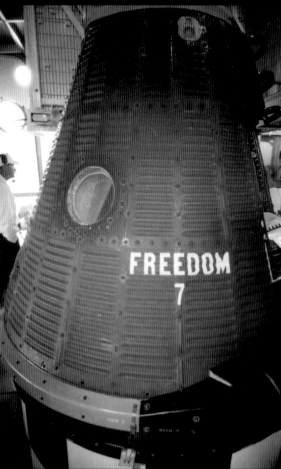

Left: Shepard arrives in the white room accompanied by Grissom (who would pilot the second and final suborbital Mercury flight eleven weeks later on July 21, 1961). Shepard entered the spacecraft at 5:20 a.m. (EST)—two hours before the planned launch time. A white cover protects the Plexiglas visor on the top of his helmet. The helmet and visor accounted for half of the suit's $5,000 cost.

Bottom left: An LOD worker stands between two of the Redstone's four movable rudders on launch morning. The flexible ducting through the access door provided heated air to maintain engine parameters and critical temperatures within specified limits in the tail section.

Bottom right: *Freedom 7* in the white room atop the Redstone with the hatch at right. A larger window on subsequent Mercury spacecraft would replace the porthole. Although it was spacecraft No. 7, Shepard also chose the name in honor of the project's seven astronauts.

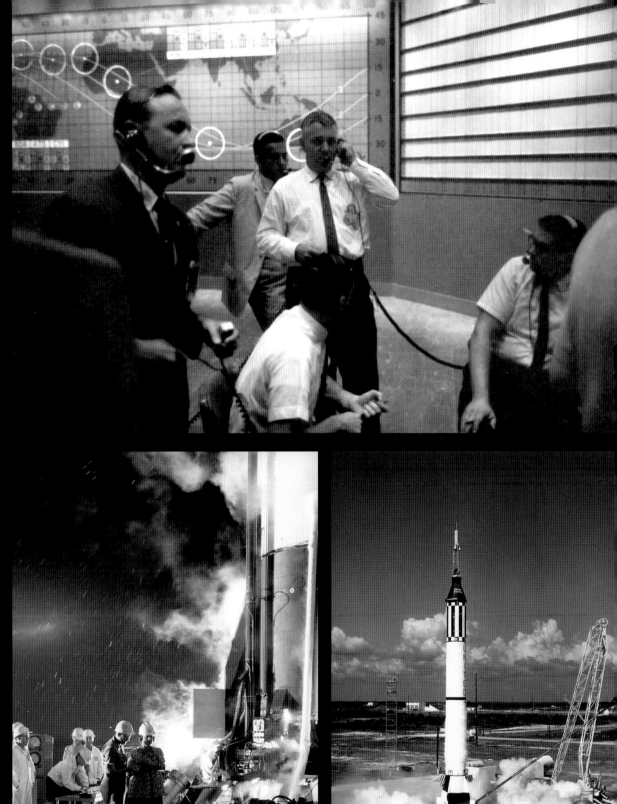

Right: Flight Director (radio call sign *FLIGHT*) Christopher C. Kraft Jr. (*foreground*) on launch day in the Mercury Control Center (MCC), a little over one and a half miles north-northwest of LC-5. Flight Operations Director Walter C. Williams holds a headset to his ear. Flight Dynamics Officer (FIDO) Glynn Lunney is seated (*center*) with Retrofire Controller (RETRO) Carl R. Huss (*right*).

Bottom left: Fueling lines run to the Redstone several hours before launch; ice particles that formed on the rocket's skin from the tank rain down on the pad crew. The Redstone burned LOX with ethyl alcohol for fuel, boosting the Mercury spacecraft for two minutes and twenty-two seconds to a speed of 5,200 mph. *Freedom 7* would reach its maximum altitude of 116 miles two and a half minutes later.

Bottom right: Ignition of MR-3 at 9:34 a.m. (EST). At 7:05 a.m. the launch was held for an hour to let cloud cover clear to permit good Earth observations and photography, and to fix a power supply. Shortly after the count resumed, another hold was called to reboot a tracking computer at NASA's Goddard Space Flight Center in Greenbelt, Maryland. The cherry picker (*right*) is folded away and a pad light is seen lower right.

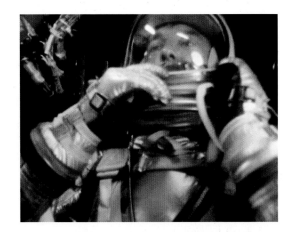

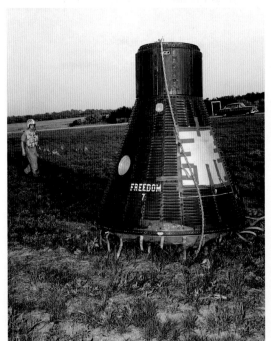

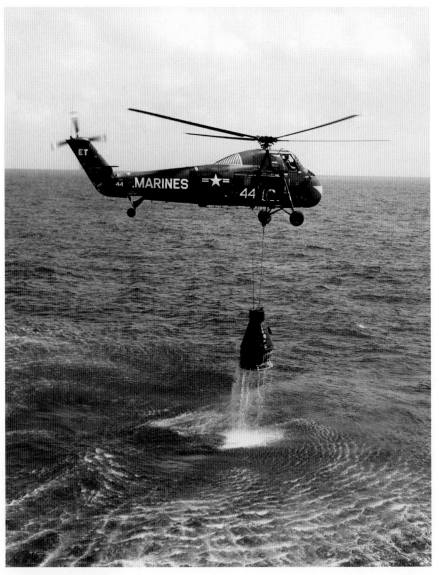

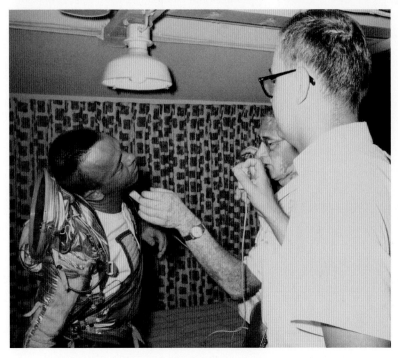

Top left: Still frame from the 16mm pilot observation camera mounted on the instrument panel captures Shepard in-flight as he prepares to open his visor shortly before splashdown.

Top right: A Sikorsky HUS-1 Seahorse helicopter from the aircraft carrier USS *Lake Champlain*, with Shepard aboard, pulls *Freedom 7* from the Atlantic eighty-five miles northeast of the Abaco Islands, the Bahamas. US Marine Corps (USMC) 1st Lt. Wayne E. Koons is the pilot and USMC 1st Lt. George F. Cox is leaning out the door. Both men later appeared on the CBS-TV game show *What's My Line?* Shepard and his spacecraft were aboard the ship eleven minutes after the 9:49 a.m. (EST) splashdown.

Center left: The spacecraft was returned to Cape Canaveral the next day by helicopter. The straps along the bottom edge held a landing bag, which dropped and filled with air to cushion the splashdown.

Bottom left: Medical personnel examine Shepard in *Lake Champlain*'s sick bay before almost two days of debriefings on Grand Bahama.

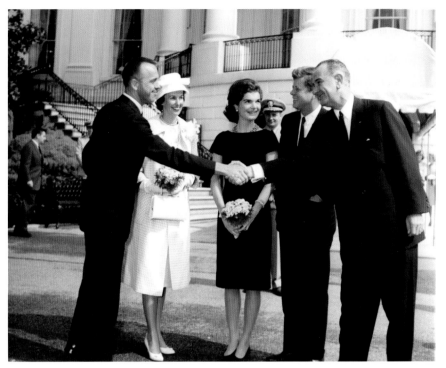

```
                        'FREEDOM 7'
                       DINNER DANCE

Launch Date:     8 June 1961
Expenditure:     $3.50 per person
Pad Location:    PAFB Officer's Club

                       COUNTDOWN

T-240   (5:00) Clean up
T-210   (5:30) Suit up (Coat-Tie/Cocktail
                            Dress)
T-180   (6:00) Pick up date
T-150   (6:30) Alcohol Loading (Dutch
                               Bar)
T-90    (7:30) Fuel Loading (Dinning
                             Room)
T-30    (8:30) Briefing
------------- Anticipated Hold
T-25    (8:35) Alcohol Topping
T-0     (9:00) Lift-off to Orbit
                          (Ballroom)
T+4 hrs.       Leave Orbit
T+12 hrs. ?    Recovery (?)

PCN #1 (Coat and Tie Required)
```

Top left: With President John Kennedy and first lady Jacqueline at center, Vice President Lyndon Johnson (*right*) greets Shepard as he and his wife, Louise, arrive near the diplomatic entrance on the south lawn of the White House at 9:00 a.m. on May 8. Kennedy would award him NASA's Distinguished Service Medal before introducing the Shepards at the National Association of Broadcasters' annual convention at a nearby hotel. A parade to the Capitol and a reception followed.

Right: Shepard signs an autograph after joining the other six astronauts at the head table during a dinner-dance in his honor at the Patrick AFB Officers' Club on June 8. "PCN" on the program (*pictured at top right*) is NASA's acronym for page change notice. Patrick operated the Cape Canaveral Missile Test Annex twelve miles to the north.

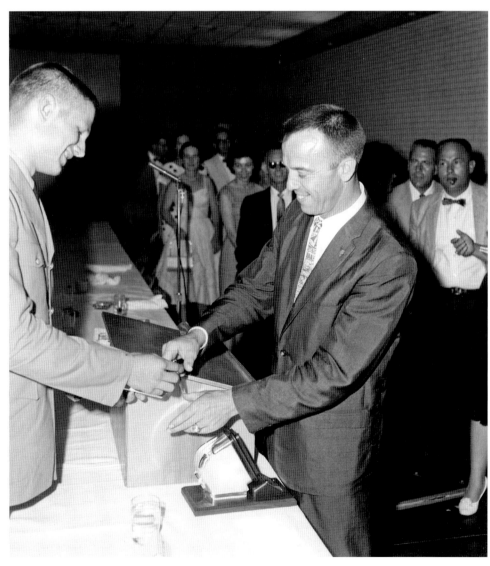

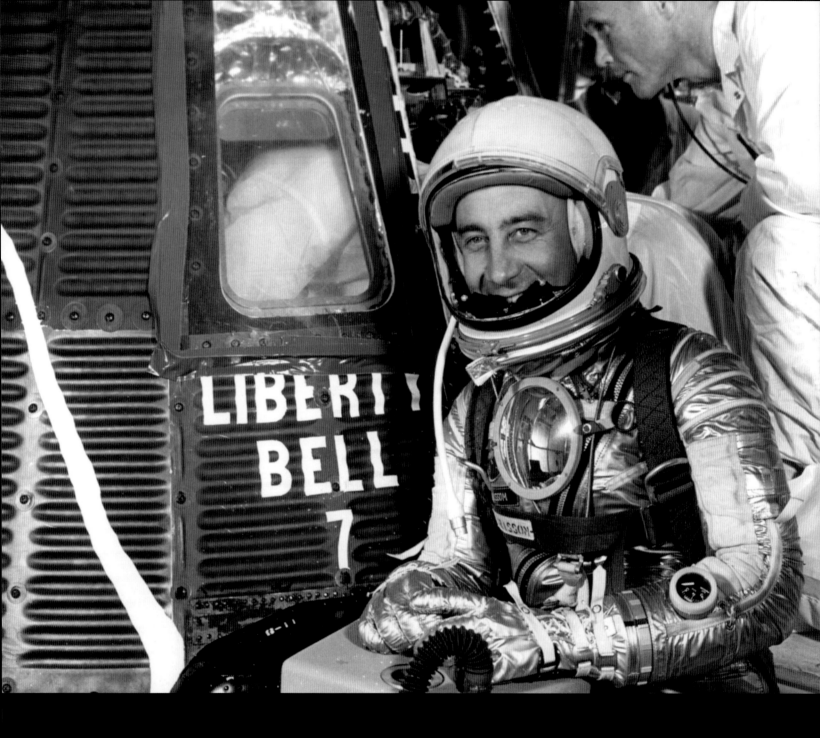

Gus Grissom poses with *Liberty Bell 7*—with painted crack (*left*)—on launch morning as his backup, Glenn, inspects the cabin. The convex mirror on his chest—dubbed the "hero medal"—was to reflect the instrument panel for the pilot observer camera.

Mercury-Redstone 4

July 21, 1961

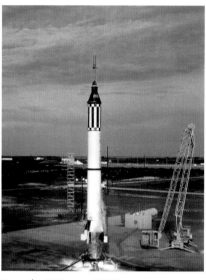

Launch: 7:20 a.m. (EST)

E xactly eleven weeks after Alan Shepard's flight, USAF Captain Virgil I. "Gus" Grissom was aboard Project Mercury's second and final manned suborbital mission on July 21, 1961. It was almost identical to Shepard's, with the exception of unexpected and dramatic spacecraft recovery problems. And at 15:37, it was fifteen seconds longer than MR-3.

The thirty-five-year-old Grissom, a test pilot who'd flown one hundred combat missions during the Korean War, named his capsule *Liberty Bell 7*, complete with a painted white crack on one side. He also had a new control system to adjust the capsule's movements with a hand controller; a redesigned hatch that opened with small explosive bolts; and the first true window in a US spacecraft. He later said he was easily distracted by the opportunity to look out the window and predicted it would be the "best friend" of orbiting astronauts.

After splashdown north-northwest of the Bahamas, Grissom spent about five minutes preparing to egress. The explosive bolts unexpectedly blew the hatch off prematurely, however, and he quickly pulled himself out of the spacecraft, which began to take on seawater. A navy recovery helicopter hooked onto *Liberty Bell 7* as planned but struggled to lift it with the added weight of the water.

In the meantime, Grissom kept feeling air escape through a rubberized seal around his neck. The more air he lost, the less buoyancy he had. He also forgot to close his suit's oxygen inlet valve. Swimming became difficult and with a second helicopter now assigned to retrieve him, he found the rotor wash between the two aircraft making it worse. Grissom was either swimming or floating for a period of only four or five minutes. "It seemed like an eternity to me," he said afterward.

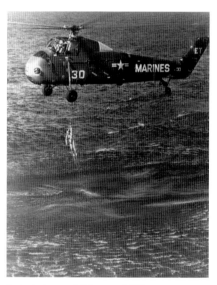

Splashdown: 7:35 a.m. (EST)

The second helicopter dropped a "horse collar" harness to the exhausted astronaut, who gratefully pulled on the sling and was hoisted aboard. The flooded *Liberty Bell 7* now weighed more than five thousand pounds—some one thousand pounds beyond the helicopter's lifting capacity. The spacecraft became too heavy and was cut loose and sank.

When Grissom was asked by reporters how he'd felt, he replied, "Well, I was scared a good portion of the time. I guess that's a pretty good indication." He later insisted he had done nothing to cause the hatch to blow, and NASA officials eventually concluded he was right. During a 1965 interview, Grissom said he thought the hatch might have been triggered by a loose external release lanyard. On *Liberty Bell 7*, it was held in place by a single screw and it was better secured on later flights.

On July 20, 1999 (one day shy of the thirty-eighth anniversary of the flight), the spacecraft was found at a depth of nearly 1,500 feet in surprisingly good condition. A team financed by the Discovery Channel lifted the capsule off the floor of the Atlantic Ocean and onto the deck of a recovery ship.

Areas of the interior aluminum panels showed deterioration, but some fabrics—including Grissom's parachute—were intact. The recovery team ran out of time and did not continue to search for the hatch. The Kansas Cosmosphere and Space Center in Hutchinson disassembled and cleaned the spacecraft. It's here that the spacecraft is normally on display.

Top left: Grissom models his pressure suit outside NASA's Space Task Group offices at Langley AFB in 1961. His gloves featured twist-lock ring connectors at the wrists instead of zippers to increase mobility. The suit also included the first urine-collection device.

Top right: Redstone Project Manager Dr. Joachim Kuettner (*left*) poses with Grissom in 1961. Kuettner was a German atmospheric scientist and glider expert who emigrated to the United States in the 1950s and led many international atmospheric field studies. He later worked in systems integration during the Apollo program.

Bottom left: Grissom and Alan Shepard at Cape Canaveral on July 3, 1961. The two would spend the next day in the grandstands—"incognito"—at the third annual Firecracker 250 at Daytona International Speedway in Daytona Beach, Florida, sixty miles to the north.

Bottom right: Grissom poses at the hatch of the human centrifuge at the US Navy's Aviation Medical Acceleration Laboratory in Johnsville, Pennsylvania. He got a one-day refresher course in the device on April 4, 1961, with Shepard and John Glenn. The centrifuge was the largest in the world, with a four-thousand-hp motor capable of producing forty gees, more than four times the force produced by a Redstone launch.

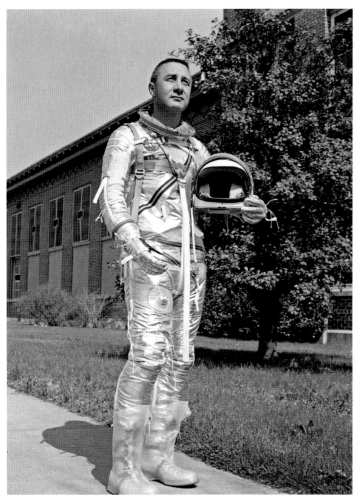

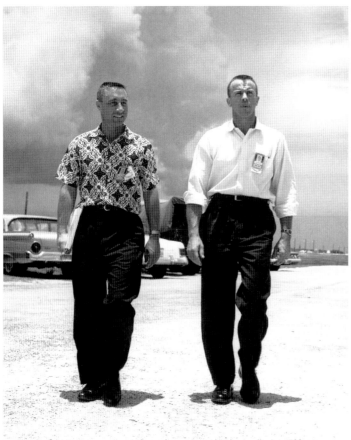

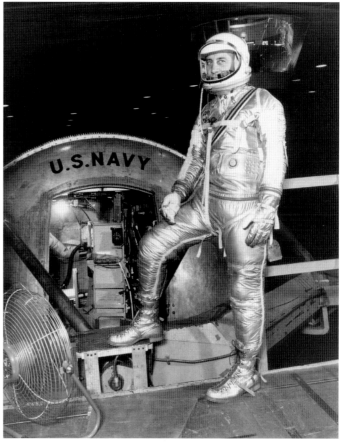

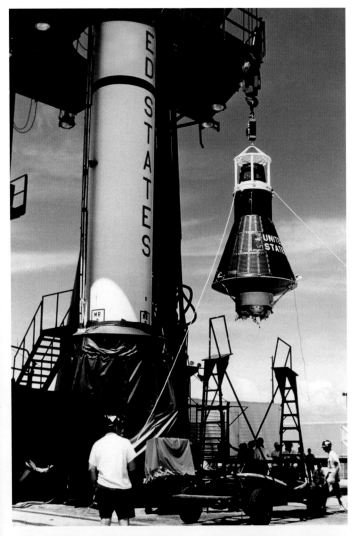

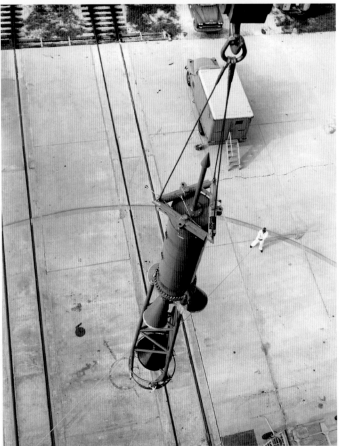

Far left: Grissom in his spacecraft at McDonnell in a sequence of 16mm frames filmed on February 2, 1961, from a test of the pilot observer camera. A photo flood-light was used to simulate the Sun.

Top right: Mercury spacecraft No. 11 is hoisted from its carrier to be mated with the Redstone. Three straps hold the spacecraft's silver retro-rocket pack (used to slow its speed before reentry) to the bottom of its parabolic heat shield.

Bottom right: A crane lifts the spacecraft's solid-fueled escape tower to the top of the stack on July 5. The black cone near the bottom would protect the spacecraft from exhaust from the three small nozzles if the rocket fired, by quickly pulling it away from the Redstone during an emergency. At the top is an aerodynamic spike. The system was built by the Lockheed Propulsion Co. near Redlands, California.

Opposite page, top left: A fully suited Grissom poses for a publicity shot in the weeks before launch. The small studs (*lower right*) are connection points for the medical electrodes glued onto his skin.

Opposite page, top right: Grissom confers with backup astronaut Glenn (who was under consideration for a possible third suborbital Redstone flight at the time) in the MCC. The building, located just more than one mile from LC-5, was used until Houston's Mission Control Center became operational for Gemini IV in June 1965.

Opposite page, bottom center: Grissom with NASA test conductor Paul Donnelly (*center*) and Sam Beddingfield at LC-5 on June 22, 1961, during the Redstone booster's erection. Donnelly helped develop the world's first "smart bomb," which was dropped by his navy squadron on Japanese forces in 1944, and later became KSC launch operations manager for Apollo. Beddingfield, a former test pilot, was Mercury's mechanical engineer and worked on all US manned spaceflight programs until retiring in 1985 as KSC deputy director of Space Shuttle operations.

Chapter 2

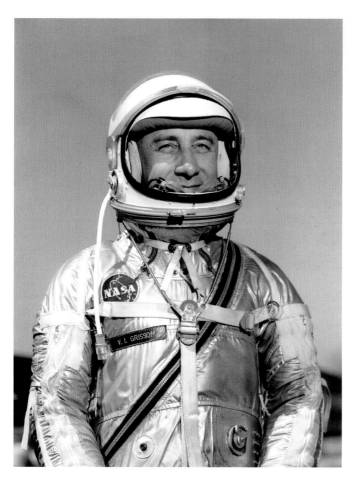

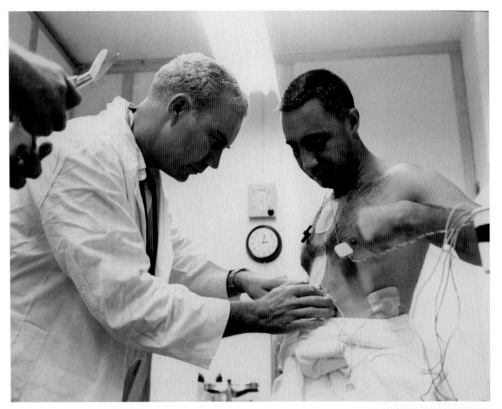

Left: Flight surgeon Dr. William Douglas attaches electrodes to Grissom's skin to monitor his vital signs during flight. Each Mercury astronaut had four tiny dots tattooed on his chest to designate optimum electrode placement.

Bottom left: NASA suit tech Joe Schmitt checks Grissom's suit for oxygen leaks. Schmitt, a former parachute rigger, helped suit astronauts for the Gemini, Apollo, Skylab, and Space Shuttle programs. At right is Don Wilfert, a biomedical technician.

Bottom right: A television cameraman perched atop a Chevrolet station wagon provides TV network pool coverage at LC-5 early on July 19, 1961—the second launch attempt—which, like the first on July 16, was called off due to bad weather.

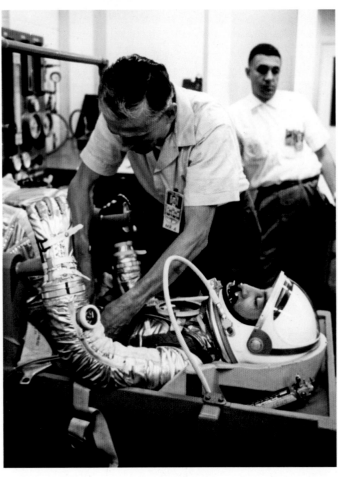

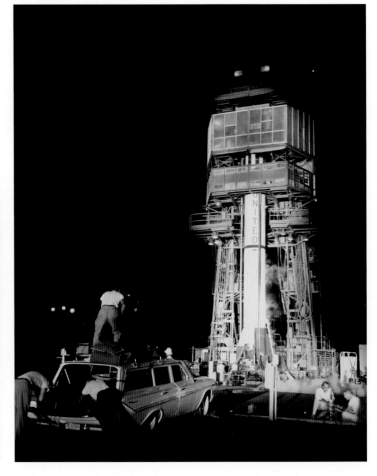

Above: MCC access badge

Below: Capsule Test Conductor Paul Donnelly in the LC-5 blockhouse prior to launch with a layout of the Mercury's controls propped in front of his count-down manual (left). Behind him is Walter J. Kapryan, who would become the launch director for several Apollo moon missions.

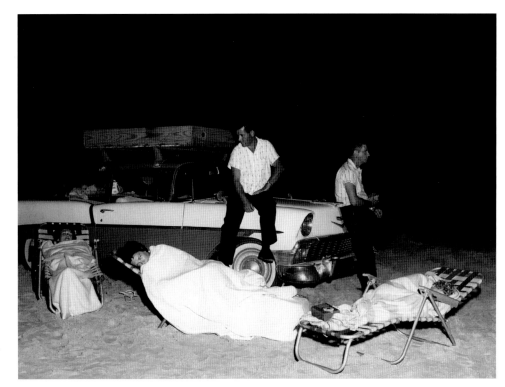

Above: Crowds—kept informed by car and transistor radios well in advance of Grissom's launch—gather on Cocoa Beach where cars were normally permitted to drive and park. A huge sign strung across US highway A1A in Cocoa Beach read, "Welcome back Gus to Cocoa Beach—Nation Acclaims Seven Astronauts."

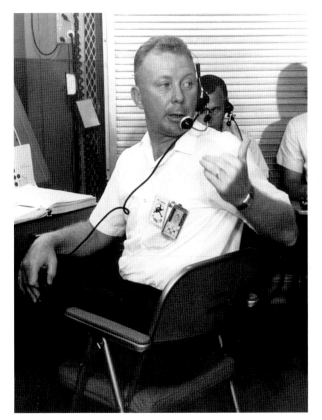

Below: Launch Operations Directorate (renamed Kennedy Space Center in 1963) Director Kurt Debus in the blockhouse, with Grissom's Redstone booster visible through the thick glass window behind him. Like Wernher von Braun, Debus had been brought to the United States from Germany after World War II and had worked closely under von Braun at the US Army's Redstone Arsenal near Huntsville, Alabama, developing a variety of missiles first used during the Korean War. Debus had supervised launch facilities at the Cape since 1952.

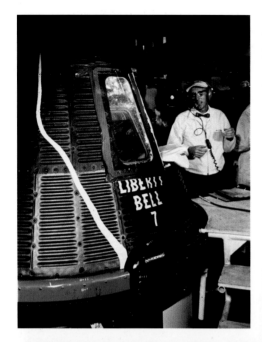

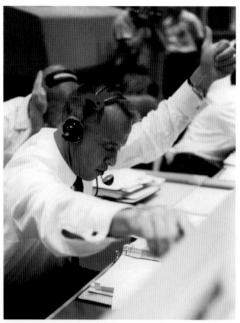

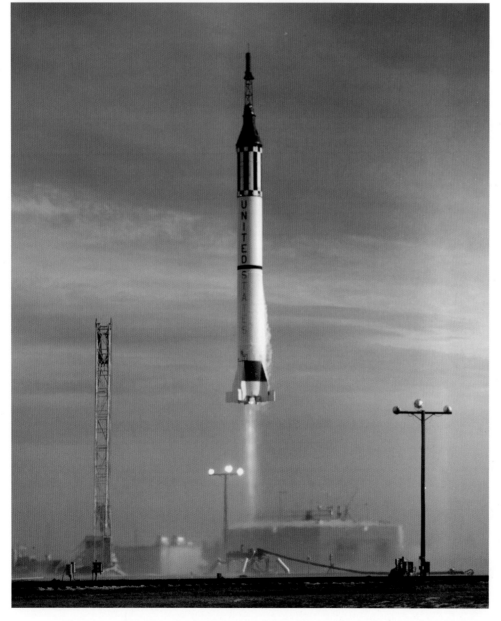

Top left: McDonnell pad leader Guenter Wendt prepares the spacecraft for Grissom's insertion on launch morning in the white room at LC-5 while wearing a white jacket with patches identifying McDonnell workers.

Top right: Shepard signals liftoff at the MCC with Glenn behind him. The seven astronauts were assigned to key communication roles during each flight (some based at tracking stations around the world for orbital missions). They served as capsule communicators (radio call sign CAPCOM)—normally the only individuals who spoke to an astronaut during flight.

Bottom: With the weather finally cooperating, MR-4 lifts off from LC-5 at 7:20 a.m. (EST) on July 21, 1961. Poor visibility had delayed the July 19 attempt with just more than ten minutes to go.

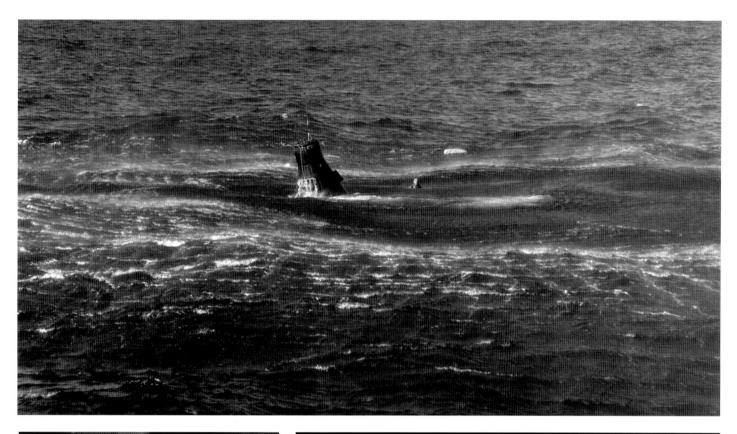

Top: Grissom treads water minutes after splash-down as a USMC helicopter tries to pull his space-craft from the Atlantic. Dealing with the sinking capsule forced the recovery crew to assign a second helicopter to rescue the astronaut, who was also having trouble staying afloat as water entered his suit through both his neck ring and an inlet valve he had failed to close.

Bottom left: Grissom enjoys breakfast aboard the aircraft carrier USS *Randolph*. President Kennedy signed NASA's $1.78 billion 1962 authorization bill hours later, vastly expanding the space program. He mentioned Grissom's flight: "Once again, we demonstrated the technological excellence of the country."

Bottom right: A shaken Grissom safely aboard the *Randolph* after stepping down from the recovery helicopter.

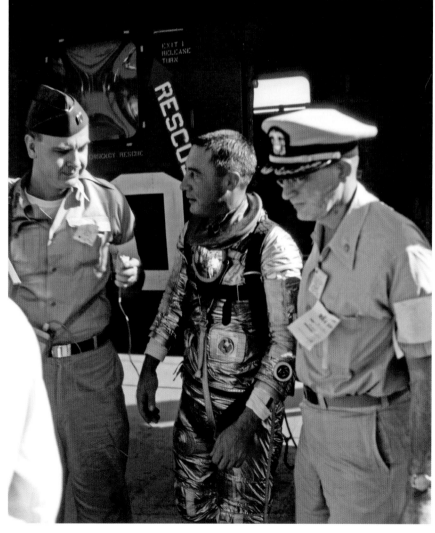

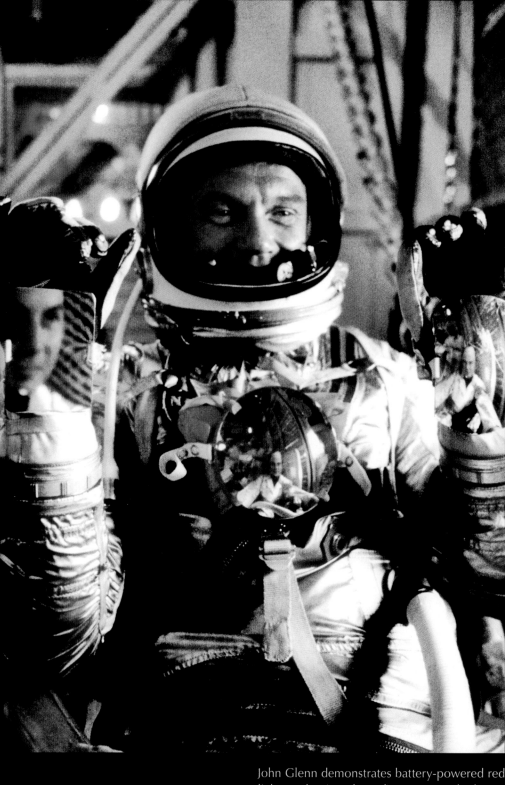

John Glenn demonstrates battery-powered red lights at the tips of two fingers on each glove to help him read charts and the instrument panel before his eyes adjusted to darkness in orbit. Wrist mirrors aided his view inside the cramped spacecraft. Dr. Douglas can be seen in his chest mirror and wrist mirrors.

Mercury-Atlas 6

February 20, 1962

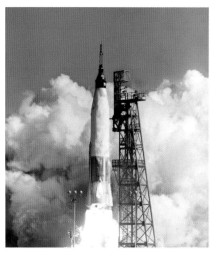

Launch: 9:47 a.m. (EST)

J ust weeks after Gus Grissom's suborbital flight, the Soviet Union launched its second cosmonaut, Gherman Titov, into orbit for a full day on August 6, 1961. Titov's seventeen orbits seemed to give the Soviets a huge lead in the Space Race. Americans had to wait another six and a half long months for the first American to orbit the earth: forty-year-old USMC Lt. Col. John H. Glenn Jr., a World War II and Korean War fighter pilot.

Glenn was launched by an Atlas booster on February 20, 1962, from LC-14 aboard a spacecraft he named *Friendship 7*. A crowd of about one hundred thousand people had gathered in Cocoa Beach, Florida, just south of the Cape, to watch as an estimated sixty million Americans tuned in on live television.

Five minutes and twenty seconds later, Glenn was traveling 17,544 mph in orbit. During his three revolutions of the earth over nearly five hours, he described sunrises and sunsets, remarked on geographical features, and carried out tests of the spacecraft and his abilities in weightlessness.

View from orbit

He soon encountered problems, however, with the spacecraft's flight control system. The capsule's small thrusters were malfunctioning, leaving only his larger jets to control the capsule when it began to drift. They were using up fuel needed to control Glenn's reentry. He solved the problem by switching to manual control.

After his first orbit, Glenn reported "brilliant specks floating around outside the capsule." He nicknamed them "fireflies," which were later identified as ice crystals venting from the spacecraft's reaction control jets.

Then a very worrisome issue presented itself: a signal indicated that his heat shield had become unlatched—something that was not supposed to happen until shortly before Glenn splashed down. That's when it was to release and pull out a cloth landing bag that would fill with air to cushion the impact with the ocean.

The MCC at Cape Canaveral asked him to flip a switch to check whether the landing bag had deployed. When a light did not go on, it seemed that the signal was false. Taking no chances, flight controllers changed the sequence of reentry events. Strapped to the shield was a package of three braking rockets used to slow the capsule to drop it out of orbit. The flight plan called for cutting the straps and jettisoning the pack, leaving the exposed heat shield to handle the heat of atmospheric friction during reentry. Flight Director Chris Kraft and Mission Director Walter C. Williams decided to instead keep the retropack attached so its straps could hold the heat shield in place.

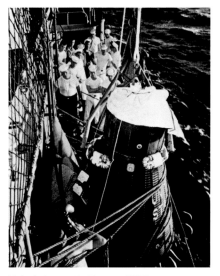

Splashdown: 2:43 p.m. (EST)

When the change was relayed to Glenn, he realized there must be a problem. He asked, "What are the reasons for this? Do you have any reasons?" "Not at this time," came the reply. The decision meant the retro-rocket pack would burn up harmlessly during reentry, and it turned out that a faulty sensor caused the original warning light.

As *Friendship 7* reentered and began to heat up, pieces of the retropack began to stream past his window, and he feared his heat shield might be disintegrating. "That's a real fireball outside," he radioed. Finally, the drogue and then the main parachute deployed. He manually released the landing bag and safely splashed down north-northwest of the Dominican Republic.

The destroyer, USS *Noa*, which was about six miles away, reached him seventeen minutes later. After the problems recovering Grissom's capsule, NASA had implemented new procedures. Glenn remained aboard *Friendship 7*, and rather than using a helicopter to retrieve the capsule, *Noa* snared the capsule with a hook and hoisted it aboard. Once *Friendship 7* was on deck, Glenn blew the hatch and climbed out.

Opposite page, top left: Glenn at home in Arlington, Virginia, with daughter Lyn, wife Annie, and son David (who became a dentist).

Center left: Glenn confers with the head of the Astronaut Training Office, psychologist Robert Voas (*right*), and Paul W. Backer of McDonnell in 1962.

Bottom left: Members of the Cape fire department pose with an M113 armored personnel carrier that would have been used to rescue an astronaut in case of a pad emergency. *Front row, left to right*: Lee Hipp, David Vannest, Franz Vulpuis, Alan Hinkson, and Gregory Acuff. *Back row, left to right*: Paul Hanna and Jack Cutter. The USAF had turned over the department and other day-to-day operations (including security and food services) to Pan American Airways in 1953 to save money.

Top right: Glenn studies spacecraft manuals in Hangar S in 1961 with two other Mercury spacecraft in various states of preparation behind him. The foreground spacecraft rests on a tapered Atlas booster adapter made of corrugated titanium.

Bottom right: Glenn surrounded by test equipment in Hangar S days before his spacecraft was moved to LC-14 on January 3, 1962. His yellow life vest—added after Gus Grissom's water egress after splashdown—can be seen behind his chest mirror.

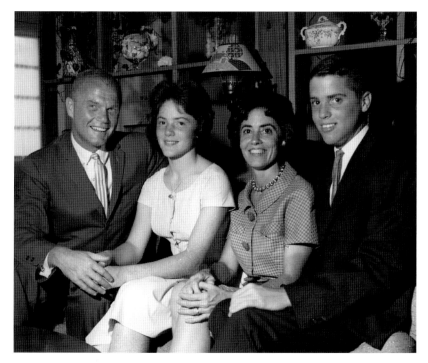

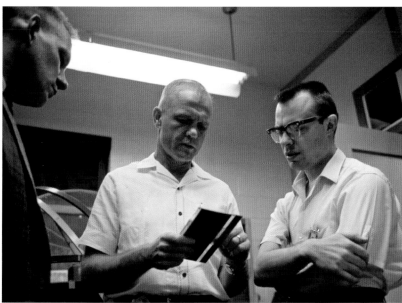

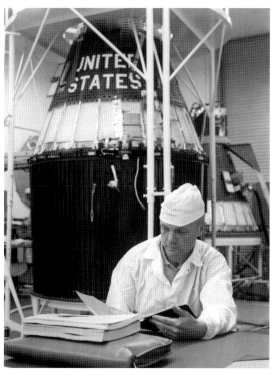

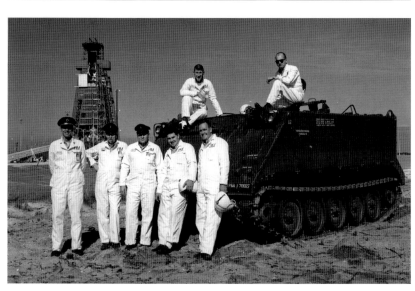

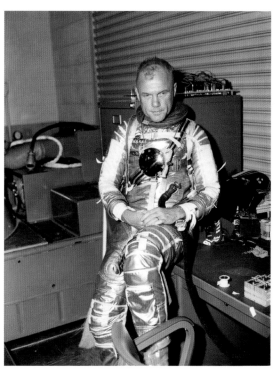

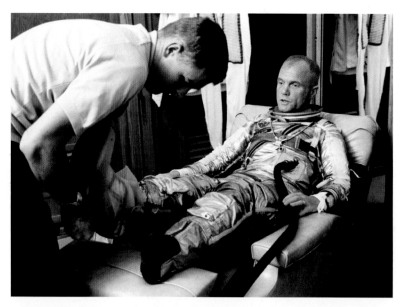

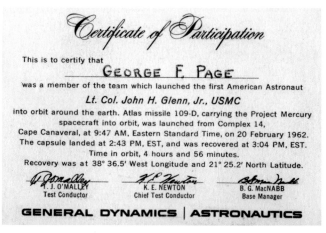

Above: Suit technician Alan Rochford removes a protective cover from Glenn's boot after a training session. A cotton undergarment hangs on the closet door.

Above: George F. Page was a launch operations engineer with General Dynamics who joined NASA in 1963 as a spacecraft test conductor. He would later become launch director and then director of launch operations for the Space Shuttle program.

Below: *Friendship 7*'s escape tower undergoes weight and balance testing in Hangar S on December 29, 1961.

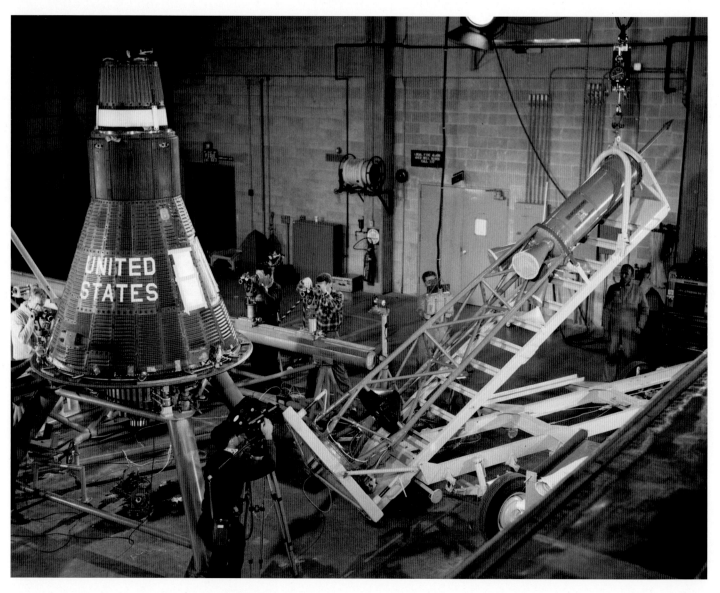

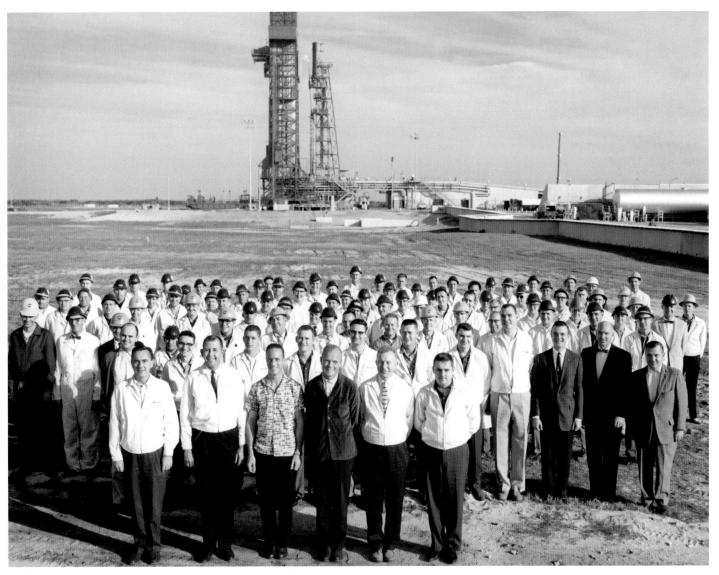

Above: The Mercury launch team at LC-14. *Front row, left to right*: Bill Mosley, H. H. Luetjen, astronaut Scott Carpenter, Glenn, test conductor Paul Donnelly, and Don "Corky" Cochran, head of the NASA spacecraft electrical group. *Third row*: Gene McCoy, NASA pad leader, is left of McDonnell pad leader Guenter Wendt (*with bow tie*). Sam Beddingfield is behind Luetjan with glasses and hard hat. *Second row, far right*: Walt Kapryan. NASA workers wear yellow hard hats while McDonnell personnel wear blue. The Atlas booster had not yet arrived at the pad.

Right: *Friendship 7* launch crew lapel pin

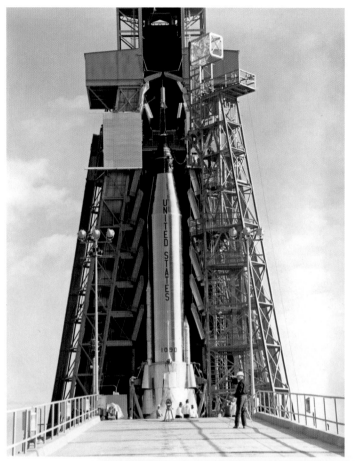

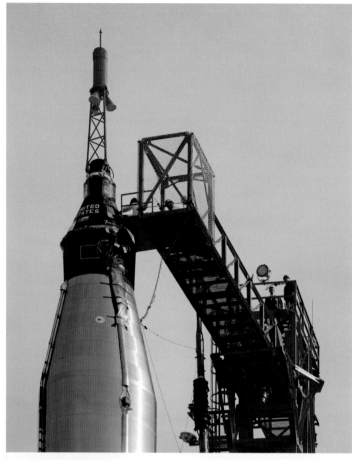

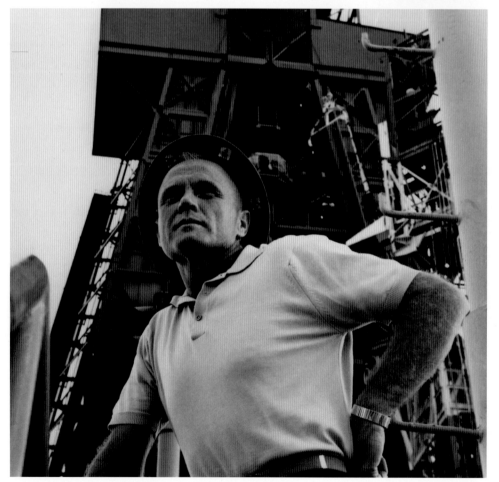

Top left: A view up the ramp of Glenn's Atlas No. 109D booster topped by *Friendship 7* at LC-14 on January 23, 1962—the second planned launch date. The attempt was called off due to heavy cloud cover. The service tower's hinged work platforms are in the raised position.

Top right: McDonnell technicians work at the hatch of the spacecraft on the emergency egress platform at the top of the umbilical tower in early February. It could be lowered into place within thirty seconds if necessary.

Left: Glenn at the pad on January 22, less than twenty-four hours before the second launch attempt. Liftoff was first scheduled for January 16, but was postponed to January 23 to solve problems with the booster's fuel tanks. More Atlas fuel problems and unacceptable weather would force three additional delays. Like the Redstone, the Atlas D was developed as a ballistic missile capable of carrying a nuclear warhead. Unlike Redstone, which was deployed in West Germany, it could reach the Soviet Union from the United States. Atlas variants were deployed at eleven sites across the country from 1959 to 1965.

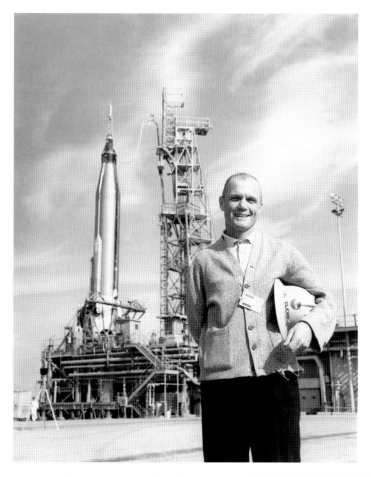

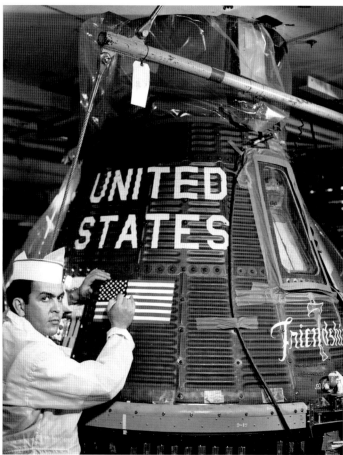

Top left: Glenn removes his hard hat and sunglasses for a photo on a cool day at LC-14 on January 22.

Top right: Chrysler artist Howard A. "Tony" Perez paints the American flag on *Friendship 7* in the LC-14 white room. The spacecraft's window remains protected by a clear shield taped to the spacecraft's titanium shingles.

Right: Glenn in the white room at LC-14 on January 20, 1962 (one month before the eventual launch). The "J" numbers on the spacecraft identified umbilical cable connections.

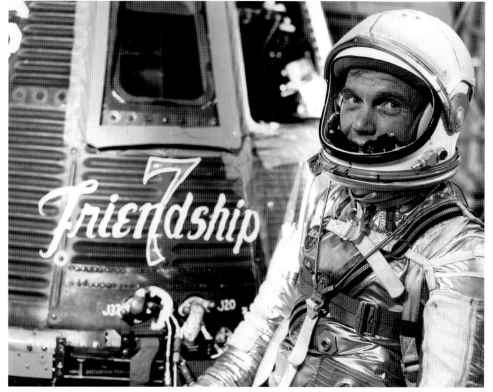

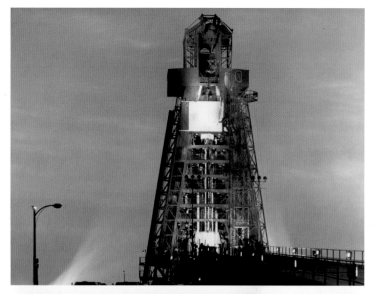

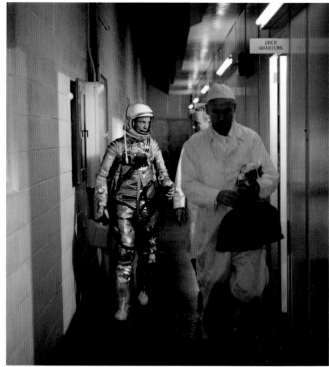

Top left: Glenn's Atlas booster, surrounded by its twelve-story service tower, gleams under floodlights at LC-14 at sunrise on February 20. The huge structure was rolled away about three hundred feet to the east on rails.

Top right: Glenn speaks with flight surgeon Douglas as they leave the crew quarters at Hangar S on launch morning. Leading the way is primary suit tech Joe Schmitt. Glenn's breakfast guest had been Gen. D. N. Shoup, commandant of the US Marine Corps.

Center left: Carrying his space suit ventilator, Glenn strides out of Hangar S in the predawn darkness, accompanied by Schmitt and Douglas, as a crowd of support personnel watches. In the background is the vacuum, or altitude chamber, used to test Mercury spacecraft in a near vacuum. Douglas died two weeks after he attended Glenn's 1998 space shuttle launch.

Bottom left: Glenn holds his orbital charts inside the astronaut transfer van heading for LC-14 on launch morning, his boots inside protective plastic covers.

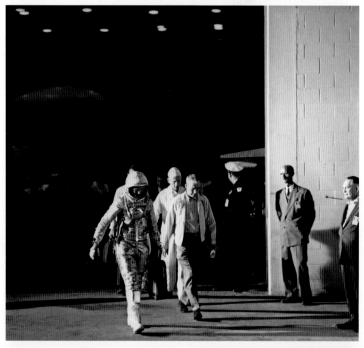

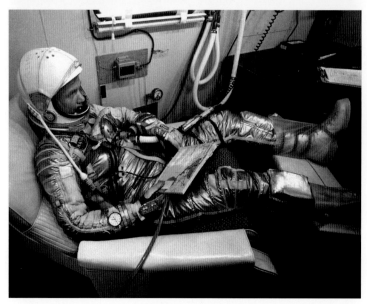

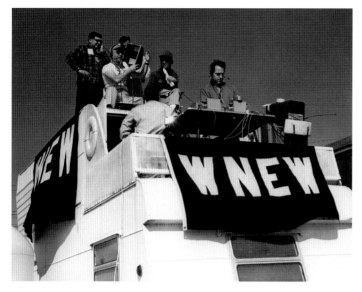

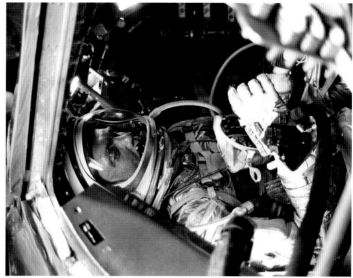

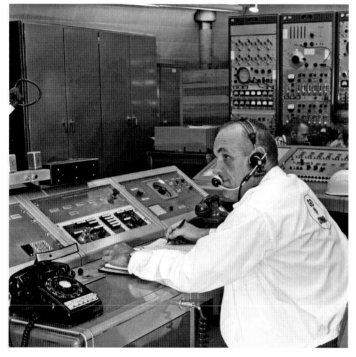

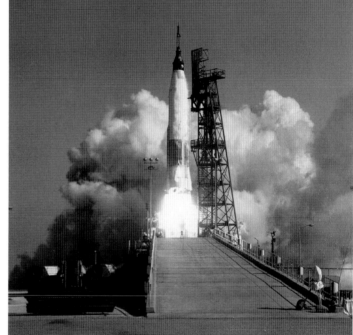

Top left: The broadcast team for New York's WNEW-AM included aerospace writer Martin Caidin (using a typewriter cover as a windshield) and Reid Collins (wearing a dark cap). Collins later was an anchor for CBS Radio and CNN. Engineer Sheldon Hoffman is at right.

Center left: Thomas J. "T. J." O'Malley at Console 1 in the LC-14 blockhouse. A feared presence, O'Malley was chief test conductor for the Convair division of General Dynamics, which built the Atlas. He pushed the button that launched *Friendship 7*.

Top right: Glenn, with visor closed and space suit pressurized, is seen shortly before the hatch was bolted closed on February 20.

Center right: MA-6 lifts off at 9:47 a.m. (EST). This view looks up the ramp used to bring the booster, spacecraft, and support vehicles to the top of the launch stand. The Atlas burned refined kerosene with LOX. Its two outboard engines were jettisoned two minutes and ten seconds into the flight. The remaining center engine continued to burn for another three minutes and twenty seconds, which put the Mercury spacecraft into orbit.

Opposite page, bottom center: Access badge issued to John Janokaitis, a mechanical engineer with the Space Task Group

Opposite page, bottom right: Access badge for Larry Summers, NASA motion picture photographer

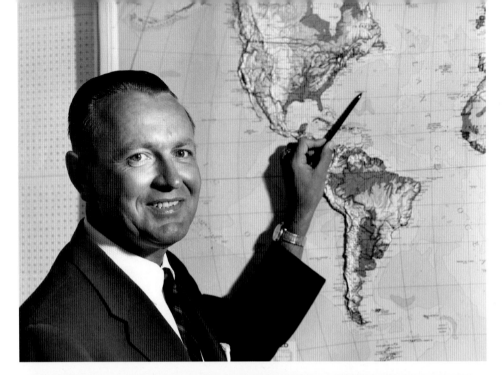

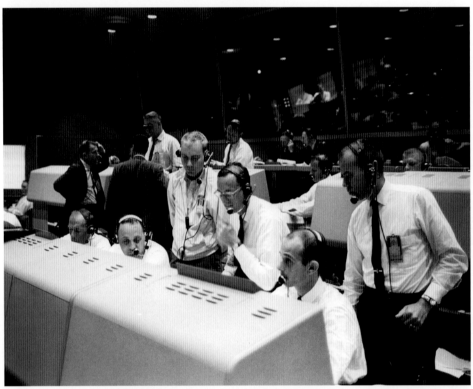

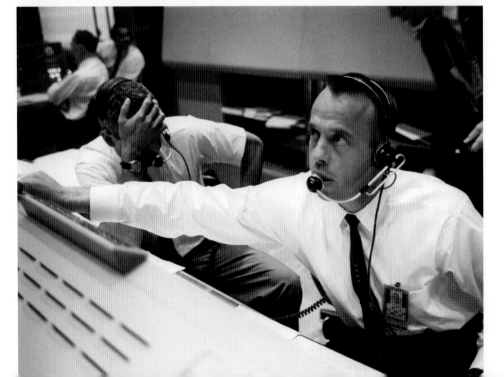

Above: News-media information booklet

Top left: Kraft, in a 1961 photo, indicates the splashdown point for Mercury's two-manned suborbital flights. An aeronautical researcher with NASA's predecessor agency, he was flight director for all six manned Mercury flights and several Gemini missions, and was instrumental in establishing Houston's Mission Control. Kraft became MSC's second director in 1972.

Center left: Dr. Stanley White (*glasses and headset*) monitors Glenn at the flight surgeon's console in the MCC. Dr. Douglas is to White's right. The group (*left*) includes Deke Slayton (*hand on head*), Operations Director Walter Williams (*dark glasses*), and Flight Director Kraft (*to Williams's left*). Gene Kranz and public affairs chief John "Shorty" Powers are also pictured (*background, far right*).

Bottom left: Alan Shepard in the MCC during his second and final stint as a CAPCOM (Grissom's MR-4 flight the other).

Opposite page, top: Glenn with his visor open during flight in a still frame from the 16mm pilot observer camera (*left*). One of two "satellite clocks" indicating mission elapsed time is also pictured (*right*). A duplicate clock was on Glenn's instrument panel. The panel's illuminated indicators are reflected in his chest mirror. The 16mm instrument panel observer camera is at left. Both cameras were manufactured by the D. B. Milliken Co. of Arcadia, California.

Opposite page, bottom: Atlantic waters rush past USS *Noa* as Glenn visits *Friendship 7*, with its periscope still extended. *Noa*'s hook is engaged to the spacecraft's top lifting loop and a special brace prevents tipping. *Noa* was a navy destroyer that specialized in anti-submarine operations. The ship was sold to the Spanish Navy in 1975, which scrapped her in 1991.

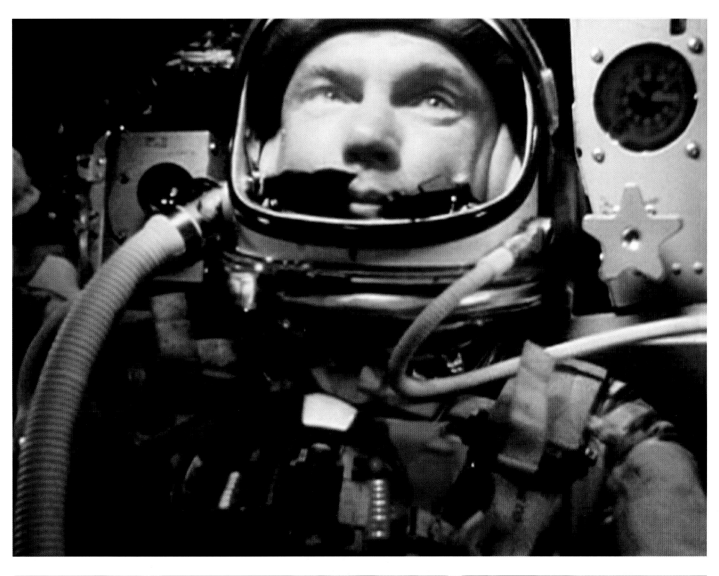

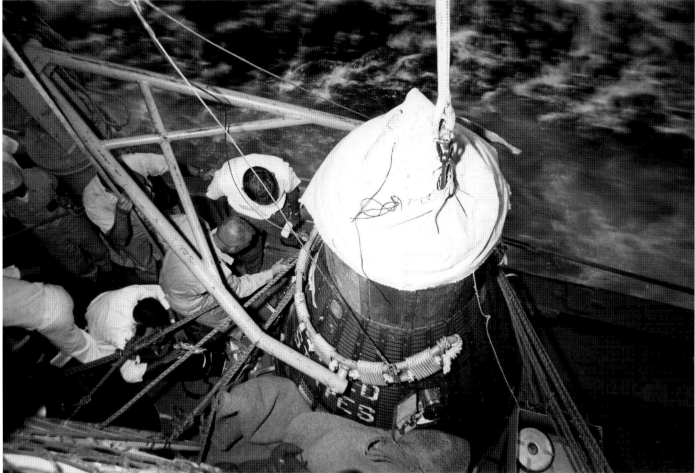

Glenn inspects *Friendship 7* aboard the *Noa* at sunset with engineer Ralph Gendiellee inside the cockpit.

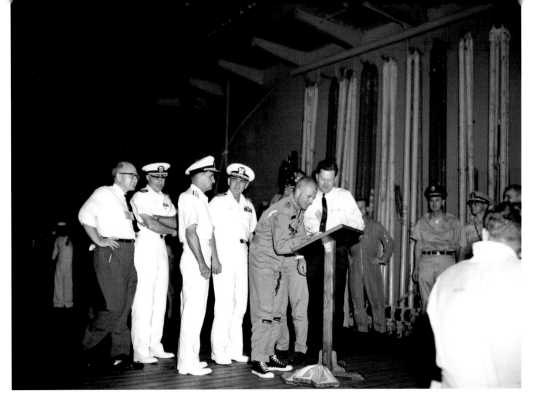

OFFICIAL

M/A - 6
GRAND TURK
ISLAND

Top: After three hours aboard *Noa*, Glenn was taken by helicopter to the designated prime recovery ship, USS *Randolph*. Here he signs in on the aircraft carrier's flight deck, with *Randolph* Capt. Max A. Berns Jr. behind him. To Berns's left is Rear Adm. Earl R. Eastwold, Carrier Division 16 commander. John C. Stonesifer, team leader of MSC's Landing and Recovery Division, is far left (*with glasses*).

Center: Glenn arrives on Grand Turk Island, where a submarine patrol plane flew him from *Randolph*, for two days of rest and interviews on technical, medical, and other aspects of his flight. Slayton is behind him (*left*). Astronaut Scott Carpenter and Mercury public affairs chief Powers are at right.

Bottom: Vice President Johnson (*right*) prepares to dine with Glenn and Project Mercury officials on Grand Turk on February 21, 1962. At left is MSC Director Robert Gilruth. Mercury Flight Operations Director Walt Williams is behind Glenn. The three flew back to the Cape together.

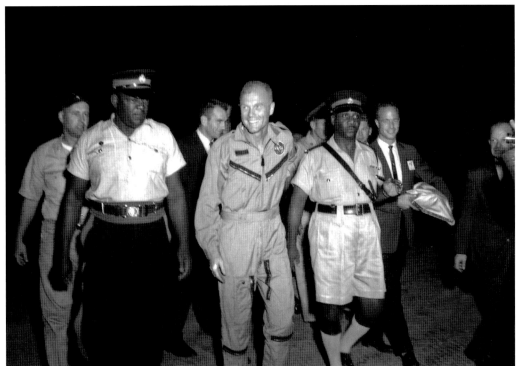

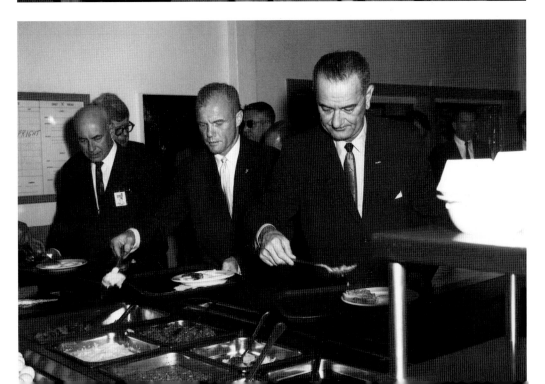

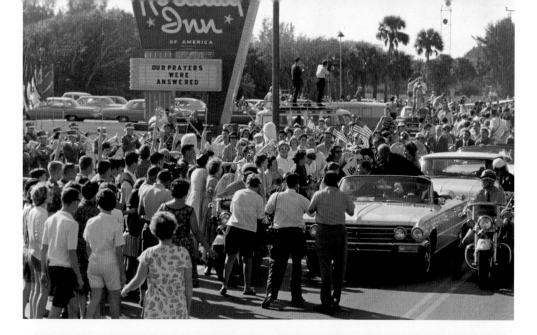

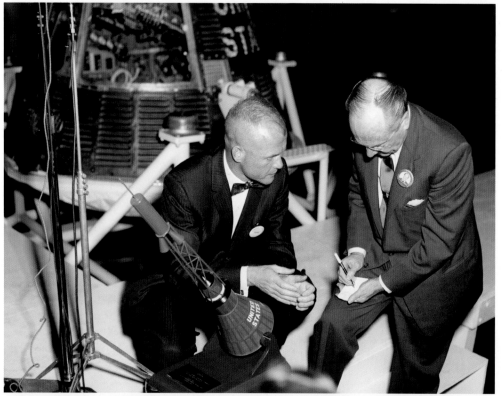

Top: Vice President Johnson autographs a welcome sign as Glenn and his wife, Annie, look on. The motorcade from Patrick AFB is heading north on A1A in Cocoa Beach on the morning of February 23, 1962.

Center: With *Friendship 7* in the background, Glenn chats with James McDonnell at the McDonnell Aircraft plant in St. Louis, Missouri, on March 15, 1962. McDonnell presented Glenn with a model of his spacecraft (*foreground*).

Bottom: Glenn is flanked at a news conference at Cape Canaveral later that day by MSC Director Robert Gilruth (*left*) and NASA Administrator James Webb. Glenn wears the NASA Distinguished Service Medal presented to him that day by President Kennedy. Powers stands at right. The location was a temporary tent near the MCC.

Opposite page, bottom left: At a dinner-dance at the Cocoa Armory on April 23, 1962, B. G. MacNabb, Convair chief at Cape Canaveral, gives Glenn a section of his spacecraft's electrical cable to the LC-14 umbilical tower, which was severed at launch.

Opposite page, right: MSC's Mercury Project Engineering Office presented Glenn with Remington's new Model 700 rifle in 1963.

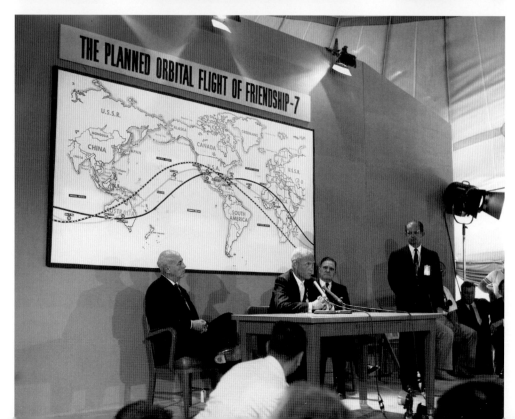

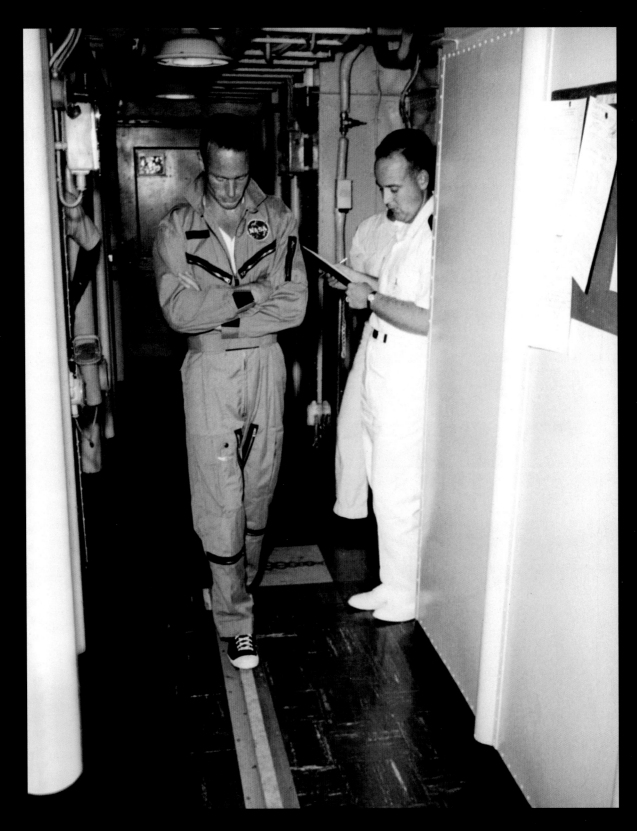

Scott Carpenter undergoes equilibrium testing
in USS *Intrepid*'s infirmary after recovery.

Mercury-Atlas 7

May 24, 1962

Three months after John Glenn's historic flight, thirty-seven-year-old US Navy Lt. Cdr. Malcolm S. "Scott" Carpenter was launched on a three-orbit mission that essentially duplicated Glenn's achievement but with a greater focus on science. The pilot was to have been Donald K. "Deke" Slayton, but after an irregular heartbeat was discovered during a centrifuge training run in 1959, he was officially removed from flight status in March 1962.

A naval aviator, Carpenter was the air intelligence officer aboard USS *Hornet* when he was selected as an astronaut. His countdown aboard *Aurora 7* on the morning of May 24, 1962, proceeded almost perfectly with only a forty-five-minute hold at T-11 minutes to provide better camera coverage of the launch.

With Glenn's flight a "shakedown" that qualified the Mercury spacecraft for manned orbital operations, NASA managers had packed Carpenter's flight plan full of various tests to complete during his five-hour mission (so much so that he fell behind in his assignments).

One experiment was the first study of liquids in weightlessness. Another—designed to provide data on atmospheric drag and color visibility in space through deployment of a thirty-inch diameter balloon—was largely unsuccessful when it failed to fully inflate. Carpenter's Earth and weather photography went well, but he was unable to observe a flare fired from Australia because of cloud cover.

At the beginning of his third and final orbit, Carpenter inadvertently bumped his hand against the hatch and created a bright shower of particles outside the spacecraft—solving the mystery of Glenn's "fireflies." He identified them as ice crystals knocked loose from the spacecraft's hull. His interest in the phenomenon, however, was a distraction and he fell behind schedule in his re-entry preparations. It set the stage for the flight's most dramatic moments.

With time now running short before retrofire, Carpenter suddenly noticed the spacecraft was not in the proper attitude. He realized the automatic control system was malfunctioning, so he quickly switched to manual. Then the three retro-rockets failed to fire automatically and he was told by Mission Control to fire them manually. Ignition came several seconds late. The delay and the fact that the automatic system wasn't controlling *Aurora 7*'s attitude meant the spacecraft would overshoot its splashdown target point.

To make matters worse, the spacecraft's fuel was running low. This was partially because Carpenter had executed so many planned maneuvers earlier in the mission, but he'd also accidentally left the automatic thruster system engaged several times while using the manual setting. To conserve fuel, he had

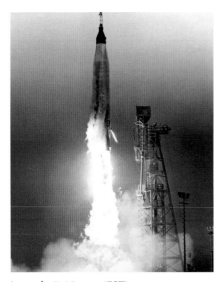

Launch: 7:46 a.m. (EST)

On orbit: sunset

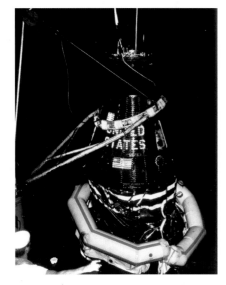

Spacecraft recovery: 6:52 p.m. (EST)

spent much of his final orbit in free drift. Then, during retrofire, he inadvertently left the balky automatic system on again (for subsequent flights, a modification prevented such double usage). During reentry, Carpenter radioed: "I hope we have enough fuel."

Aurora 7 overshot its intended target area by 290 miles, splashing down north of the Virgin Islands at 12:41 p.m. (EST). An aircraft spotted the spacecraft thirty-nine minutes later.

In the meantime, Carpenter wiggled free through the neck of the spacecraft, climbed into his life raft in calm waters, and patiently waited about an hour for recovery forces to arrive. His only company was "a black fish . . . and he was quite friendly." When navy divers swam up from some distance away, Carpenter "broke out the food and asked them if they wanted any, but they had finished lunch recently." A navy helicopter soon appeared and hoisted Carpenter aboard for a flight back to the aircraft carrier USS *Intrepid*. Like Glenn, he spent two days undergoing medical tests and recuperating at Grand Turk Island.

The destroyer USS *Farragut*, which was about one hundred miles southwest of the planned landing site, was first to reach *Aurora 7* about three hours and forty minutes later and monitored it until it was retrieved by the destroyer USS *John R. Pierce* about six hours after landing.

Soviet Premier Nikita Khrushchev commented that the USSR no longer had priority in space since the United States had matched its orbiting two men successively. That same day, an explosion during a fueling test destroyed a Titan I and its silo at the ICBM complex in Chico, California.

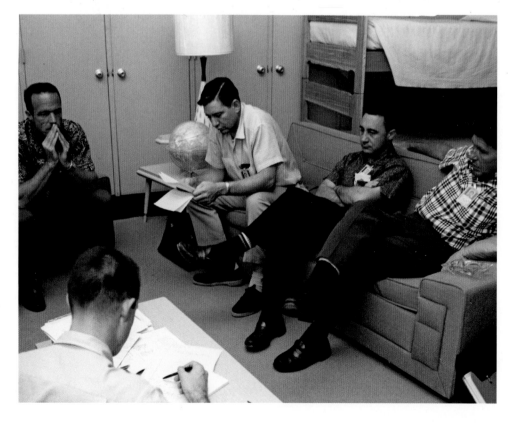

Left: Carpenter (*left*) at a briefing at the crew quarters at Hangar S. Gus Grissom (*center*) and Wally Schirra (*right*) are on the couch.

Opposite page, top: Carpenter (*right*) examines a Mercury helmet at B. F. Goodrich in Akron, Ohio in 1960 during a visit by several astronauts to the space suit manufacturer.

Opposite page, bottom left: Carpenter stops outside the MCC. He flew Lockheed P2V Neptune aircraft on reconnaissance and antisubmarine missions during the Korean War, and later flew surveillance missions from Guam along the Soviet and Chinese coasts. After being chosen for Project Mercury in 1959, Carpenter served as backup pilot for John Glenn's orbital mission.

Opposite page, bottom right: Carpenter works with the camera he'd use during the flight: a Robot Royal, a West German 35mm sequence camera with a thirty-foot load-film adapter (*left*). He later reported loading different films into the camera was difficult, preventing him from taking all the photos requested by the US Weather Bureau. The Robot was the first motorized 35mm camera using a spring windup system.

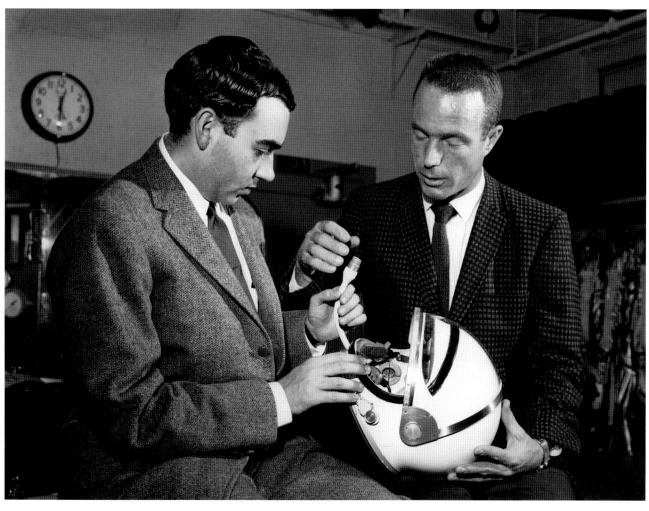

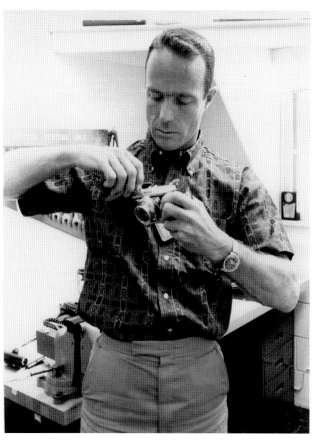

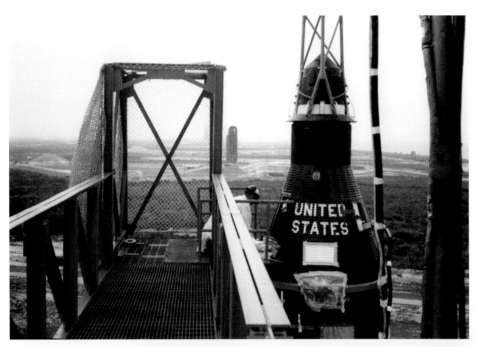

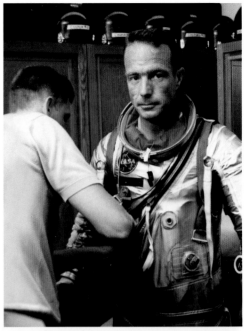

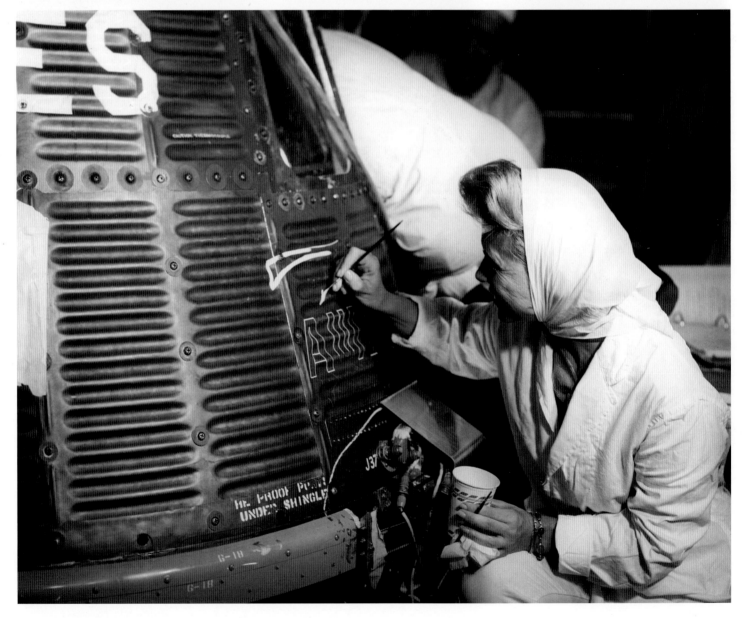

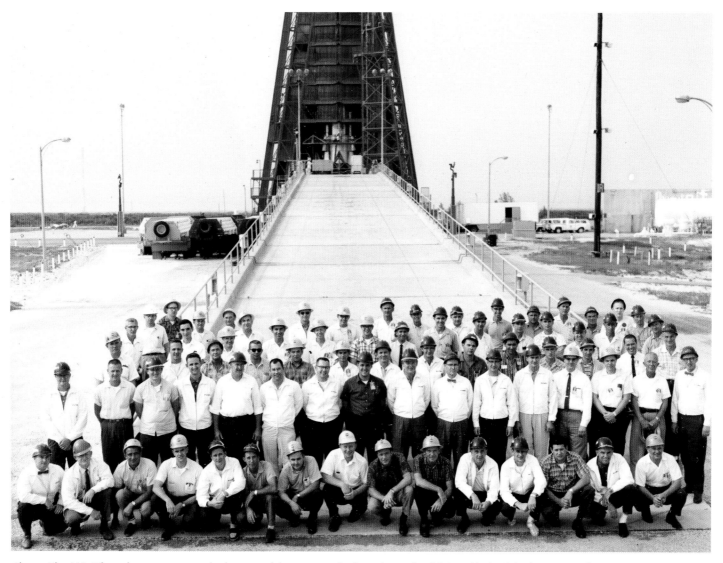

Above: The MA-7 launch crew poses at the bottom of the ramp to the launch stand at LC-14 with the Atlas booster in place. *Front row center*: Carpenter and Schirra; *left of Carpenter*: Paul Donnelly and Don Cochran; *far left*: Gene McCoy, launch pad coordinator; *far right*: pad leader Guenter Wendt; *back row center*: Sam Beddingfield.

Opposite page, top left: A McDonnell technician works at the open hatch of *Aurora 7* on the emergency egress platform at LC-14. The black cable (*right*) is the spacecraft umbilical, which carried electrical power to the spacecraft until it was ejected thirty-five seconds before launch. The service structure at LC-15, a Titan launch pad, is in the background to the north.

Opposite page, top right: Suit tech Al Rochford helps Carpenter don his space suit before a simulator run. Other astronauts' helmets are in blue carrying cases on top of the cabinet, which was used for storing the pressure suits.

Opposite page, bottom: Chrysler graphic artist Cece Bibby designed the insignia for *Aurora 7* (*shown at direct left*) with multicolored rings symbolizing the aurora borealis. She used different types of paint to evaluate which would best survive the heat of reentry. Bibby also painted the insignias on Glenn's and Schirra's Mercury spacecraft.

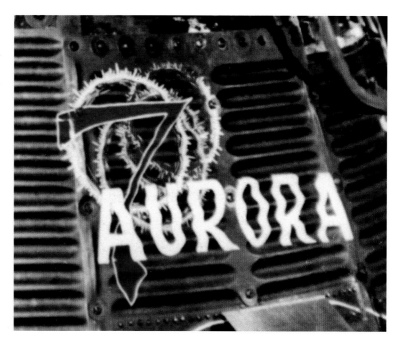

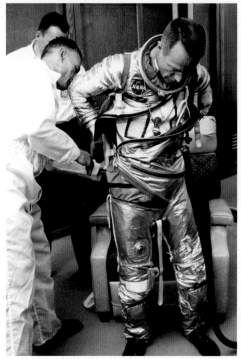

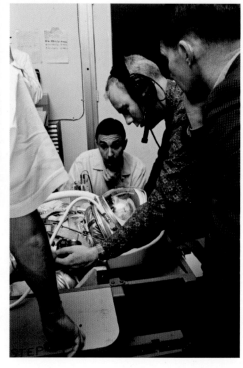

Top: Suit tech Joe Schmitt works with Carpenter's space suit components and pressurization test equipment in Hangar S, with the astronaut test couch behind him. A problem in the cooling system led to Carpenter's suit becoming quite warm during the first part of his flight.

Bottom left: Carpenter, still wearing slippers, dons his one-piece space suit with Schmitt's help around 3:00 a.m. (EST) on launch morning.

Bottom right: Carpenter undergoes final checks while lying in a duplicate of his spacecraft couch. Biomedical technician Don Wilfert (*right*), Dr. William Douglas (*wearing headset*), and Carpenter's backup, Schirra, who would pilot the next mission, conduct a suit pressurization test in Hangar S a few minutes later.

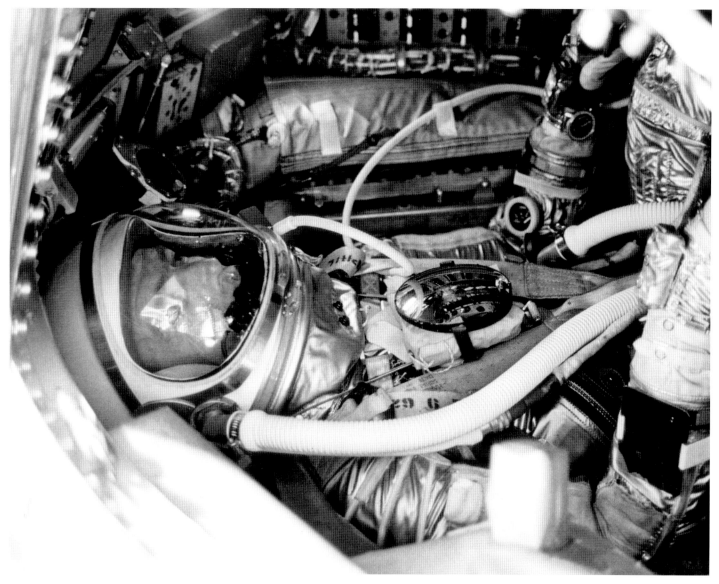

Top: Carpenter was inserted into his spacecraft at 4:40 a.m. (EST) on launch morning. His survival kit (*to his left*) included a life raft, shark repellant, a bar of soap, sunglasses, a pocket knife, rope, and a whistle (among other items).

Bottom left: Larry Summers's name is misspelled on this MA-7 badge.

Bottom right: Capsule Test Conductor Paul Donnelly during a test on May 4, 1962, in the LC-14 blockhouse. Declared a National Historic Landmark in 1984, the facility was restored and converted to a conference center in 1998 to commemorate the thirty-fifth anniversary of the final Mercury flight.

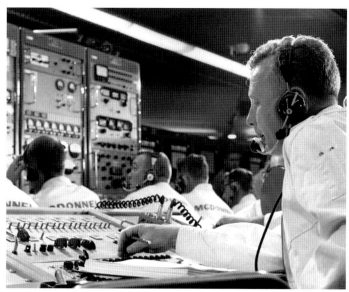

MA-7 rises from the LC-14 launch stand at 7:46 a.m. (EST) after a nearly perfect countdown. One of two Rocketdyne LR-101 vernier engines, which provided directional control, burns below the booster's serial number.

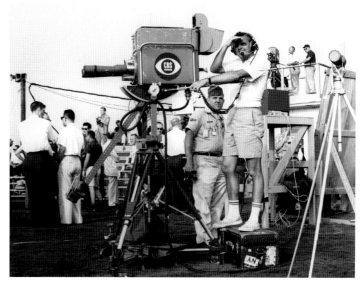

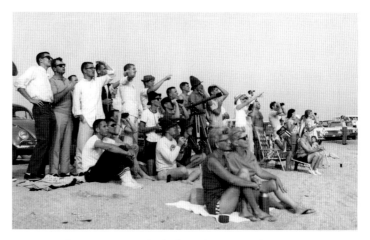

Top left: A much smaller crowd gathered on Cocoa Beach for Carpenter's flight than for Glenn's; the *Miami Herald* estimated about one thousand spectators.

Center left: The launch also attracted fewer journalists. A cameraman from Mexico's weekly newsreel *El mundo en marcha* (*right foreground*) documents the liftoff from the Mercury Press Site with a 35mm film camera. Note the hard hat (*lower right*) covered with decals indicating the launches the owner supported.

Bottom left: Rene Carpenter, with son Marc (*to her right*), was the first wife to watch her husband's launch in person. To her left at the postflight news conference is NBC's Roy Neal.

Top right: A reporter from XEW, a powerful AM station in Mexico City, dispatches from the Press Site.

Center right: A CBS-TV cameraman on launch morning at the Mercury Press Site. He operates an RCA TK-31 black-and-white camera with turret-mounted telephoto lenses. A white ABC-TV camera can be seen just below the CBS camera. On the roof (*right*) is a pool camera shared by the three broadcast television networks.

Bottom right: Local authorities banned overnight camping on the beach, which had been permitted for previous Mercury launches. "Visitors have cluttered the beach and used it for a sanitary facility for too long," said a Brevard County sheriff's deputy.

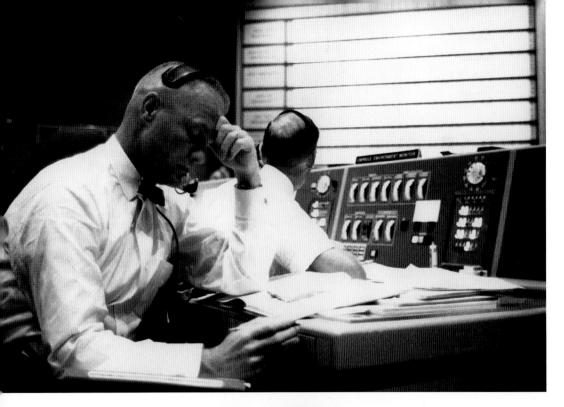

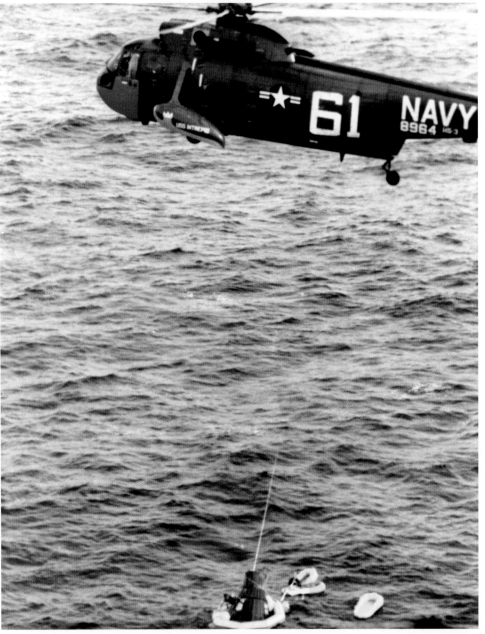

FLIGHT PLAN
FOR
MA-7/18

NASA-MSC
LANGLEY STATION
HAMPTON, VIRGINIA

MAY 1, 1962

COPY 161

Top left: Glenn at the CAPCOM console in the MCC during *Aurora 7*'s flight with the Capsule Environment Monitor Console (*right*). Behind the consoles on the wall are trend charts showing the astronaut's condition.

Bottom left: Three hours after splash-down, a navy HSS-2 helicopter pre-pares to lower a sling to hoist Carpenter aboard. He is with the spacecraft as a USAF paramedic watches from a life raft. Carpenter's life raft is to the right. The spacecraft's sixteen-foot telescoping recovery antenna was automatically deployed from the top of the spacecraft thirty seconds after water impact along with a dye marker. The Sikorsky-made HSS-2's designation was changed to the SH-3 Sea King in October, which would become the standard astronaut recovery chopper.

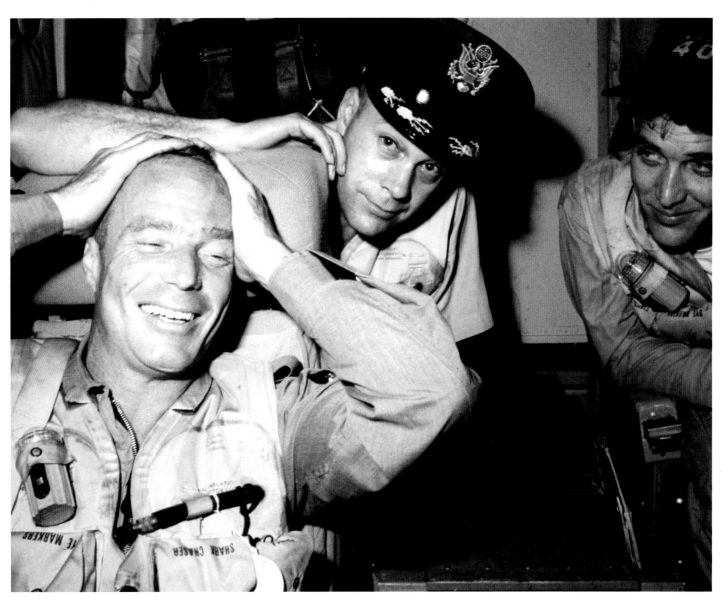

Top: Carpenter relaxes during the flight from *Intrepid* to Grand Turk Island.

Bottom left: A message in Styrofoam letters welcomes Carpenter to the small USAF hospital at the Grand Turk Island tracking station around midnight on May 24.

Right: Carpenter aboard the *Intrepid*. His medical exam was interrupted by a brief congratulatory phone call from President Kennedy, in which the astronaut offered "apologies for not having aimed a little better on reentry."

STAFF

M/A-7
GRAND TURK
ISLAND

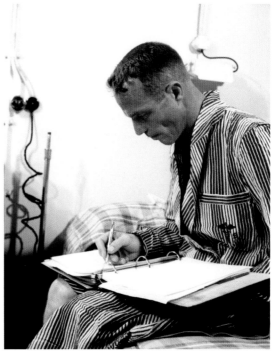

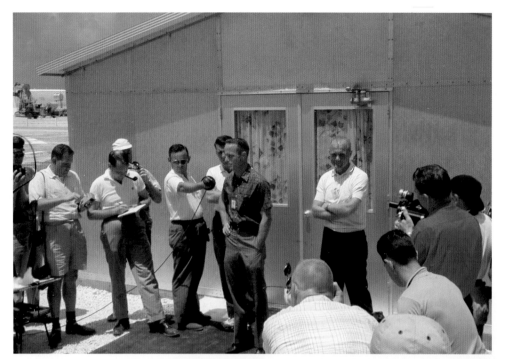

Top: Carpenter surprised reporters with an impromptu news conference at the hospital's back door the next morning with Schirra (*to his right*) and Glenn (*to his left*). The three went skin diving the next day.

Bottom: NASA Administrator James Webb speaks to the launch team in front of Hangar S on May 27, 1962, following a parade from Cocoa Beach. Webb presented Carpenter with NASA's Distinguished Service Medal at the event. *Aurora 7* is displayed on the right and the next mission's spacecraft, *Sigma 7*, is displayed on the left.

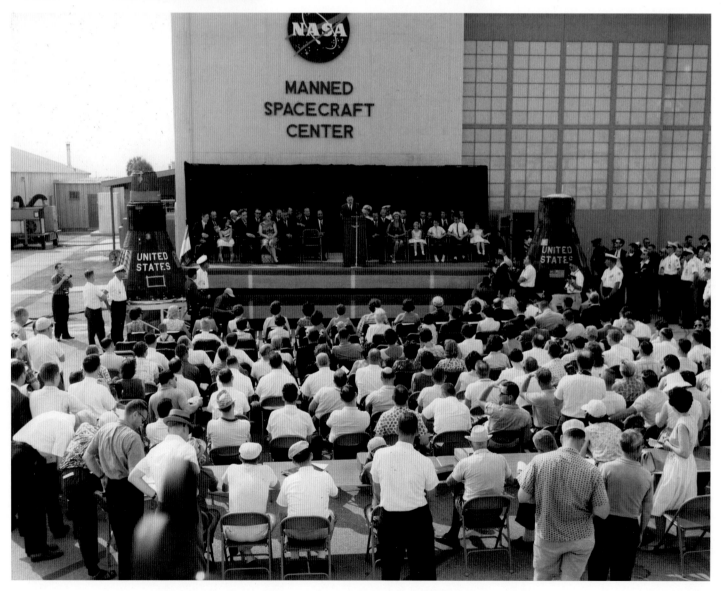

Chapter 4

Top: Carpenter and wife Rene ride down Broadway in downtown Boulder, Colorado, on May 29, 1962, on Scott Carpenter Day. The parade followed a ceremony at the University of Colorado football stadium where he received his bachelor of science in aeronautical engineering (he'd fallen one course short thirteen years earlier). His boyhood home was in Boulder at the corner of Aurora Avenue and 7th Street.

Bottom: Carpenter (*back to camera*) and Walt Williams, seated on the edge of the couch with his wife and daughter, meet with President Kennedy in the Oval Office on June 5, 1962. Mrs. Carpenter (*not seen*), is also present along with the four Carpenter and three Williams children.

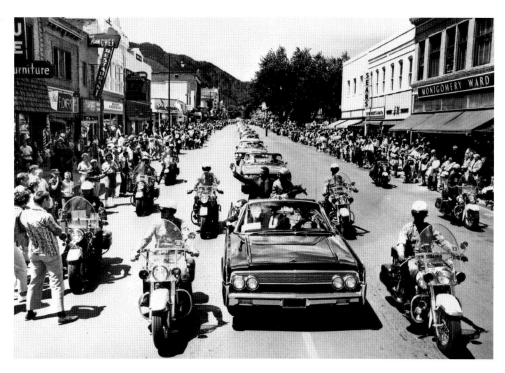

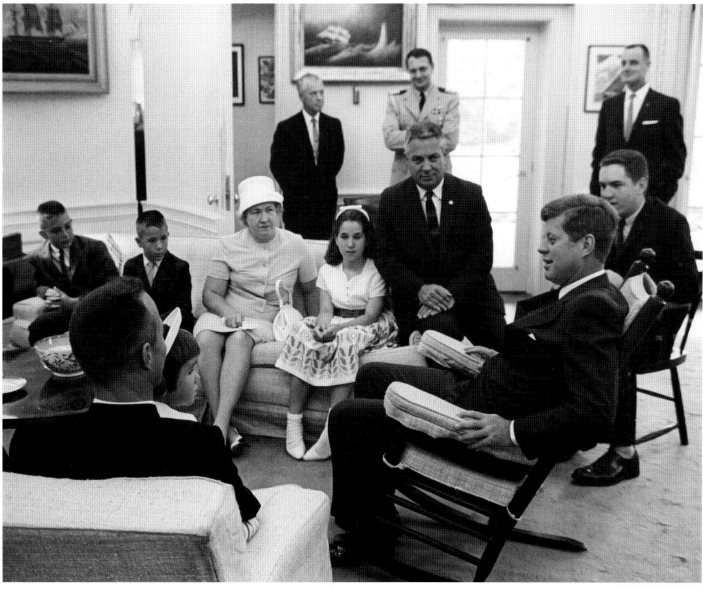

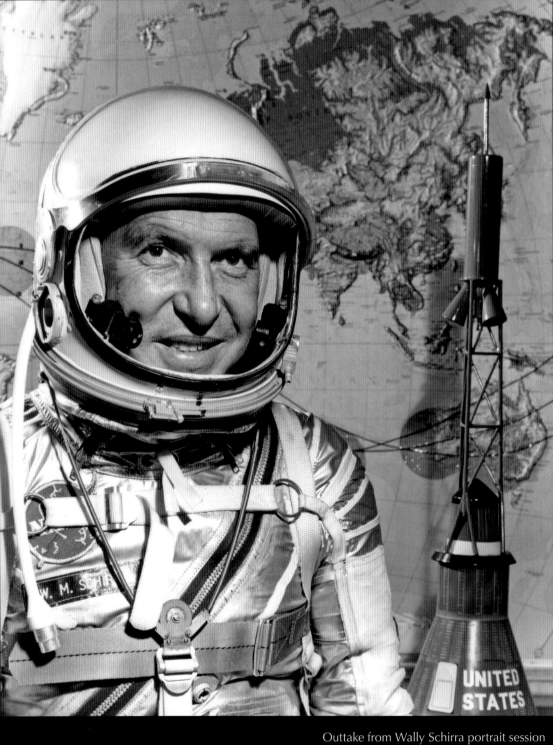

Outtake from Wally Schirra portrait session in Hangar S released in May 1962 while he was training as Scott Carpenter's backup. At right is a Mercury model made by McDonnell. The map (*background*) shows a three-orbit ground track with tracking stations highlighted, including the Muchea Tracking Station near Perth, Australia.

Mercury-Atlas 8

October 3, 1962

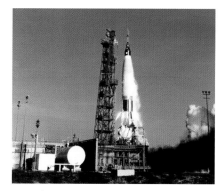

Launch: 7:15 a.m. (EST)

Five months after Scott Carpenter's flight, his backup, thirty-nine-year-old US Navy Cmdr. Walter M. Schirra Jr., would orbit the earth six times on MA-8 in his Mercury spacecraft, *Sigma 7*. The nine-hour mission would nearly double Carpenter's duration and was aimed at verifying that the Mercury spacecraft would be ready for a full twenty-four hours in orbit during the program's next (and last) flight. An associated planning goal was to see how little fuel, water, and power could be comfortably consumed. Both John Glenn and Carpenter had run low on reaction control system (RCS) fuel, so better consumables management was a key objective.

On launch morning, October 3, 1962, Schirra was up at 1:40 a.m. (EST) and had a filet from a bluefish he'd caught the afternoon before along with steak and eggs for breakfast. He arrived at Pad 14 at 4:23 a.m. Noticeably fewer spectators, signs, and banners appeared in Cocoa Beach, and although TV networks carried the launch and landing live, they cut back on coverage. Local traffic was reported to be normal.

MA-8's Atlas D booster launched into a clear blue sky from LC-14 at 7:15 a.m. (EST), putting Schirra into a 176-by-100-mile-high orbit. Other than a recurrent space suit heating problem, the mission was what he would later call "textbook."

Sixth orbit: over South America

Schirra's activities included briefly tracking the Atlas, conducting four science experiments, and observing and photographing Earth. He took fifteen photos for the US Weather Bureau to compare to the video still pictures sent down the same day by TIROS 5 and 6, two weather satellites launched earlier in 1962 that had been used to support his launch. The results would be used to help design the *Nimbus* series of next-generation weather satellites launched in 1964.

To prevent the RCS fuel problems Carpenter experienced, that system had been modified to disarm the high-thrust jets and to permit use of the low-thrust jets only in manual operation. A considerable amount of drift time was also built into the timeline for *Sigma 7*, including 18 minutes during the third orbit and 118 minutes during the fourth and fifth orbits. As a result, 78 percent of the RCS fuel remained in both the automatic and manual tanks at the start of reentry.

Extending the mission to a possible six orbits would mean a Pacific splashdown, so MA-8 was the first to have Atlantic and Pacific recovery forces deployed. In case the mission was aborted before orbit or ended after the first, second, or third orbit, however, deploying more than twenty Atlantic Ocean ships was still necessary. *Sigma 7* splashed down in the

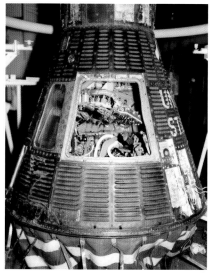

Splashdown: 4:28 p.m. (EST)

Pacific Ocean 250 miles northeast of Midway Island, but just nine thousand yards from USS *Kearsarge*.

The splashdown happened during the fifth inning of NBC's telecast of the deciding game of a three-game Major League Baseball playoff series between the San Francisco Giants and the Los Angeles Dodgers for the National League pennant. The network provided updates on the flight across the bottom of the screen during the game.

Although the Soviets sent official congratulations, the media there was dominated by marking the fifth anniversary of Sputnik 1, the world's first satellite. Less than three weeks later, President Kennedy went on national television to announce the United States' discovery of Soviet intermediate-range offensive missiles in Cuba.

Two days after MA-8, the Cape Colony Inn, a Cocoa Beach motel partly owned by the astronauts, was put on the market as a result of criticism of their investments in the project. Much of the money had come from their *Life* magazine contract. Project Mercury was nearing its end.

Mrs. Florence Schirra inspects her son's pressure suit in Hangar S in August 1962. She sometimes stood on the wing of her husband's, Walter Schirra Sr., biplane during his barnstorming days after World War I when he flew bombing and reconnaissance runs over Germany. The tri-lock spacers on the cotton Hanes underwear (*right*) allowed air to circulate in the pressure suit.

MSC press kit folder

General Dynamics "Mercury pass-port" sticker

Above: Schirra leaves the MCC between suit tech Dick Sandridge (*left*), who carries Schirra's helmet, and suit tech Al Rochford in September 1962 after a session in the Mercury Procedures Trainer. Schirra carries his portable suit ventilator. He was suited earlier in Hangar S.

Right: Schirra tries out a Hasselblad 500C camera during a briefing at Cape Canaveral on July 20, 1962, by Roland "Red" Williams (*right*), who modified the cameras for flight use. McDonnell's Paul Backer is pictured at left. Detachable 24-exposure 70mm film magazines and filters were used in two studies of photographic and spectral definition of features on the ground. Since a flight rule was to conserve maneuvering fuel, Schirra only took a few photos. A silver bubble level attachment, a spare magazine, and a tracking chart are on the table (*left of camera*).

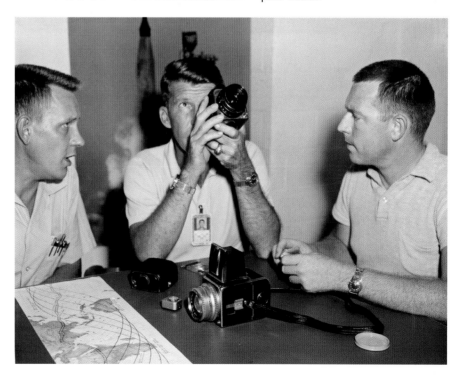

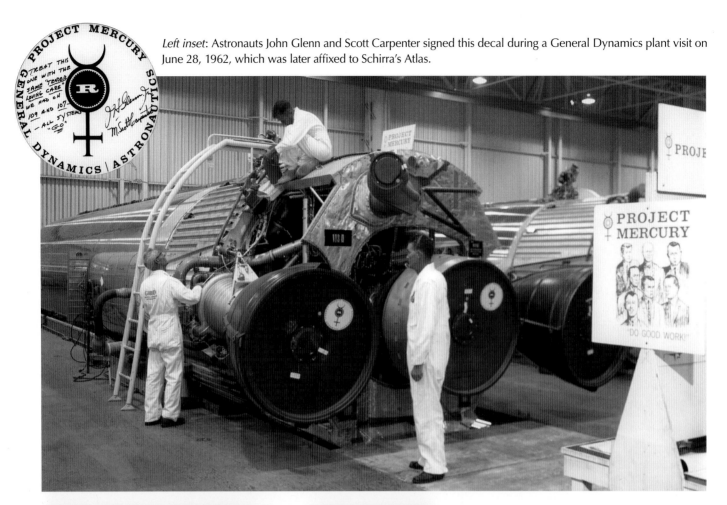

Left inset: Astronauts John Glenn and Scott Carpenter signed this decal during a General Dynamics plant visit on June 28, 1962, which was later affixed to Schirra's Atlas.

Above: Schirra in clean-room garb with *Sigma 7* at LC-14 on September 15, 1962. A red cover protects the spacecraft's window to the left of its open hatch.

Above: Technicians prepare the Atlas 113D booster for Schirra's flight for a simulated countdown and flight on an assembly dock at the General Dynamics|Astronautics plant in San Diego, California. The booster was trucked to Miramar Naval Air Station on August 7, 1962, for shipment to Cape Canaveral via a C-130 cargo aircraft. A poster (*right*) reminds employees of their critical responsibilities.

Opposite page, top left: Schirra in Mercury Procedures Trainer No. 2 at the MCC on April 18, 1962. Between this trainer at the Cape and one at Langley, he spent nearly seventy hours in trainers, including thirty-seven simulated missions and sixty-eight simulated failures.

Opposite page, top right: The Atlas's three main engines and twin vernier engines were ignited for less than five seconds at LC-14 on September 8, 1962, to test new fuel injectors intended to provide smoother engine combustion. The Mercury spacecraft had not yet been mated to the booster.

Opposite page, bottom left: McDonnell technicians make checks in Hangar S before moving *Sigma 7* to LC-14 for mating with its Atlas for the first time on September 10, 1962. The spacecraft had arrived on November 15, 1961.

Opposite page, bottom right: The spacecraft is mated to its Atlas adapter at LC-14 for the second time on September 26, 1962. Repairs to the spacecraft's attitude control system had forced it to be removed four days earlier.

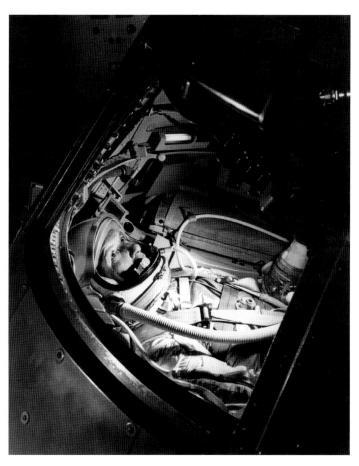
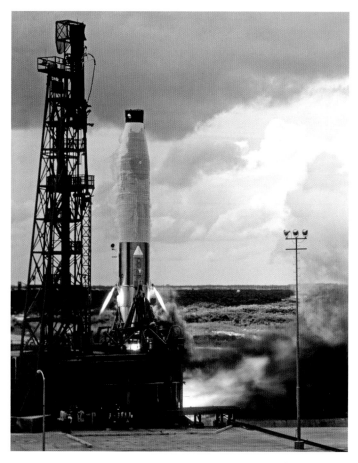
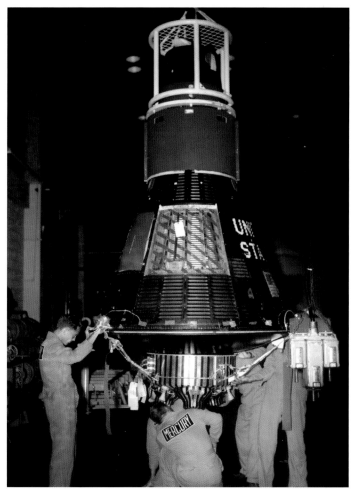
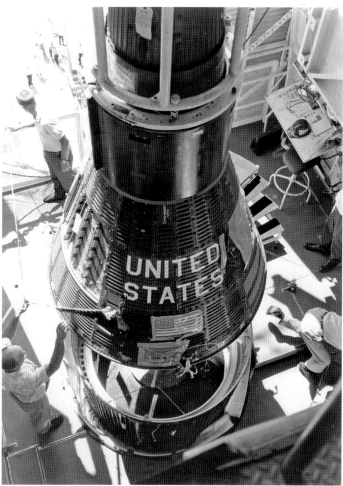

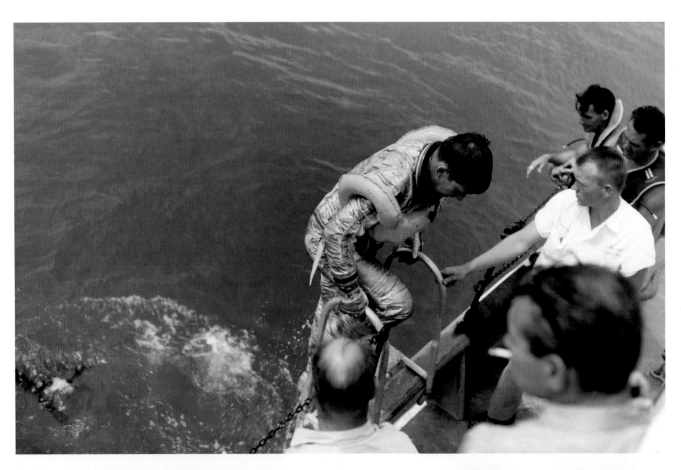

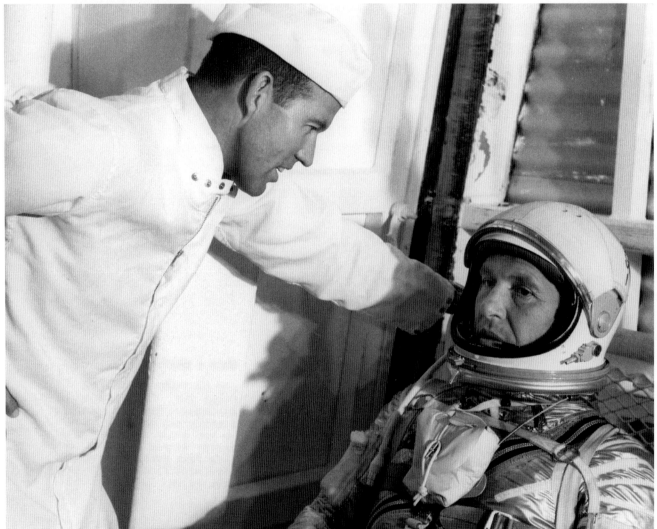

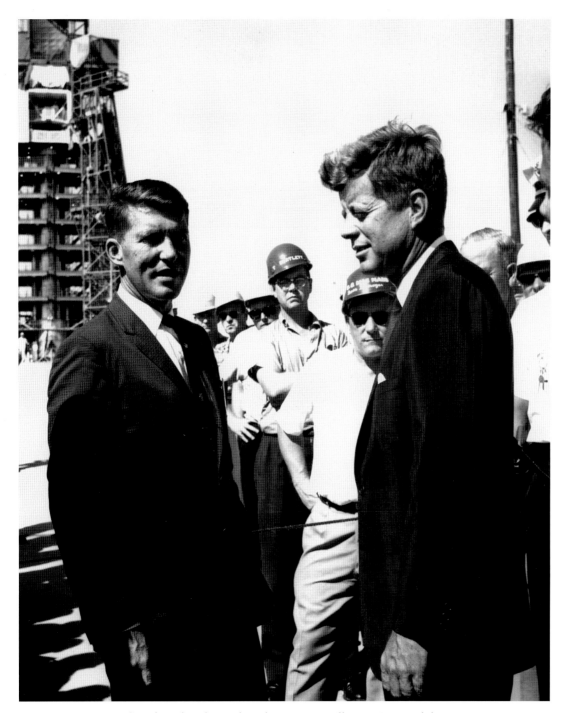

Opposite page, top: Schirra boards a ship in the Atlantic Ocean off Cape Canaveral during water egress training on May 5, 1962. At the time, he was the backup pilot for Carpenter's *Aurora 7* flight.

Opposite page, bottom: MA-8 backup pilot Gordon Cooper chats with Schirra at LC-14 before the final simulated six-and-a-half-hour countdown and flight on September 28, 1962. It was one of two simulations involving Schirra out of a total of seven days of Mercury flight control exercises in the weeks before launch.

Top left: Schirra briefs President Kennedy at LC-14 on September 11, 1962—his second visit to the Cape—with MA-8 in the gantry (*left*). Convair operations manager at the Cape, B. G. MacNabb, is next to Kennedy. The president spent two and a half hours touring and spoke to 1,500 workers. He'd seen a Saturn I first-stage test firing at MSFC in Huntsville that morning and ended the day at MSC in Houston. Kennedy reiterated his moon landing goal at Rice University the following day, then visited McDonnell Aircraft in St. Louis.

Top right: General Dynamics press booklet

Second right: Press booklet from Western Electric, the manufacturing arm of Bell Telephone, which built Mercury's ground-based tracking and instrumentation system (see also booklet at bottom right)

Third right: Larry Summers was the motion picture cameraman working for NASA under contract from RCA.

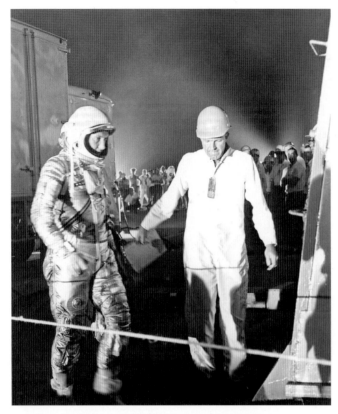

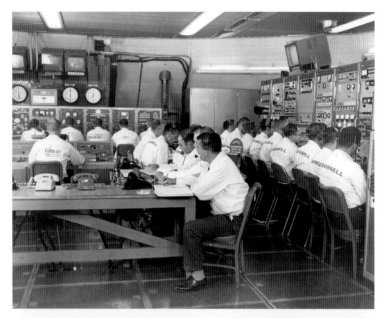

Top left: Cooper escorts Schirra into the service tower elevator after they arrive at Pad 14 on October 3, 1962. The transfer van is at left. Schirra was wakened at 1:40 a.m. (EST).

Top right: NASA, McDonnell, and General Dynamics personnel in the LC-14 blockhouse on September 13, 1962, for the flight acceptance test, which included a fully simulated flight of the spacecraft. *Center foreground*: Don Phillips, who coordinated support with the Atlantic Missile Range; *second from left*: Launch Vehicle Test Conductor Cal Fowler, who pushed the button to launch Schirra; *seventh from left*: Paul Donnelly.

Bottom right: The second group of astronauts (announced on September 17) watches the launch near the blockhouse. *Left to right*: Neil Armstrong, Frank Borman, Jim Lovell, Tom Stafford, Pete Conrad, John Young (*crouching*), Ed White, and Jim McDivitt. *Not pictured*: Elliot See.

Opposite page, top: View of MA-8 on launch morning looking east-southeast along the cable run between Pad 14 and the blockhouse, which is just off the left side of the photo

Opposite page, bottom: MA-8 launches at 7:15 a.m. (EST), in this view looking northwest with the ramp to the hardstand in the foreground. *Sigma 7* would separate from its Atlas booster after staging five minutes and eighteen seconds later—exactly one hundred miles in altitude over the Atlantic Ocean and just three seconds after the booster's center sustainer engine cutoff. A videotape of the launch was relayed for the first time to seventeen European countries an hour later via the Telstar 1 communications satellite launched three months earlier from LC-17B. Although the Soviet-bloc TV network Intervision requested and received the feed, it was not aired behind the Iron Curtain.

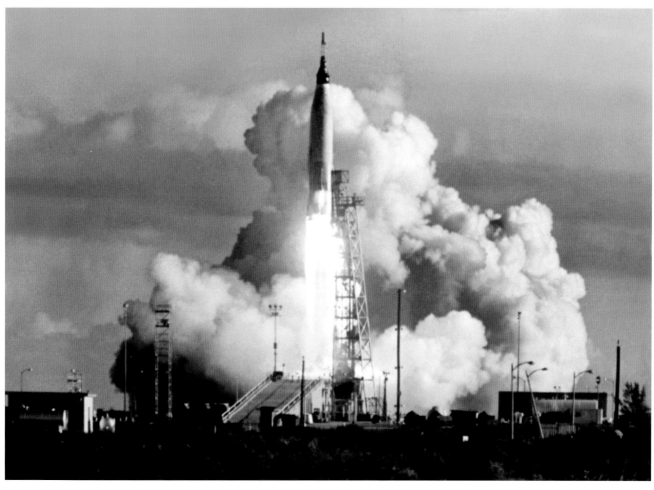

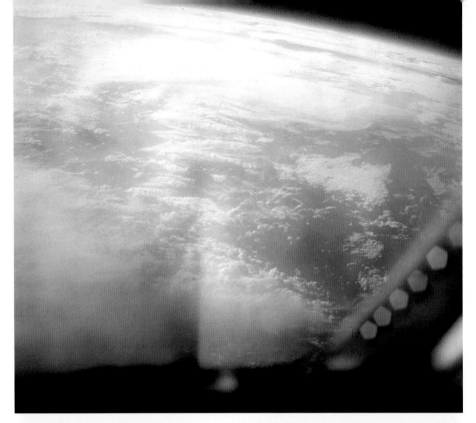

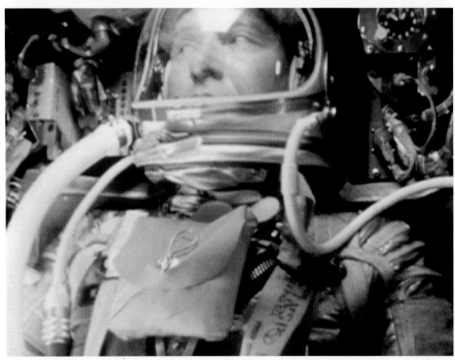

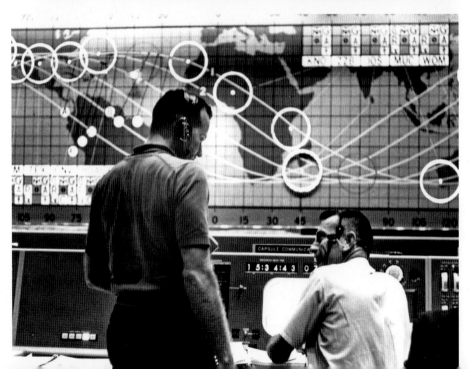

Top left: View from *Sigma 7*'s window looking west over South America on the sixth orbit in an orbit ranging from 100 to 176 miles high.

Center left: Schirra raises his left glove in this 16mm film still frame. The onboard clock is also pictured (*upper right*).

Bottom left: Cooper (*left*) and Slayton confer at the CAPCOM console in the MCC at 10:35 a.m. (EST) as Schirra begins his third orbit. The spacecraft indicator on the tracking map shows the capsule about halfway across the Atlantic.

Opposite page, top left: Sailors aboard USS *Kearsarge* line up to spell MERCURY on the flight deck as the aircraft carrier heads to the Pacific Ocean recovery area on October 2 with three destroyers, including USS *Phillip* (*top*).

Opposite page, center left: A motor whaleboat arrives with a nylon lifting line that attached to *Sigma 7*'s recovery loop. The spacecraft was then hauled about 350 feet to under the *Kearsarge*'s crane.

Opposite page, bottom left: After blowing off the hatch, Schirra is helped from the spacecraft at 10:15 a.m. local time. He spoke by phone with President Kennedy, Vice President Johnson, and his wife before a two-and-a-half-hour medical exam.

Opposite page, top right: Underwater view of *Sigma 7* (surrounded by a flotation collar) after splashdown at 10:28 a.m. local time on October 3. The detached heat shield (*bottom right*) hangs below the deployed landing bag.

Opposite page, bottom right: The *Kearsarge*'s boat crane lowers *Sigma 7* onto mattresses inside a wooden pallet resting on the ship's No. 3 elevator about forty minutes after splashdown. John C. Stonesifer, team leader of MSC's Landing and Recovery Division, stands to the right (*tie*).

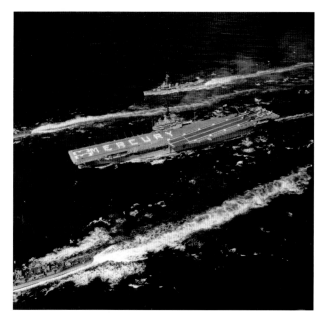

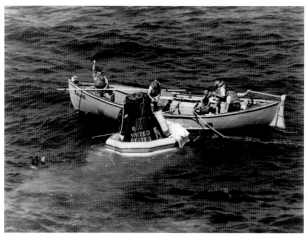

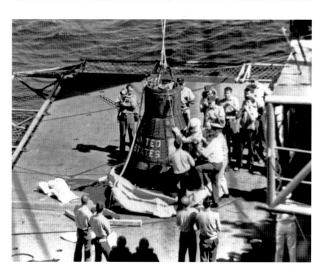

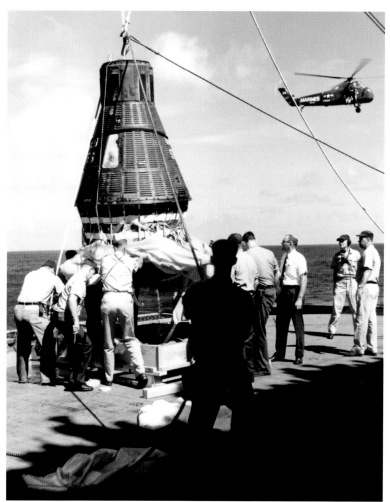

Top: *Sigma 7*'s instrument panel photographed through the hatch as the spacecraft sits in the hangar bay aboard the *Kearsarge* on October 3. The black square at left contains a clock and three timers; below it is the circular periscope display. In the center panel are cabin and suit environment gauges, power gauges and switches, and radio controls. The green panel contains a vertical row of warning lights and switches; blood pressure cuff controls; and switches for interior lights, the suit fan, and the retro-rocket pack.

Left: NASA Administrator James Webb (*right*) speaks at the post-flight news conference at Rice University on October 7, 1962, following a motorcade through Houston. MSC Director Robert Gilruth is also pictured (*left*). Schirra revealed that Cooper had hidden a steak sandwich aboard *Sigma 7* but "out of reach."

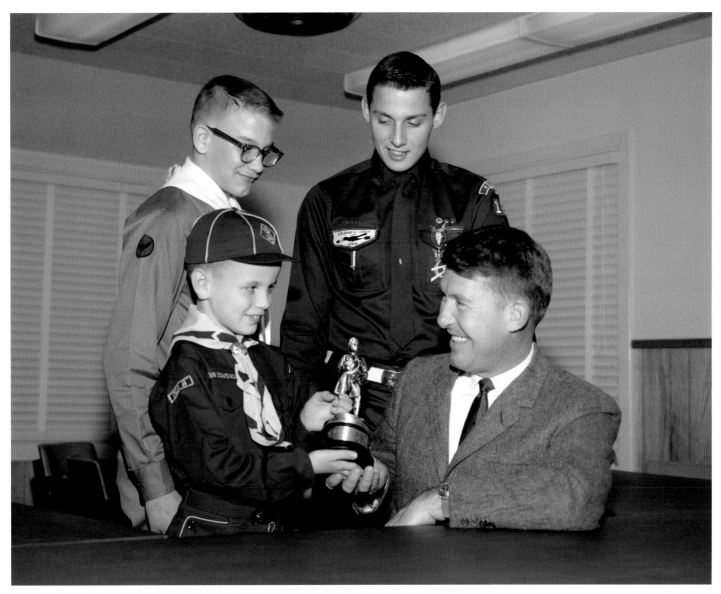

Top: A Houston Cub Scout (*left*) presents Schirra with a statuette as a Boy Scout and an Explorer look on at MSC's Site 8 at Ellington Field on February 24, 1963. The Explorer wears a Colonneh Lodge 137 patch of the Order of the Arrow, Boy Scouts of America's national brotherhood of honor campers at the time, and an Eagle Scout medal. Schirra earned the rank of First Class in Boy Scout Troop 36 in Oradell, New Jersey.

Bottom left: Schirra during dinner aboard the *Kearsarge* on October 3, which consisted of two-minute steaks, grapefruit salad, mixed vegetables, iced tea, and a strawberry sundae. He'd stay on the ship for three days before debarking in Pearl Harbor, Hawaii.

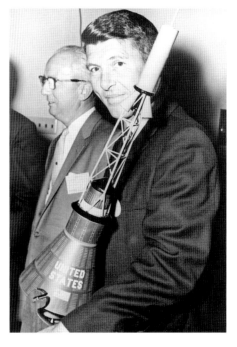

Bottom right: Schirra carries a ¹/₁₀th-scale model of *Sigma 7* presented to him by James McDonnell during a St. Louis plant visit on November 15, 1962, with other astronauts to evaluate changes to a Gemini mock-up.

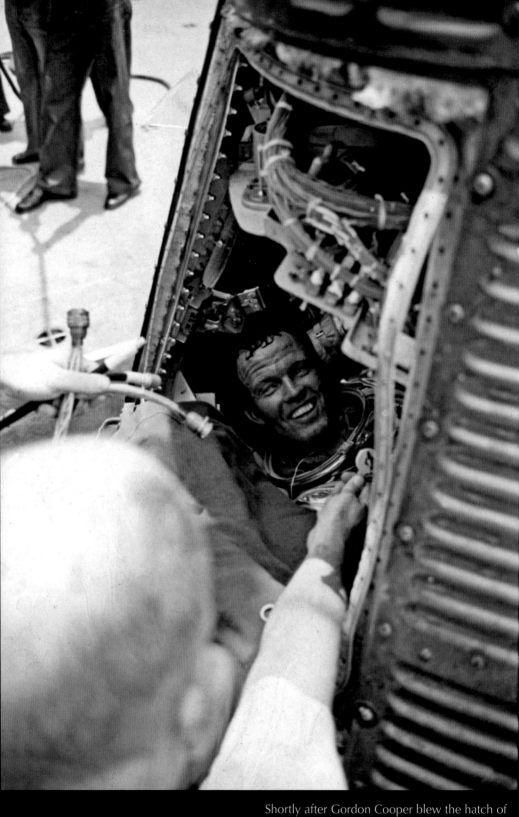

Shortly after Gordon Cooper blew the hatch of
his spacecraft on the deck of USS *Kearsarge*, a

Mercury-Atlas 9

May 15–16, 1963

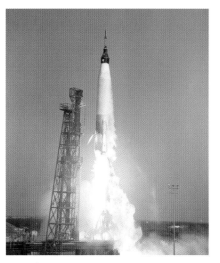

Launch: 8:04 a.m. (EST)

MA-9 in the spring of 1963 was the final Mercury mission, sending its pilot, thirty-six-year-old USAF Maj. Gordon Cooper, into Earth orbit for thirty-four hours and twenty minutes. This mission was longer than all previous US space flights combined and the first American mission to last more than twenty-four hours. The Soviet Union's *Vostok 2* had been the first (almost two years earlier), and all subsequent Soviet flights had also lasted at least one day. Cooper's mission was to last twenty-two orbits and total nearly 550,000 miles.

A launch attempt on May 14 was delayed about two hours when the diesel engine used to roll the mobile service tower away from Pad 14 on rails malfunctioned. While it was being repaired, a computer at the Bermuda tracking station failed and the launch was scrubbed.

The next day, however, *Faith 7* was launched from LC-14 at 8:04 a.m. (EST) after a brief unplanned hold. Cooper became the last American to be launched alone into Earth orbit.

He released a six-inch-diameter sphere with strobe lights from the nose of the spacecraft, which he could see during the next orbit—the first time a satellite was deployed from a manned space vehicle. The experiment was to test his ability to spot and track a flashing beacon in orbit. Cooper also reported seeing a 44,000-watt xenon lamp in South Africa.

He had planned to deploy a beach ball–sized Mylar balloon inflated with nitrogen and attached to a one-hundred-foot nylon tether from the antenna canister. A strain gauge would measure differences in atmospheric drag between the orbit's high and low points. The balloon, however, failed to deploy.

Cooper was able to sleep for about eight hours during his tenth through fourteenth orbits, a first for an astronaut. He had also briefly drifted off to sleep during the second orbit. At the start of his seventeenth orbit over Cape Canaveral, Cooper briefly transmitted slow-scan black-and-white television pictures to the ground, a first for an American astronaut.

NASA was pleased that Cooper and *Faith 7* used much less fuel and consumables like oxygen than anticipated, and the mission proceeded largely according to plan. Late in the flight, however, problems cropped up quickly.

During the nineteenth orbit, a warning light falsely indicated the spacecraft had fallen into an unacceptably low orbit. On the twentieth orbit, Cooper lost all attitude readings and on the next revolution, a short circuit

On orbit: Tibetan lakes north of Katmandu, Nepal

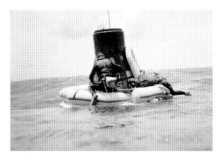

Splashdown: 12:24 p.m. (Samoa time)

left the automatic stabilization and control system without power. Mission managers ordered him to reenter manually for the first time.

Carbon dioxide levels began rising and the cabin temperature jumped to more than one hundred degrees Fahrenheit. Relying on star sightings, Cooper took manual control and successfully estimated the correct pitch for reentry into the atmosphere, drawing lines on *Faith 7*'s window to help check his orientation before igniting his retro-rockets.

The last Mercury mission splashed down less than five miles from the prime recovery ship, the aircraft carrier USS *Kearsarge*, at 12:24 p.m. local time and eighty miles south of Midway Island in the Pacific Ocean. *Faith 7* with Cooper aboard was lifted from the water with the ship's crane and set down on deck thirty-six minutes later.

NASA had considered a seventh flight, but Project Mercury officially ended on June 12, 1963, when NASA Administrator James Webb told Congress that no more Mercury flights were needed and that the agency would proceed with the Gemini program.

Cooper with a Convair F-102A *Delta Dagger* interceptor jet in March 1963. He had been assigned to the Flight Test Engineering Division at Edwards AFB, California, where he served as a test pilot and project manager for the F-102A and F-106B. The F-102A was intended to intercept invading Soviet bomber fleets.

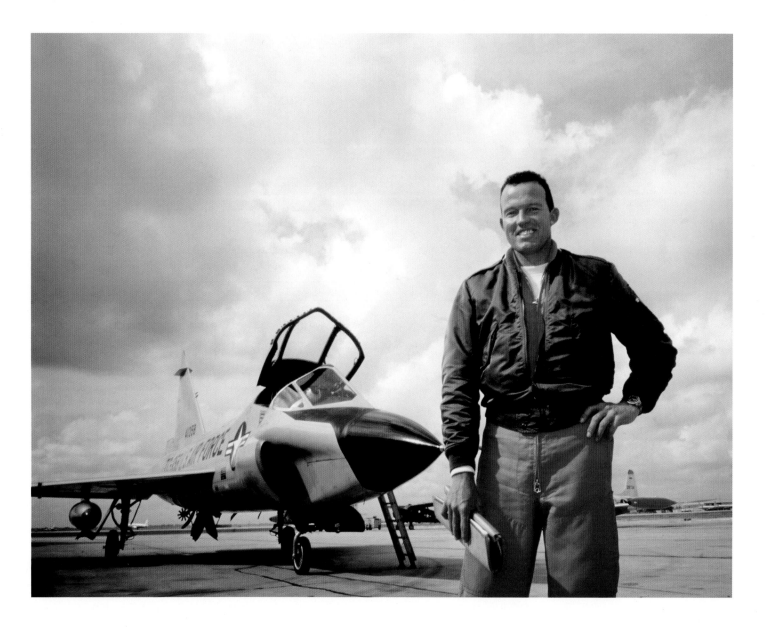

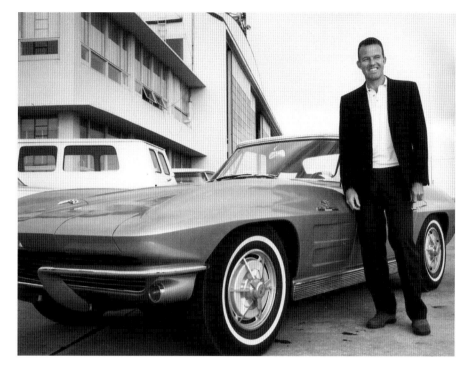

Right: Cooper with his 1963 Chevrolet Corvette Stingray after he landed his Beechcraft Bonanza F35 airplane at Patrick AFB in 1963. His wife, Trudy, also had a private pilot's license.

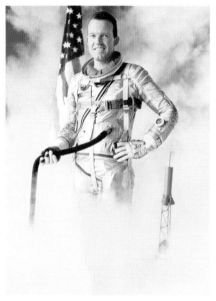

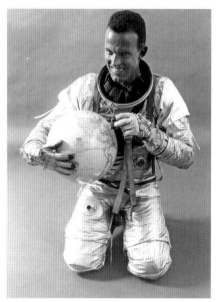

Center trio: Cooper had the greatest variety of publicity photos taken of any Mercury astronaut, including the two taken September 25, 1962, at Cape Canaveral (*left and center*) and an alternate to his official portrait taken in 1964 at MSC.

Bottom left: Cooper with his suit ventilator in front of Hangar S at Cape Canaveral. His Mark IV Goodrich suit incorporated many changes from Shepard's suit, including boots, improved gloves, and new shoulder construction.

Bottom right: Cooper at the flight director's console in the MCC in the week before launch. An unassuming Oklahoman, Cooper became known for his calm, laid-back attitude.

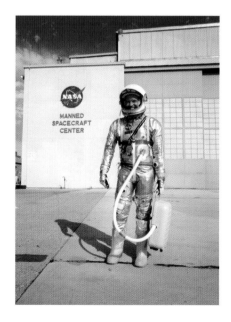

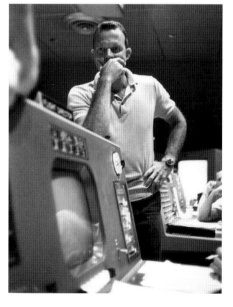

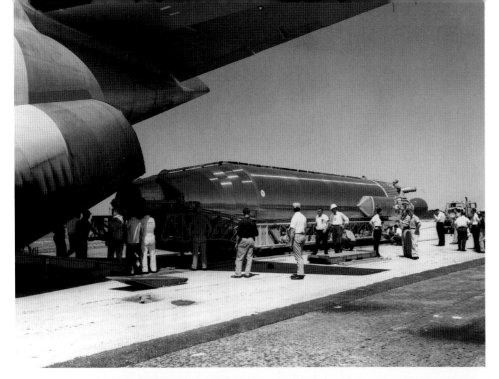

Top left: General Dynamics personnel inspect *Faith 7*'s Atlas D booster after off-loading from a Douglas C-133 *Cargomaster* aircraft at the Cape Canaveral Skid Strip on March 18, 1963. The aircraft arrived from a runway at the Convair Division of General Dynamics' Kearny Mesa plant north of San Diego, California. The Atlas was towed to Hangar H for checkout.

Top right: McDonnell engineering draftsman B. R. Schuster paints the insignia on Cooper's spacecraft in Hangar S in April 1963. *Faith 7* was the last officially sanctioned call sign for a US spacecraft until Apollo 9's *Gumdrop* and *Spider* seven years later.

Center left: A crew begins to raise the Atlas at Pad 14 into its service tower on March 21, 1963.

Bottom left: McDonnell technicians conduct a test of *Faith 7*'s Automatic Stabilization Control System in Hangar S on March 23, 1963.

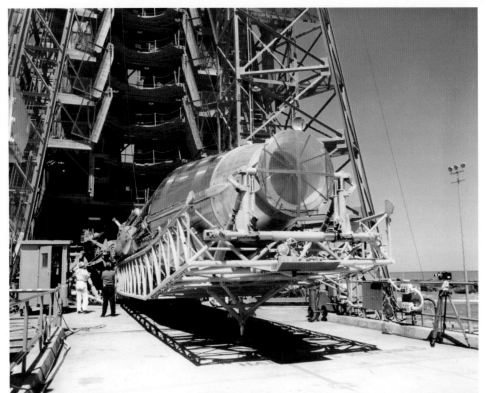

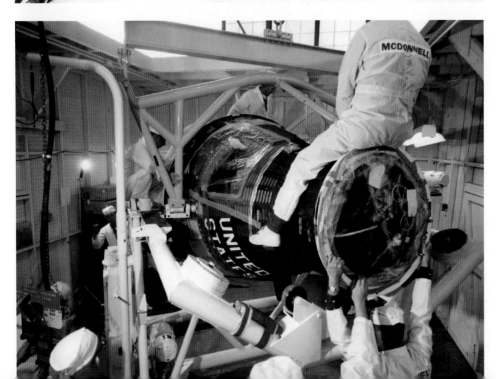

Above: Ed Zirnfus was a NASA quality-control inspector. The Engineering & Operations Building was next to Hangar S.

Above: Access badge

Below: Seamstresses adjust Cooper's suit at the B. F. Goodrich plant in Akron, Ohio.

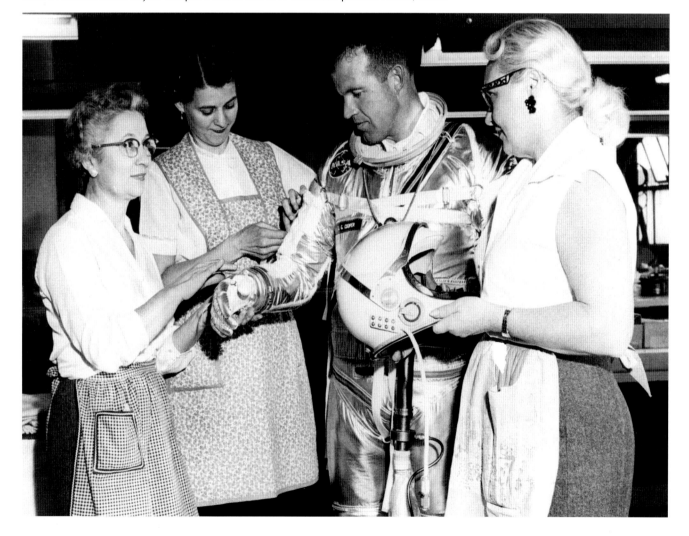

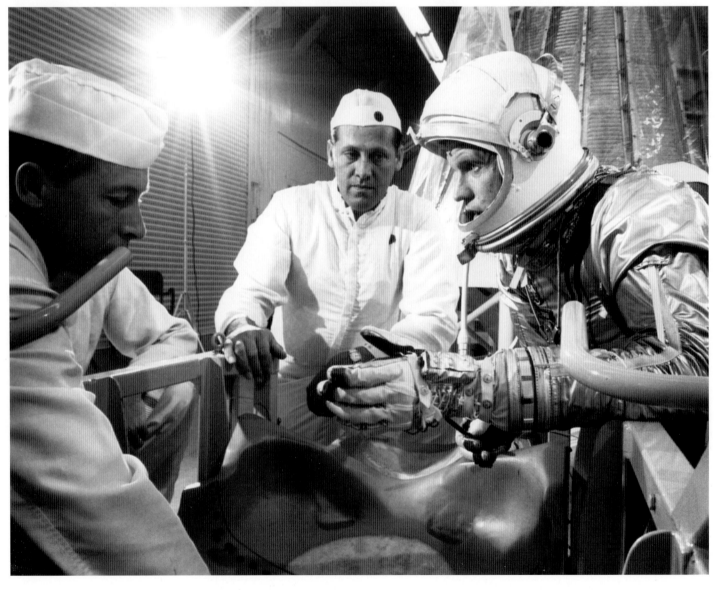

Opposite page, top left: Cooper gives his family a tour of LC-34, including daughters Janita, thirteen (*left*), Camala, fourteen, and his wife, Trudy (*right*). Behind them are the Atlantic coast and a series of unmanned Atlas launch pads to the south known as Missile Row. They watched the launch on TV at home in Houston's El Lago Estates suburb.

Opposite page, top right: Alan Shepard and Cooper park on the west side of Pad 14 with the Atlas in the service tower behind them.

Opposite page, bottom: McDonnell technicians Joe Trammel and C. R. Coyle assist Cooper during couch fit checks at Hangar S in February 1963.

Right: Cooper stands on the LC-14 service tower on March 21 before his Mercury spacecraft was mated to the Atlas.

Bottom left: Cooper jogs on Cocoa Beach on May 11.

Bottom right: Cooper autographs a Bible the next day after Sunday services at First Christian Church in Cocoa Beach. He drove his Corvette there that morning after a beach run and another countdown and launch simulation in *Faith 7*.

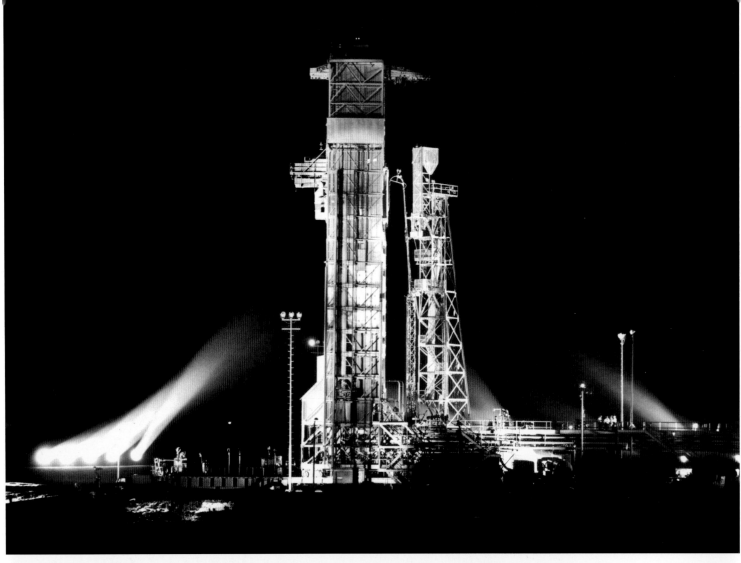

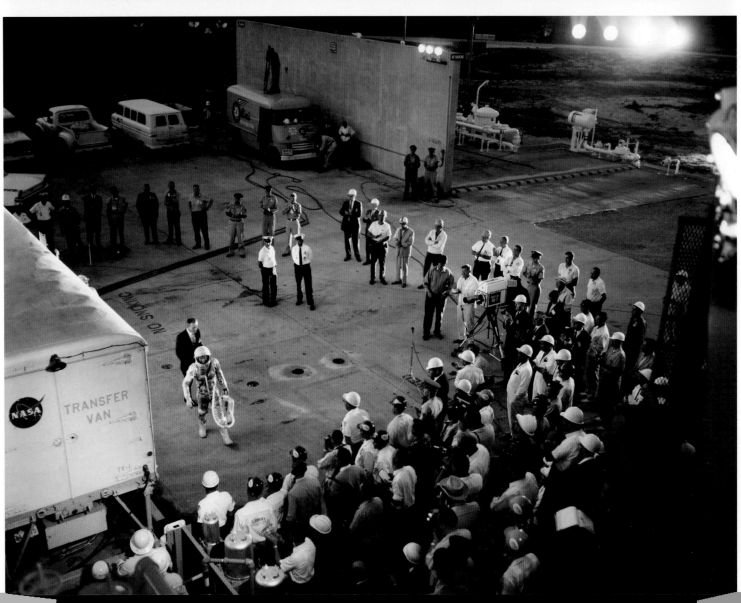

Opposite page, top: Floodlights illuminate the service tower and gantry at LC-14 the night before launch.

Opposite page, bottom: NASA, contractor, and USAF personnel applaud as Cooper leaves the transfer van and walks toward reporters on his way to the elevator in predawn darkness at Pad 14 on May 15, 1963. *Right center*: the TV network pool camera; *top center*: a cameraman films from the roof of a rented green van; *foreground center*: AP space reporter Howard Benedict (*in a white shirt and no hat*) holds a notebook in the third row.

Right: B. G. MacNabb, director of launch operations for General Dynamics, shakes hands with Cooper near the transfer van as a broadcast reporter (*left*) attempts a question. Jim Dempsey, General Dynamics Astronautics president, is behind B. G. MacNabb.

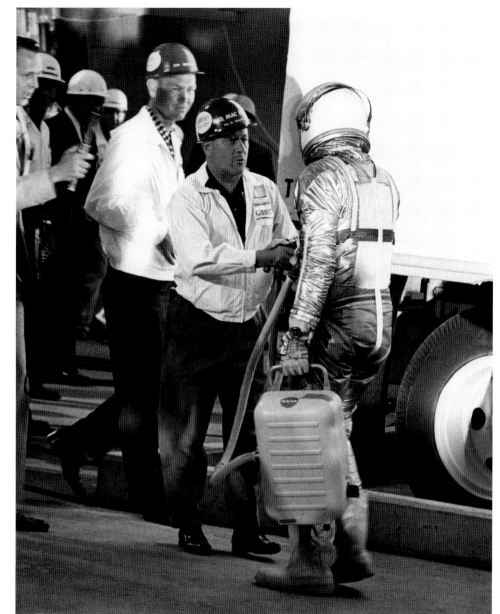

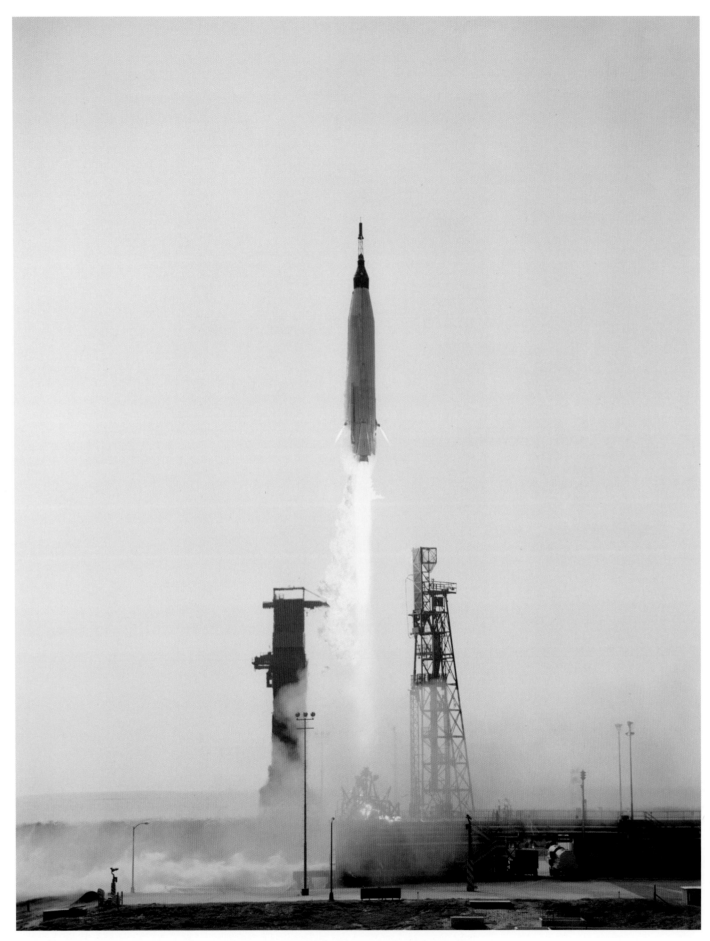

Faith 7's Atlas roars skyward at 8:02 a.m. (EST) on May 15 into a 165-by-101-mile-high orbit.

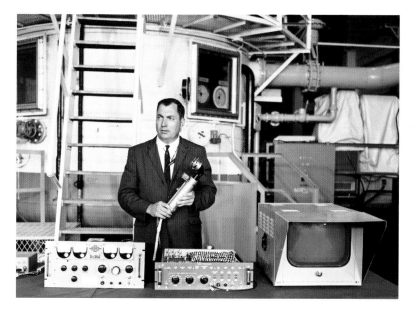

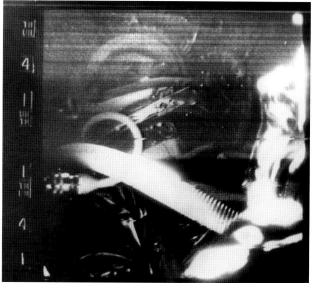

Top left: William Humphrey of MSC's Mercury Project Office holds the MA-9 onboard TV camera during a news briefing. On the table are the monitor and ground electronics for the system. The altitude chamber in Hangar S is behind him.

Top right: Photo of a monitor in the MCC showing a live video image of Cooper during orbit seventeen. The system had first briefly sent images of Cooper during launch.

Right: NASA Deputy Associate Administrator Walter Williams in the MCC. He'd left MSC four months earlier to move to NASA Headquarters. Chris Kraft is at the flight director's console at right.

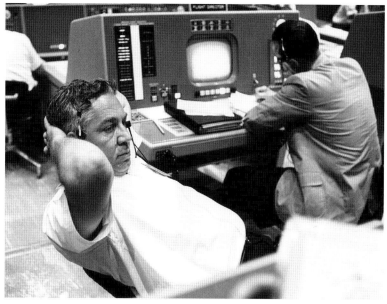

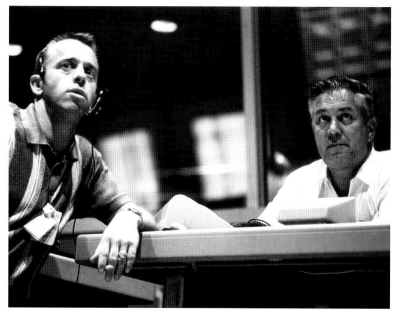

Alan Shepard and Williams monitor Cooper's progress during the early morning hours of May 16 in the MCC. Shepard would have piloted a seventh Mercury flight had Cooper's mission encountered significant problems.

Flight Surgeon Dr. Charles Berry reacts to word of Cooper's splashdown.

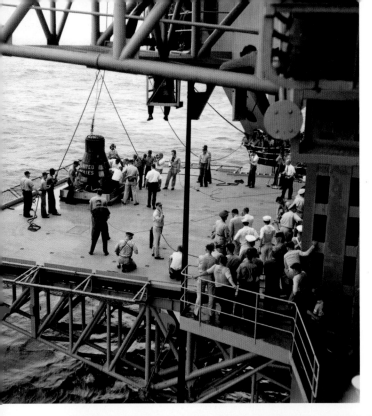

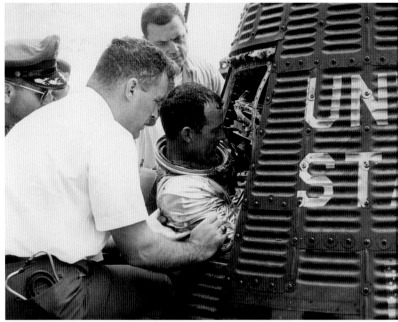

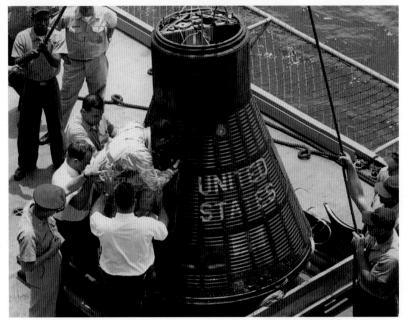

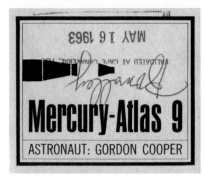

MAY 16 1963

VALIDATED AT CAPE CANAVERAL, FLA.

Mercury-Atlas 9

ASTRONAUT: GORDON COOPER

Top left: Recovery personnel aboard the *Kearsarge* prepare for Cooper to blow off *Faith 7*'s hatch on the fantail of the aircraft carrier (the prime recovery ship). He splashed down five miles from the ship, eighty miles south of Midway Island in the Pacific Ocean at 12:24 p.m. local time.

Top right: Dr. Richard Pollard of the Aeromedical Operations Office at MSC helps Cooper egress *Faith 7* after taking his blood pressure. NASA Public Affairs Officer Bennett A. James (*behind Cooper*) and USAF flight surgeon Col. Charles Upp (*left*) are also pictured.

Center left: James; John Graham, prime recovery team leader and member of Flight Operations Division, Recovery Branch at MSC; and Pollard assist as Cooper climbs from the spacecraft.

Center right: General Dynamics Mercury "passport" sticker signed by T. J. O'Malley

Bottom left: Graham and Pollard steady Cooper after thirty-four hours in space as his blood pressure and EKG data are sent to the spacecraft's onboard recorder from the cables attached to his suit's biomedical connectors at the chest and thigh. He then walked down a red carpet on the deck to sick bay for a medical exam and debriefing. He was flown to Hickam AFB in Honolulu, Hawaii, the next day and reunited with his wife for parades there and in Waikiki. They left that afternoon for Florida, arriving at Patrick AFB the next morning.

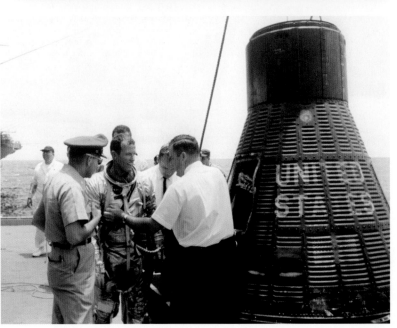

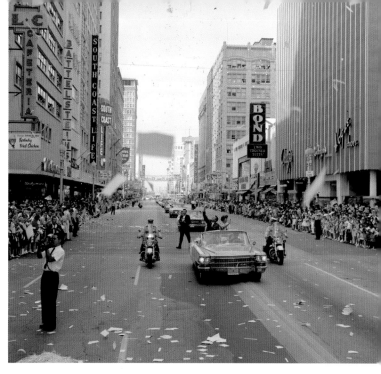

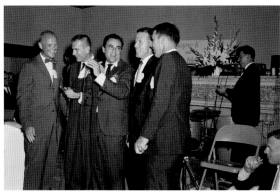

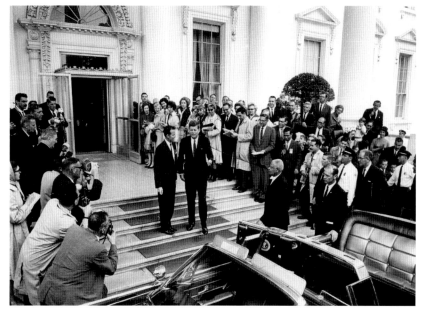

Top left: A TV pool camera in front of The Carriage Inn on N. Atlantic Avenue in Cocoa Beach provides coverage as Cooper's parade approaches from the south on May 20, 1963. The two microwave dishes (*right*) sent the camera's signal out to a relay point. The camera's CBS logo is covered for its use in the broadcast pool. The parade began at Patrick AFB and ended at the Inn, where Cooper held a news conference at the NASA Mercury News Center.

Center left: Glenn, Slayton, comedian and actor Bill Dana, Cooper, and Schirra entertain at the Project Mercury public affairs party on July 27, 1963. Dana was known at the time for his "José Jiménez, the Reluctant Astronaut" routine on *The Ed Sullivan Show*. Also pictured are MSC procurement officer Robert L. Kline (*far left*) and Forrest L. Sealy of the Public Affairs Office (*standing at right*).

Top right: Cooper and his wife pass the Battlestein Building (*left*) on Main Street in downtown Houston during a thirty-two-block parade on May 23—the largest ticker-tape parade in city history at the time.

Center right: At the North Portico of the White House, President Kennedy escorts Cooper to the presidential limousine that took him to the US Capitol to address Congress on May 21. Earlier, Kennedy presented Cooper with NASA's Distinguished Service Medal. The day ended with a parade through Manhattan.

Bottom right: Spectators along the Houston parade route

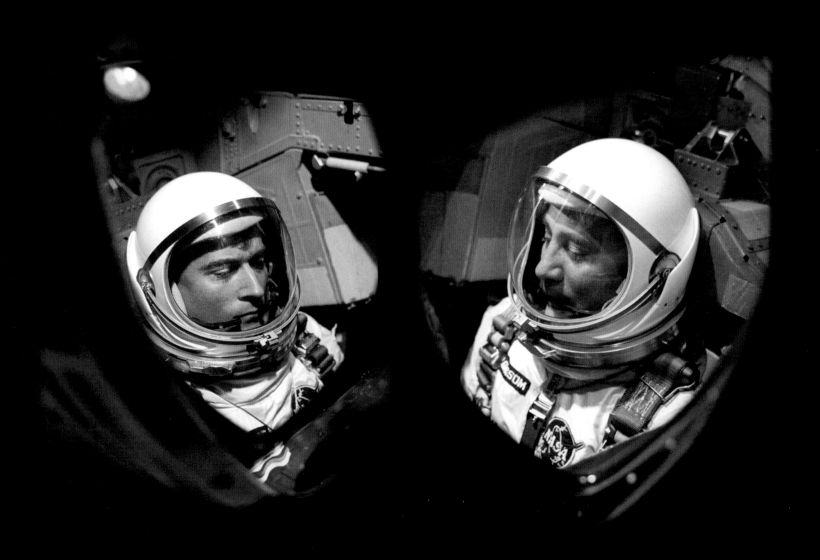

John Young (*left*) and Gus Grissom are seen in separate photos through the cockpit windows of their spacecraft several hours before launch on March 23. Both are strapped into ejection seats that would have propelled them away from their booster in an emergency on the launch pad or shortly after liftoff.

Gemini 3
March 23, 1965

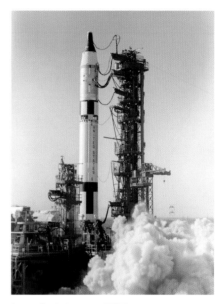

Launch: 9:24 a.m. (EST)

A fter two unmanned test flights of the new two-man Gemini spacecraft, thirty-eight-year-old USAF Maj. Virgil I. "Gus" Grissom and thirty-four-year-old US Navy Lt. Cdr. John W. Young made three orbits of the earth on March 23, 1965, on their Gemini 3 mission.

Command Pilot Grissom, a Mercury veteran, became the first person to fly in space twice. He named the spacecraft *Molly Brown*—a reference to the 1964 musical film *The Unsinkable Molly Brown*—in view of his spacecraft sinking after his 1961 flight. NASA officials argued the name wasn't dignified, but since Grissom's second choice was *Titanic*, they grudgingly agreed and banned future naming of flights.

The spacecraft's thrusters were test-fired on the pad during the countdown, which was delayed briefly by a leak in the Titan II booster's first-stage oxidizer line. Five and a half minutes after launch, the second-stage engine shut down and Grissom fired the aft thrusters to insert the spacecraft into orbit.

A central goal of the Gemini program was to gain experience with spacecraft changing orbits—a requirement for later testing the rendezvous and dockings necessary for Apollo moon missions. The crew used the capsule's maneuvering thrusters to first circularize their orbit and later alter their orbital plane and altitude—all space firsts.

Earth from orbit

During the second orbit, Pilot Young surprised Grissom by offering him a corned beef sandwich that was secretly stowed by suit technician Al Rochford in a pocket on Young's lower leg that morning. Backup pilot Wally Schirra had supplied the sandwich at Young's request from Wolfie's restaurant at the Ramada Inn on Cocoa Beach. The prank became the most memorable moment of the mission and prompted NASA to restrict what astronauts could carry on flights.

After three orbits, the pair performed the first controlled reentry, landing *Molly Brown* northeast of the Turks and Caicos Islands in the Atlantic Ocean. During descent, the spacecraft shifted from a vertical to horizontal attitude under its main parachute. The change (although planned) was so sudden that Grissom cracked his helmet's faceplate on the control panel and Young's faceplate was scratched.

Gemini 3 landed much farther from its landing target than wind tunnel tests had predicted—about sixty miles from the aircraft carrier USS *Intrepid*. Remembering his *Liberty Bell 7* experience, Grissom refused to open the

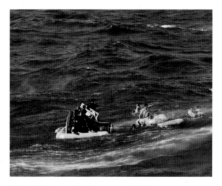

Splashdown: 2:16 p.m. (EST)

hatches until navy divers arrived and attached a flotation collar to the spacecraft.

During the half-hour wait, Gemini 3 pitched and tossed in the water, and the cabin was hot from the reentry. The combination made Grissom nauseated. Once the collar was in place and a swimmer opened the hatches, the two men quickly climbed out and put on the "horse collar" hoists that lifted them to a helicopter. *Intrepid* arrived soon afterward and recovered the spacecraft.

It was Grissom's final space flight. He died three years later during a test of what would be the first manned Apollo mission.

Opposite page, top left: Grissom in early 1964 with a Gemini model in the lobby of NASA headquarters in Washington, D.C.

Opposite page, top right: Grissom and Young in front of the Gemini simulator at MSC in 1964. They wear early models of the G2C space suit, developed by the David Clark Co. of Worcester, Massachusetts. The suits were direct descendants of pressure suits used by USAF supersonic aircraft pilots.

Opposite page, bottom: Grissom poses with a Martin model of the Gemini-Titan II launch vehicle after receiving an award on October 23, 1963. The Martin Co. of Baltimore, Maryland, a division of the Martin Marietta Corp., manufactured the Titan II GLV (Gemini launch vehicle). Much as manned launches had upgraded boosters, Titans had supplanted the Atlas as the US intercontinental ballistic missile with nuclear warheads, stationed in silos in the western United States from 1963 to 1987.

Bottom left: Young inspects the interior of a Gemini mock-up's equipment section of the adapter module at the McDonnell plant in St. Louis in 1963. A Korean War veteran, Young set world time-to-climb records in the F-4 *Phantom II* jet fighter as a navy test pilot in 1962. The large spheres (*bottom*) would contain cryogenic gases for the spacecraft's fuel cells: liquid hydrogen (*left*) and LOX (*right*), which produced electricity and water. *Upper left*: the environmental control system pump with a sphere for the primary cabin oxygen supply; *upper right*: the two spheres would contain helium to pressurize fuel for the sixteen orbit attitude and maneuvering system (OAMS) thrusters.

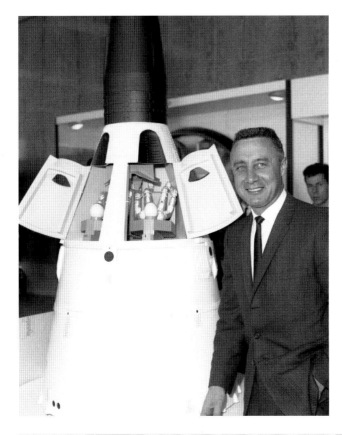

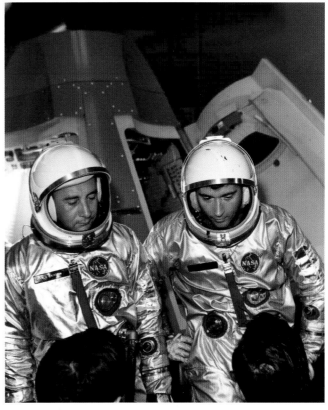

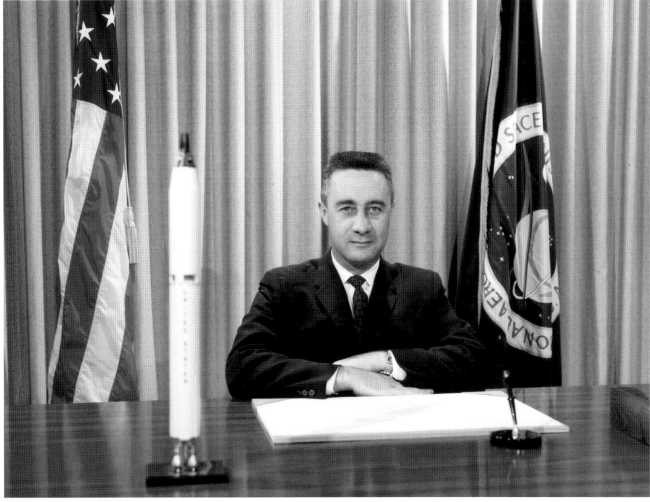

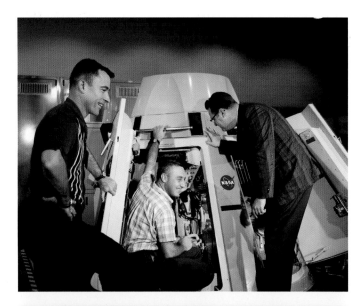

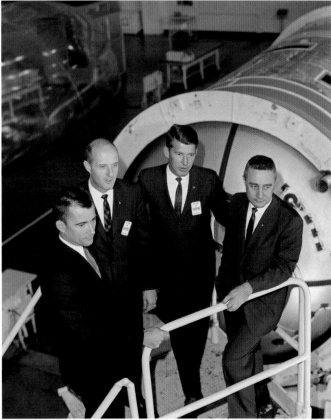

Top left: Young, Grissom, and Riley D. McCafferty, manager of NASA's Manned Flight Simulation Division, inspect the crew station of a McDonnell Gemini Mission Simulator in the MCC at Cape Kennedy Air Force Station (AFS) on October 25, 1964. A second simulator was installed at MSC in Houston. The Florida launch site was renamed on January 22, 1964, from Cape Canaveral Missile Test Annex. The name would change again to Cape Canaveral AFS in 1973.

Bottom left: The prime and backup flight crews for Gemini 3 on a platform near the top of the second stage of the Titan II booster to be used for Gemini 3. The photo was taken at the Martin plant in Baltimore on October 28, 1964, when the booster was officially turned over to the USAF. Prime crewmen Young and Grissom flank backup crewmen Tom Stafford and Wally Schirra, who would be the prime crew for Gemini VI.

Top right: The Gemini 3 spacecraft after arriving at the Cryogenic Building at Cape Kennedy, bearing red "remove before flight" streamers. White covers protect four of the sixteen total oval-shaped RCS engines near the top of the spacecraft.

Bottom right: Young models a new G2C pressure suit with a ventilator unit in 1963 at McDonnell in St. Louis. Casts of the custom form-fitted couches for the seven Mercury astronauts are behind him. A portion of the red escape tower on a Mercury spacecraft mock-up is also pictured (*upper left*).

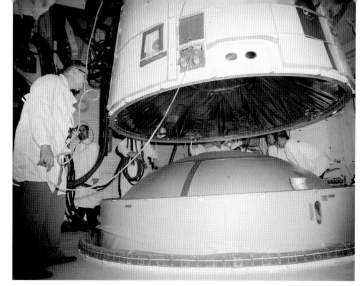

Above: Young and Grissom confer at the crew quarters on the fourth floor of the Manned Spacecraft Operations Building (MSOB) on March 17, 1965. They were the first crew to use the new quarters in KSC's Industrial Area on Merritt Island, west of Cape Canaveral.

Top right: Technicians carefully mate Gemini 3 with its Titan II in the lower level of the white room at LC-19 in February 1965. The rear of the adapter section is covered with gold Mylar as thermal protection. The top dome of the Titan's oxidizer tank is visible.

Second right: A test of the booster erector on March 19. Both stages of the Titan were rolled into the erector horizontally then raised into position on the launch stand. The erector also provided seven work platforms as well as the white room, which housed the Gemini spacecraft. The crane at right brought the spacecraft to pad level.

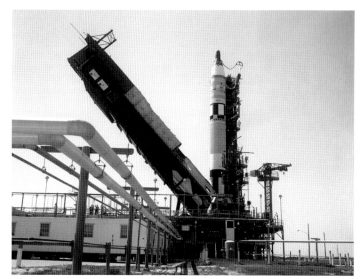

Third right: Grissom at the Gemini simulator in the MCC with astronaut "den mother" Lola Morrow during a photo shoot for Gregg shorthand magazine, *Today's Secretary*, on November 27, 1964. The document is a purchase order for linens from the Titusville, Florida, JC Penney store for the astronaut crew quarters. This room was part of a 1962–1963 addition to the MCC for Gemini.

Bottom right: Young and Grissom talk to reporters on September 15, 1964, in a double-wide trailer installed at LC-16 to suit the crew. President Johnson stopped by to see them in the Gemini simulator in the MCC during a surprise visit. *Far left*: Chris Butler of the *Orlando Sentinel* and Al Rossiter Jr. of UPI; George Meguier of WRKT-AM is in sunglasses. *Fifth from right*: Paul Haney; *third from right*: Dr. Gordon Benson; *far right*: NBC's Jay Barbree, who would cover every US manned launch through the Space Shuttle program; *lower left*: ABC's Jules Bergman.

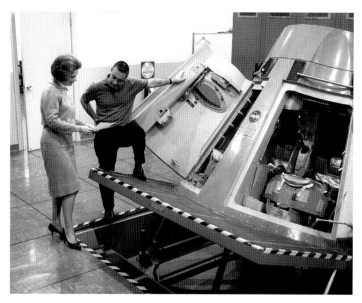

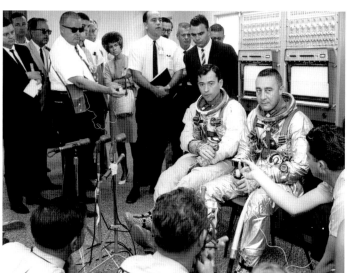

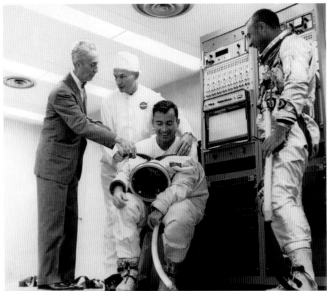

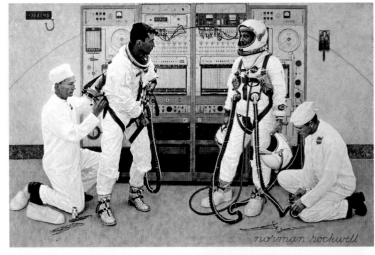

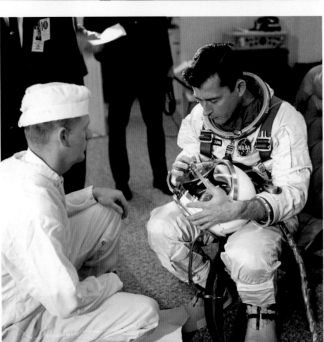

Top left: Artist Norman Rockwell poses Young in the astronaut suiting trailer, with suit tech Joe Schmitt and Grissom on November 15, 1964. Rockwell's resulting oil painting (*pictured at top right*) was part of the NASA Art Program and was published in the April 20, 1965, issue of *Look* magazine. Schmitt, who accompanied a space suit to Rockwell's studio so the artist could get the details correct (despite NASA's objections), was included in the painting (*left*), as was suit tech Al Rochford (*right*).

Center left: Young checks out his helmet visor with Rochford in the suiting trailer on March 9, 1965. The trailer (which included two bedrooms, a bathroom, and a small kitchen) was used to minimize the crew transfer time since LC-19 was just four hundred yards north of LC-16, a former Titan missile pad. By some accounts, it also satisfied Grissom's desire to keep the media at bay.

Bottom left: Grissom enters Gemini 3 at the Merritt Island Launch Area Radar Range Boresight Tower on February 6, 1965, during a communications check. The recovery light, recovery antenna and descent antenna are extended (*bottom, from left*).

Inset left: Young prepares for a session in the Gemini simulator at Cape Kennedy on February 26, 1965. The new C3G suits used interlocking rings at the wrists to attach gloves.

Inset right: Grissom during training on September 15, 1964. A drinking port on the front of his helmet is new to Gemini.

Top left: Backup Command Pilot Wally Schirra (*right*) jokes with Grissom (*left*), and Assistant Director of Flight Crew Operations Deke Slayton in the suiting trailer about 6:00 a.m. (EST) on launch day. Schirra, insisting he was ready to fly in case either Grissom or Young were reluctant to conduct the mission, wears a training suit festooned with access badges in part to lampoon KSC's preoccupation with them.

Right: Young reviews a checklist from his briefcase around 6:45 a.m. (EST) in the suiting trailer.

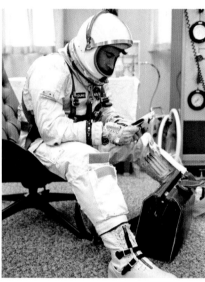

Top right: "BI" on a Gemini badge indicated Eugene Stifel passed a background investigation. Stifel spent thirty-six years with McDonnell/Douglas, including serving as supervisor for the Skylab Orbital Workshop in 1972.

Center right: McDonnell technicians make final preparations in the LC-19 white room with the hatches closed at 7:35 a.m. The white stripe covers the trough for the "bridle" that will suspend the spacecraft from its main parachute before splashdown.

Bottom right: Grissom dons his pressure suit in the suiting trailer. To the right is NASA physician Dr. Gordon Benson, chief of medical operations at Cape Kennedy.

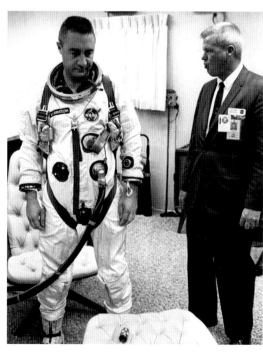

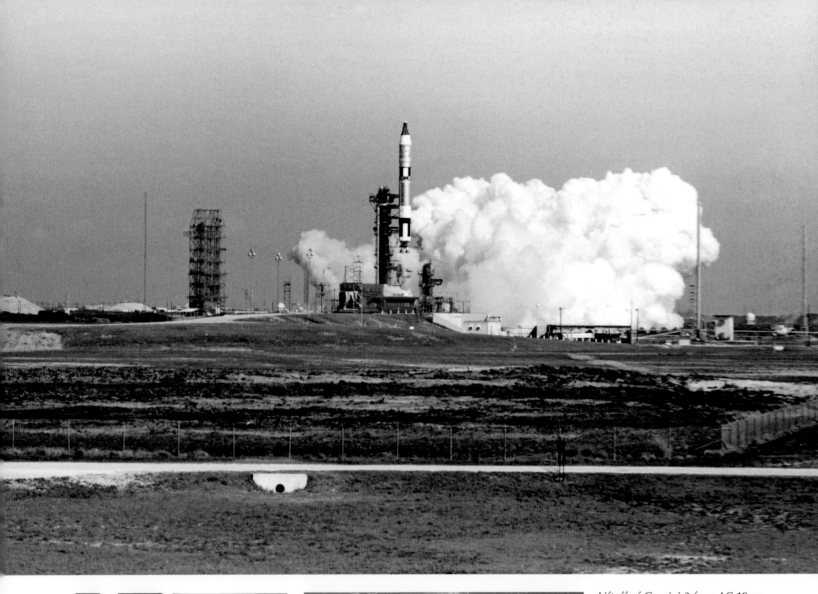

NASA Spacecraft Test Conductor George Page (*left*) in the LC-19 blockhouse holds his headset mic switch and makes notes during the countdown demonstration test (CDDT), a rehearsal on March 8, 1965, with the crew in the spacecraft. McDonnell spacecraft manager Bob Graham (*right*) and Countdown Test Conductor Paul Donnelly (*left background*) are also pictured.

Young's photo through his window of Bermuda in the Atlantic Ocean on the second orbit taken with a Hasselblad 500 camera and an 80mm lens.

Liftoff of Gemini 3 from LC-19 on March 23, 1965, looking north-northwest. The booster's fuel, a 50/50 mix of hydrazine and unsymmetrical dimethylhydrazine (known as Aerozine 50), burned with a characteristic yellow smoke. *Left*: the service tower at LC-34, two pads away; *center right*: the Titan's oxidizer's storage area, or "propellant farm."

George Van Staden was KSC director of administration.

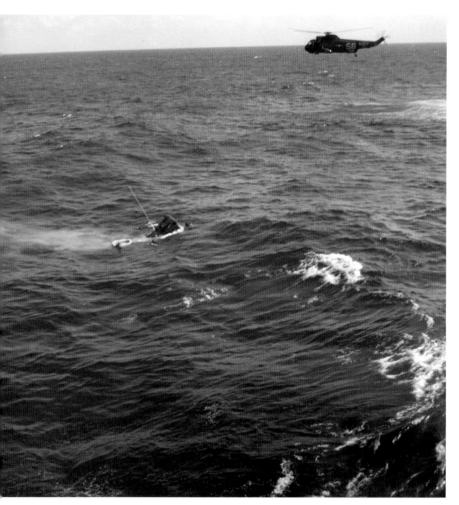

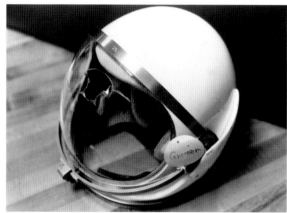

Top left: Divers from USS *Intrepid* attach a yellow flotation collar to Gemini 3 northeast of Turks and Caicos Islands. The crew extended the thirteen-foot-high frequency whip antenna for voice communication with recovery forces. A yellow life raft left of the spacecraft awaits the crewmen. Fluorescent green dye was automatically released from the spacecraft on impact.

Top right: Young and Grissom with *Molly Brown* in the *Intrepid*'s hangar deck. They hold the parachute riser guard ring in the RCS system section of the spacecraft.

Center right: An instrument panel knob punched a hole in Grissom's acrylic faceplate when the spacecraft—suspended by its main parachute—shifted from its vertical to more horizontal position as planned just before splashdown.

Above: Grissom speaks to the media with Young on the Skid Strip upon their return to Cape Kennedy AFS on March 25. To Young's right stands Robert Seamans, NASA associate administrator. Behind them is a Grumman C-1 Tracker, a navy carrier aircraft. Filming at lower center is Larry Summers with Technicolor, NASA's audio-visual contractor, with NASA still photographer Bill Taub at lower right. Grissom's father, Dennis, can be seen third from far left.

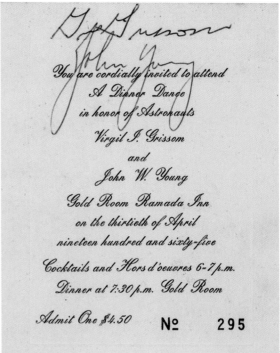

You are cordially invited to attend
A Dinner Dance
in honor of Astronauts
Virgil I. Grissom
and
John W. Young
Gold Room Ramada Inn
on the thirtieth of April
nineteen hundred and sixty-five
Cocktails and Hors d'oeuvres 6-7 p.m.
Dinner at 7:30 p.m. Gold Room

Admit One $4.50 № 295

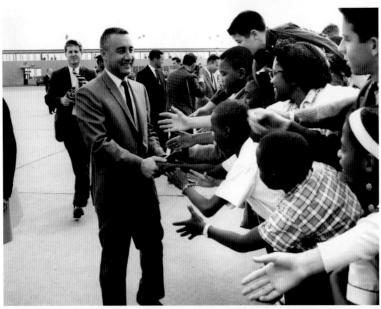

PHOTOGRAPHER
CHICAGO'S SALUTE
to
America's Astronauts
Grissom & Young
Tuesday, March 30th
O'HARE FIELD

Top left: Participants at the postflight news conference at the Carriage House Motor Lodge in Cocoa Beach on March 25, 1965, include (*left to right*) KSC Director Kurt Debus, Flight Director Chris Kraft, Young, Grissom, MSC Director Robert Gilruth, NASA Associate Administrator Robert Seamans, and public affairs chief Julian Scheer.

Center left: Some ten thousand schoolchildren are on hand to welcome Grissom and Young and their families as they arrive home from Chicago at Houston International Airport on March 31, 1965.

Bottom left: Young and Grissom listen to Vice President Hubert Humphrey on March 29, 1965, after arriving at New York's LaGuardia Airport. Seamans is also pictured (*upper right*). The astronauts received a ticker tape parade and keys to the city from Mayor Robert Wagner at City Hall.

Top right: An autographed invitation

Opposite page, top: Young and Grissom listen to comments from backup crewmen Schirra and Stafford at a dinner-dance in their honor at the Cocoa Beach Ramada Inn on April 30, 1965.

Opposite page, bottom: Young and Grissom ride in a noontime parade south on State Street in Chicago on March 30, 1965. Chicago Mayor Richard Daley is in the front passenger seat.

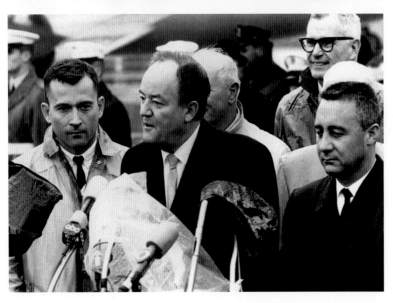

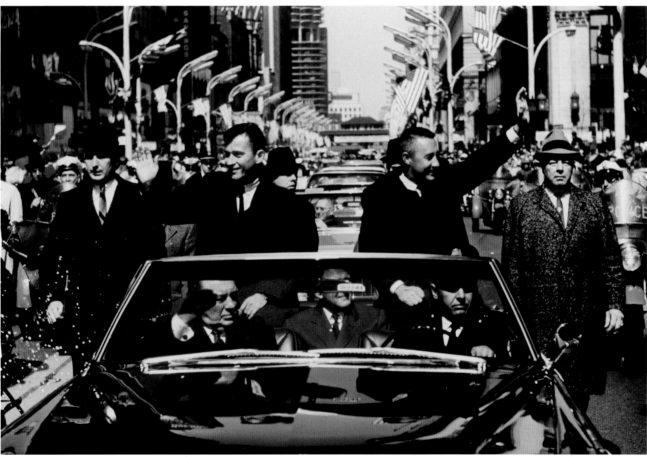

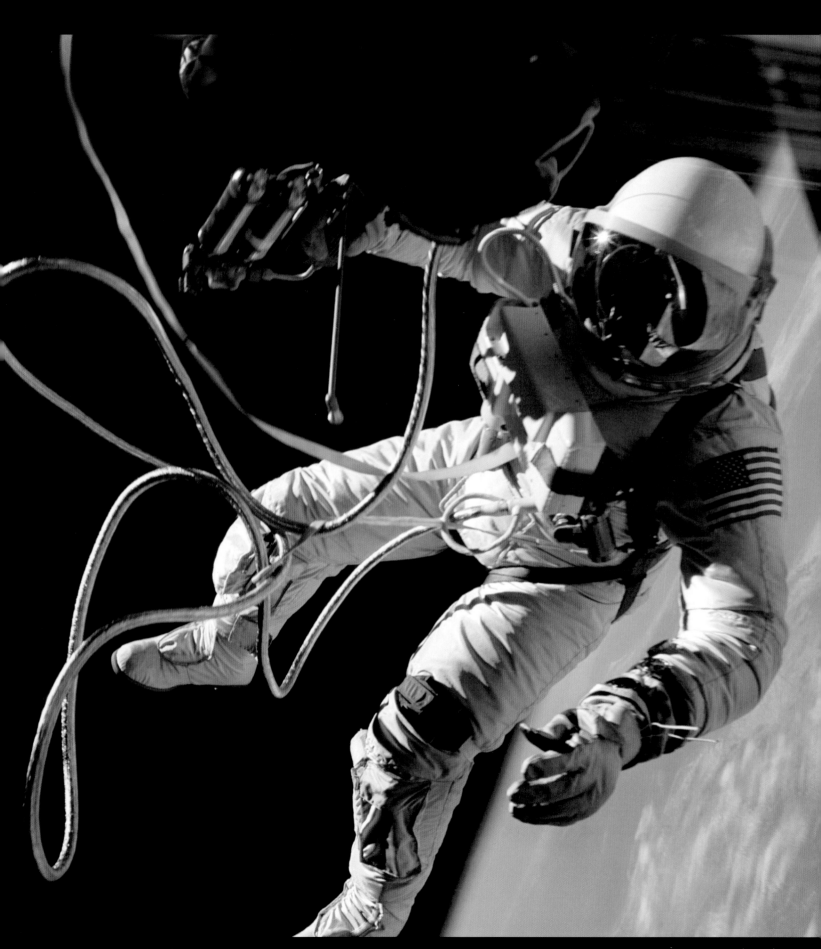

Ed White floats free of Gemini IV 105 miles above the United States on the third orbit of the mission, connected to the space-craft by an umbilical three-quarters of an inch in diameter. The spacecraft with his hatch open is reflected in his gold visor.

Gemini IV

June 3–7, 1965

Launch: 10:16 a.m. (EST)

B y the time Gemini IV launched on June 3, 1965, the Soviet Union had seemingly taken a huge lead in the Space Race. Three weeks earlier, cosmonaut Alexei Leonov stepped outside his Voskhod 2 spacecraft on the world's first extravehicular activity (dubbed a "spacewalk" by the media). The United States came nowhere near the record-setting five-day mission of Vostok 5 in 1963; the flight was the second time two Russian-manned spacecraft had orbited together. The USSR even launched a three-man spacecraft and the first woman.

But Gemini IV was the first in a series of flights that would put the United States in the lead to stay. Thirty-five-year-old Commander James A. McDivitt and thirty-four-year-old Pilot Edward H. White II, both USAF majors, spent four days in orbit, tripling the combined time of all previous American missions after an inauspicious hurdle: an electrical problem froze the tall orange erector as it was being lowered at LC-19 thirty-five minutes before launch. The repair delayed liftoff by more than an hour.

After reaching orbit, McDivitt tried to rendezvous with the second stage of the Titan II booster (outfitted with tracking lights), but lacking onboard radar or experience with orbital mechanics, he abandoned the effort after using 40 percent of Gemini IV's maneuvering fuel.

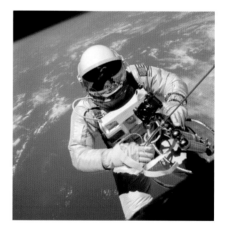

EVA: 2:46 p.m. (EST) June 3

The astronauts then prepared for White's spacewalk, which was postponed for one orbit after he became overheated while attaching his gear. They depressurized the cabin but had trouble opening the hatch. Once they succeeded, White left the spacecraft about 2:46 p.m. (EST) over California with his combination umbilical and safety tether attached to his seat. With short bursts of compressed oxygen from his Hand-Held Maneuvering Unit (HHMU), White moved away from the spacecraft and made small changes to his position, but the jet gun soon ran out of propellant. His hand brushed McDivitt's window, who complained: "You smeared up my windshield, you dirty dog!" And one of his thermal gloves floated away.

Caught up in the event, the twenty minutes passed quickly for the astronauts. Because they were using their internal communication channel, Mission Control could not break in. After almost sixteen minutes, McDivitt reopened the ground link and heard CAPCOM Gus Grissom immediately instruct him to get White back inside. His time was almost up and Gemini IV would soon be in darkness over Africa and out of voice communication for about an hour.

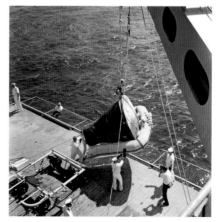

Splashdown: 12:12 p.m. (EST)

White reluctantly complied, saying, "It's the saddest moment of my life." He had trouble relatching the hatch, which led the astronauts to cancel plans to later open it to throw out the EVA gear.

The rest of the mission was uneventful (although the flight easily set a new US space endurance record). On the afternoon of the third day in orbit, the onboard IBM computer shut down and refused to come back online. It meant they'd be forced to fall back on a rolling Mercury-type reentry rather than the lifting banked angle the computer was to provide. As a result, Gemini IV undershot its target in the Atlantic by forty-six miles but was still within sight of a navy helicopter. Splashdown was 390 miles east of Cape Kennedy at 12:12 p.m. (EST) on June 7.

Within a few minutes, divers attached a flotation collar. The two crewmen emerged after thirty minutes and were hoisted into the helicopter. Less than an hour after splashdown, the astronauts stepped onto a red carpet on the deck of the aircraft carrier USS *Wasp* and were cheered by the ship's crew. Despite concerns about the effects of four days of weightlessness, both men were in good shape. The *Wasp* docked in Jacksonville, Florida, on June 10 and the astronauts immediately flew home to Houston.

The mission kept the public fascinated and set the stage for bigger US space achievements. But two other events on the day the flight ended signaled times were changing. On June 7, Gen. William Westmoreland formally requested forty-one thousand more troops be sent to Vietnam as the first step toward an active American ground combat role there. The same day, the Supreme Court ruled that the Constitution protected a right to privacy, laying the groundwork for the legalization of most abortions.

Top left: White and Jim McDivitt with a Gemini spacecraft model shortly after they were selected for Astronaut Group 2—dubbed "the New Nine"—in September 1962. Neither man had yet been chosen for a flight.

Top right: White and McDivitt on July 29, 1964—two days after they were named as the Gemini IV crew. McDivitt was chosen as command pilot over the six remaining Mercury astronauts (Glenn had resigned), as all but Cooper had medical issues at the time. The spacecraft model is shown in a proposed configuration—by then abandoned—to touch down on dry land using skids and an inflatable paraglider.

Bottom left: Thirty-five-year-old McDivitt suited for weight and balance testing on May 21, 1965, in the Pyrotechnic Installation Building. He flew 145 combat missions during the Korean War in F-80s and F-86s, and was an experimental test pilot at Edwards AFB, California. In 1962 he flew a chase plane when Robert M. White's X-15 reached an altitude of 59.5 miles. White became the first space flier awarded astronaut wings based on the USAF definition of fifty miles.

Bottom center: McDivitt and White pose at the radar tracking and communication antenna at the Mission Control Center at Cape Kennedy. This station—first used during Mercury—was known as CVN in NASA's worldwide Manned Space Flight Network.

Bottom right: Thirty-five-year-old White on April 14, 1965, on NASA's Motor Vessel *Retriever*, a converted World War II landing craft used to train astronauts for postsplashdown water egress in the Gulf of Mexico near Houston. White's father was a USAF major general. A 1952 US Military Academy graduate, White chose a commission in the USAF. In 1956 he flew the F-86 Sabre and F-100 Super Sabre at Bitburg Air Base in West Germany—where he first met Buzz Aldrin.

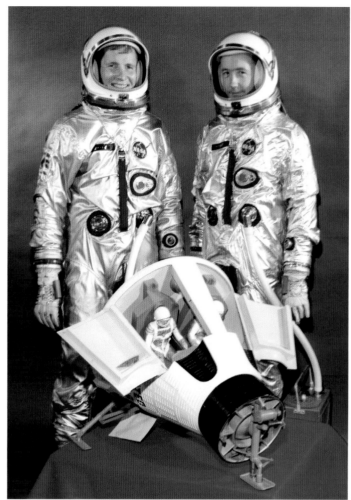
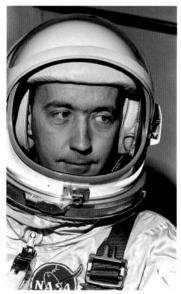
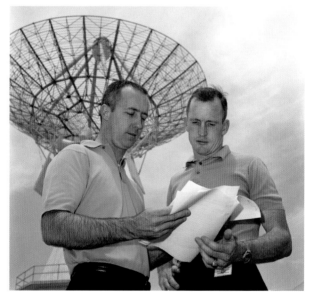

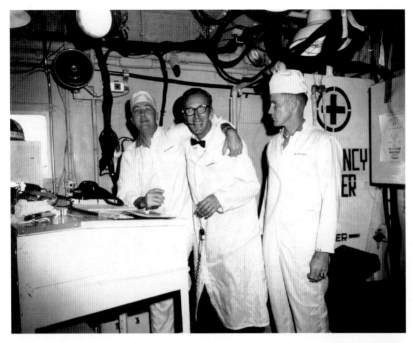

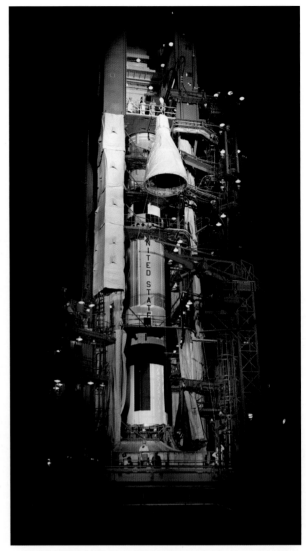

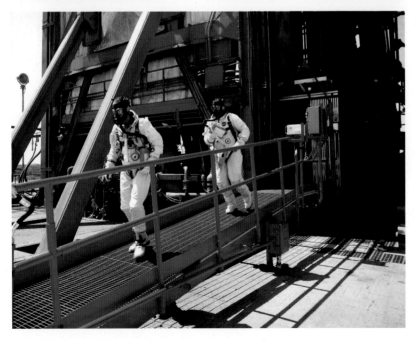

Above: The Gemini IV spacecraft (wrapped in a white plastic shroud) is hoisted 109 feet to the top of its Titan II booster on April 14, 1965. The pad's 138-foot-tall erector surrounds the launch vehicle as personnel wait in the open white room at the top. After system tests, the spacecraft was mated to the booster nine days later.

Top left: McDivitt and White flank McDonnell pad leader Guenter Wendt in the white room at LC-19. An emergency shower (*behind White*) and a taped notice stress the need for a clean spacecraft (*far right*).

Center left: White and McDivitt with Dee O'Hara, NASA staff nurse, on June 1, 1965, at the crew's final preflight medical exam. O'Hara, a former USAF second lieutenant at Patrick AFB, was with the astronaut program through 1974.

Bottom left: Wearing gas masks with oxygen supplies, McDivitt (*left*) and White (*right*) run from the express elevator on the east side of the erector during an emergency drill at LC-19 on May 21, 1965.

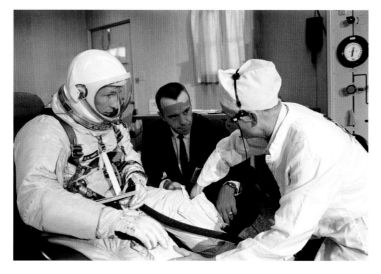

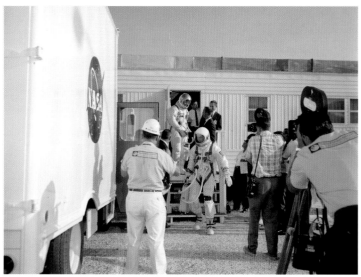

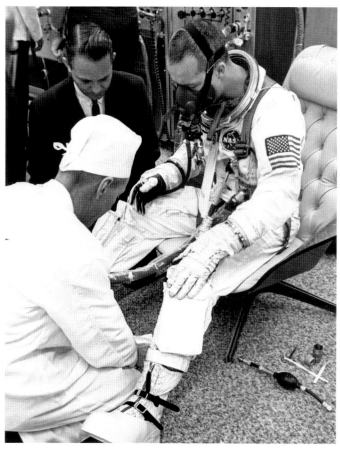

Top left: Suit tech Joe Schmitt reaches into a pocket on White's pressure suit on launch morning in the suiting trailer at LC-16. Astronaut Office chief Alan Shepard (*center*) had been named to command Gemini 3 before an inner ear disorder took him off flight status in 1964.

Bottom left: McDivitt followed by White (shaking hands with Shepard) on launch day leave the suiting trailer to board the transfer van for the short trip to LC-19. Both wear the new G4C pressure suits, which included additional layers of insulation and micrometeoroid protection since the cabin would be opened in flight for White's EVA. Fortune Homes Corp. of Sarasota, Florida, made the suiting trailer. Technicolor photographer Ed Thomas is at left.

Top right: White's Hand-Held Maneuvering Unit (HHMU) displayed with its wrist tether. Powered by compressed oxygen in the two bottles, one forward-facing jet and two rear-facing jets on the extensions allowed White to make small movements during his EVA. A Zeiss Ikon Contarex Special 35mm camera with a 50mm lens is mounted on the unit.

Center right: McDivitt breathes pure oxygen (the spacecraft cabin's environment) to purge nitrogen from his blood before donning his helmet. He is assisted by suit tech Clyde Teague.

Bottom right: McDivitt enters the white room at the top of the LC-19 erector three hours before launch, carrying his suit ventilator. Wendt (*center*) and mechanic Bill Nagle (*wearing white ball cap*) are also pictured.

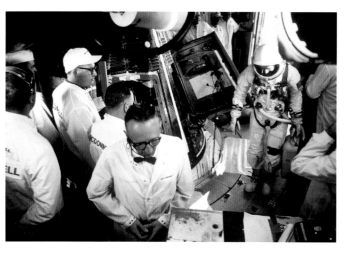

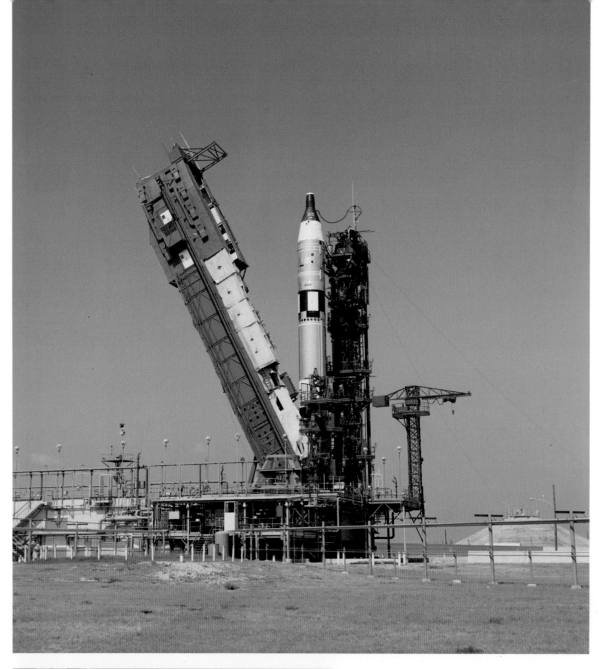

Above: An electrical problem caused the 130-ton erector to become stuck thirty-five minutes before the planned launch. The problem was solved after an hour and fifteen minutes. The igloo-shaped LC-19 blockhouse is six hundred feet west of the pad (*right*). The Space Systems Division of the USAF Systems Command handled Gemini launch vehicle program management for NASA.

Opposite page: Gemini IV seconds after liftoff at 10:16 a.m. (EST) on June 3, 1965. For the first time, television coverage of the launch had an international audience, as the event was relayed to twelve European nations via Intelsat I, the first commercial communications satellite in geosynchronous orbit (which had been launched from the Cape two months earlier).

Above: Spectators watch the launch from bleachers at the main VIP viewing site known as the Merritt Island Causeway viewing stand. This location was along the NASA Causeway East over the Banana River (about two miles west of LC-19). The crew families and VIPs watched from a closer location on Cape Kennedy itself.

Chapter 8

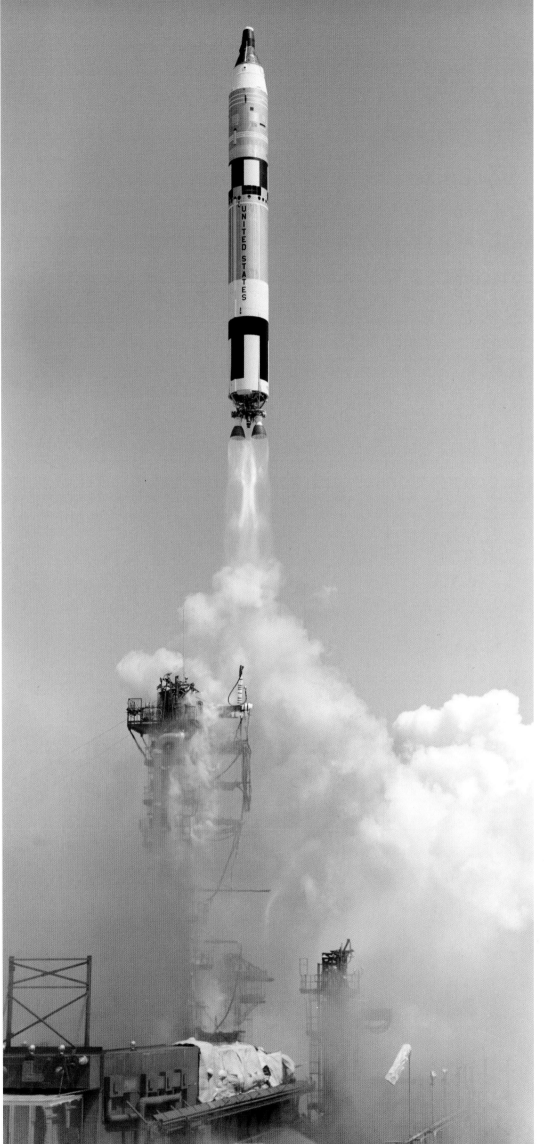

GEMINI

MISSION CONTROL
CENTER

PAVELKA, E.L.JR.
NAME

7

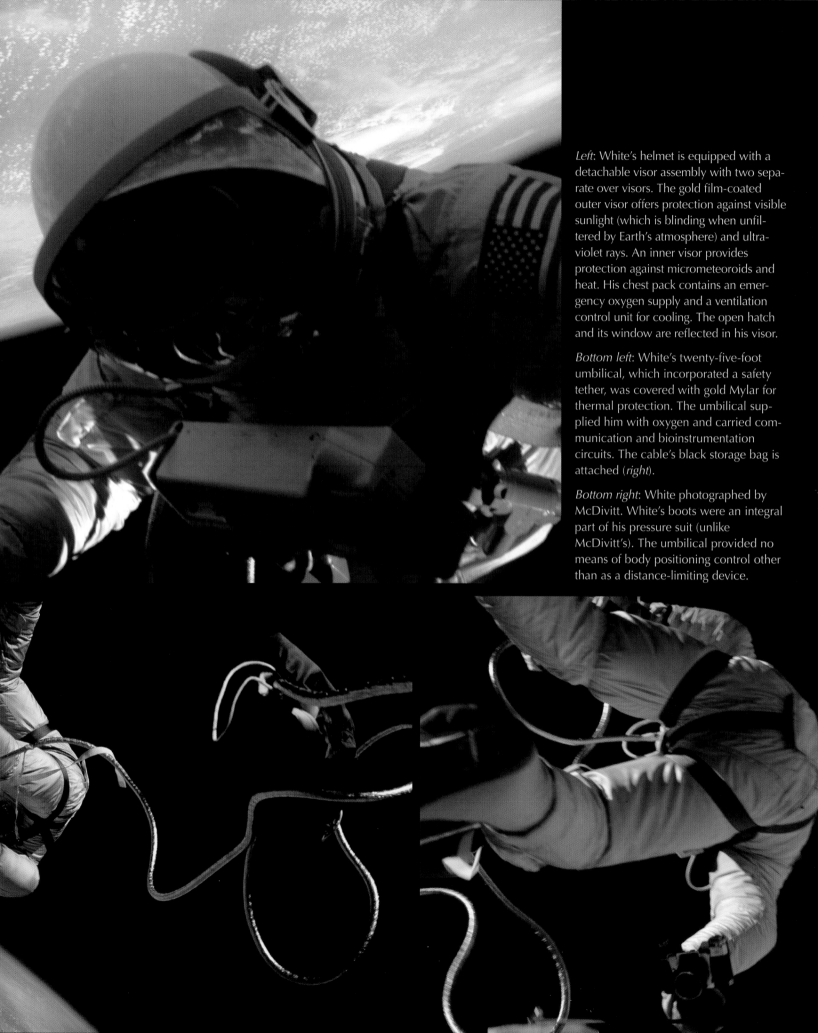

Left: White's helmet is equipped with a detachable visor assembly with two separate over visors. The gold film-coated outer visor offers protection against visible sunlight (which is blinding when unfiltered by Earth's atmosphere) and ultraviolet rays. An inner visor provides protection against micrometeoroids and heat. His chest pack contains an emergency oxygen supply and a ventilation control unit for cooling. The open hatch and its window are reflected in his visor.

Bottom left: White's twenty-five-foot umbilical, which incorporated a safety tether, was covered with gold Mylar for thermal protection. The umbilical supplied him with oxygen and carried communication and bioinstrumentation circuits. The cable's black storage bag is attached (*right*).

Bottom right: White photographed by McDivitt. White's boots were an integral part of his pressure suit (unlike McDivitt's). The umbilical provided no means of body positioning control other than as a distance-limiting device.

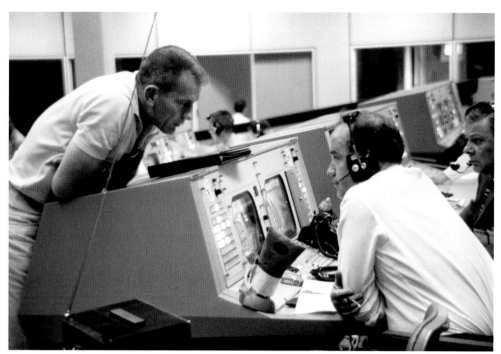

Above: White's photo of the adapter section at the aft end of the spacecraft shows two of the eight OAMS engines. The painted black stripes help control temperatures in cooling tubes underneath the magnesium skin. White reported he set foot on the adapter.

Top right: Director of Flight Crew Operations Deke Slayton confers with Paul Haney in the Mission Operations Control Room (MOCR) 2 during Gemini IV. Haney, chief of public affairs at MSC, provided mission commentary for the media. The television (*lower left*) received local Houston TV broadcasts. Public Affairs Officer Al Alibrando is also pictured (*far right*).

Center right: Pat McDivitt, right, briefly speaks with her husband at the flight director's console in MOCR 2 as Pat White listens in on June 4. As the spacecraft passed over Texas, McDivitt told her husband their young children thought he was still in Cocoa Beach. It was the first time family members spoke with astronauts during a mission.

Bottom right: The new MOCR 2 at MSC on May 30, 1965, during a final flight simulation before Gemini IV. The four-day flight was not only the first use of the Houston facility, but it also required three shifts of flight controllers. Second shift Flight Director Chris Kraft (*seated fourth from left*) points to a document on his console as John Hodge, Gemini IV's third shift (overnight) flight director, stands behind him. Two large rear projection screens show the Atlantic recovery area (*left*) and the spacecraft's location. The four launch performance chart plotters below the screens (*right*) are temporary holdovers from the MCC at Cape Kennedy until managers gain confidence in the projection screens.

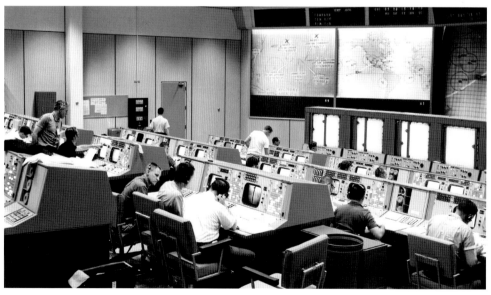

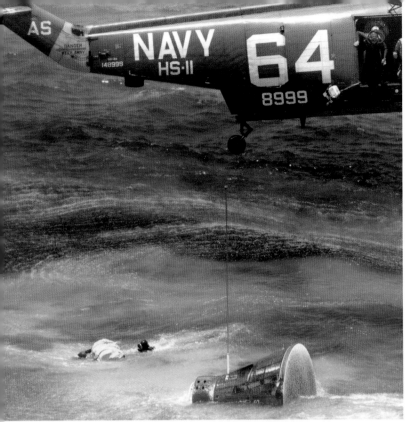

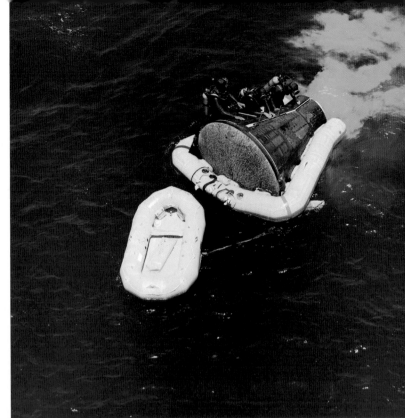

Top left: A Sikorsky SH-3A *Sea King* from Helicopter Antisubmarine Squadron 11 (HS-11) hovers over Gemini IV in the Atlantic northeast of the Bahamas as navy divers prepare to attach the flotation collar to the spacecraft.

Top right: With the collar in place and a life raft ready, a diver inserts the recovery hatch handle (which had been stowed on the spacecraft's main parachute adapter assembly) into a fitting to open McDivitt's hatch. The green marker dye was automatically released from the spacecraft when the dye package made contact with the water.

Left: White inspects Gemini IV on the hangar deck aboard USS *Wasp* on the night of June 7. Two stick antennas are still deployed between the open hatches: the antenna closest to White was used for telemetry and voice communications during descent, while the antenna to the right was for the recovery radio beacon. An outer panel of the RCS section has been removed for hypergolic fuel safing (*bottom left*), exposing four of the sixteen Rocketdyne SE-6 thruster nozzles blackened from firing.

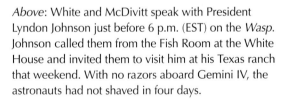

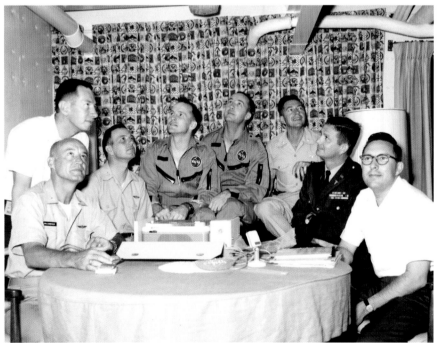

Above: White and McDivitt speak with President Lyndon Johnson just before 6 p.m. (EST) on the *Wasp*. Johnson called them from the Fish Room at the White House and invited them to visit him at his Texas ranch that weekend. With no razors aboard Gemini IV, the astronauts had not shaved in four days.

Top right: White and McDivitt walk down a red carpet as they disembark the *Wasp* at Naval Station Mayport, Florida, on June 10 after three days aboard the aircraft carrier. They carry 16mm film of White's EVA developed on the ship. About two thousand people showed up to welcome them and see them leave for Houston.

Bottom right: White and McDivitt pause for a ship's announcement during their medical debriefing aboard the *Wasp*. The session is being preserved on the Italian Geloso reel-to-reel tape recorder on the table. Dr. Howard Minners (*left, white shirt*) and Dr. Charles A. Berry (*far right*) are also pictured. The astronauts received a congratulatory telegram from cosmonaut Yuri Gagarin, the first man in space, while aboard the ship.

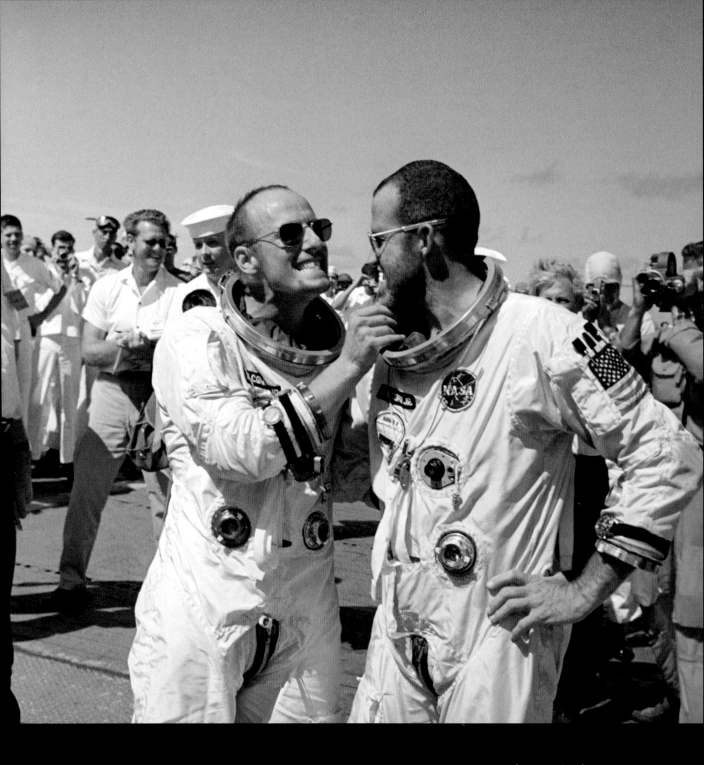

Pete Conrad tugs at Gordon Cooper's chin on the deck of the aircraft carrier USS *Lake Champlain* around 9:25 a.m. (EST) on August 29. Jane Conrad described the scene as "Frankenstein meets the Wolf Man."

Gemini V

August 21–29, 1965

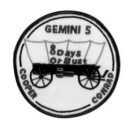

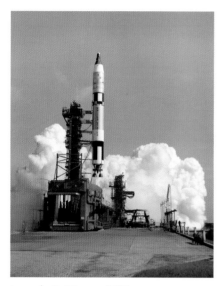

Launch: 9:00 a.m. (EST)

J ust eleven weeks after Gemini IV, thirty-eight-year-old USAF Lt. Col. L. Gordon Cooper Jr. and thirty-five-year-old US Navy Cmdr. Charles "Pete" Conrad began a planned eight-day flight (the duration of a round-trip moon mission). It was the first flight with a radar system to rendezvous and dock with another spacecraft and to generate electricity and water from fuel cells—both critical for subsequent Gemini flights to successfully pave the way for Apollo; previous flights had relied on batteries only.

Cooper, the mission's commander, became the first person to orbit Earth for a second time. He designed a patch in the tradition of military flying units—a first for a manned space flight. It featured a covered wagon bearing the motto "8 Days or Bust." But after NASA Administrator James Webb argued anything less could be seen as a failure, the mottos on the patches on their space suits were covered up.

On August 19, 1965, a computer malfunction and approaching thunderstorms meant a launch scrub. The mission got underway two days later from LC-19 after a problem-free countdown but soon ran into problems.

To test the rendezvous and navigation system, Gemini V planned to meet up with a small Rendezvous Evaluation Pod (REP) Conrad released during the second orbit. But soon the astronauts noticed that the pressure in the oxygen supply tank for their fuel cells was falling. They abandoned the rendezvous test, powered down the spacecraft, and realized the flight might quickly come to an end.

Flight Director Chris Kraft had his first major problem at Houston's Mission Control Center. He knew the spacecraft had enough battery power for reentry but wanted to know if the flight could make it to the next landing opportunity on the sixth orbit.

During the fourth orbit, however, the oxygen tank pressure stabilized and Kraft was told the batteries were good for thirteen more hours. McDonnell reported its tests in St. Louis to establish the lowest working pressure for a fuel cell were going well, so Kraft approved the fight to continue for at least one day.

During the second shift, Flight Director Gene Kranz and his controllers decided it would be safe to operate the cells at higher power. The pressure remained stable, but it had been a harrowing first day for Gemini V. Conrad drew a covered wagon halfway over a cliff on the instrument panel.

Since the REP's batteries were exhausted after five hours, Mission Control developed alternatives and four rendezvous radar tests were conducted starting on orbit fourteen on the second day. The crewmen then reduced power consumption again, and with the inertial guidance platform off began to

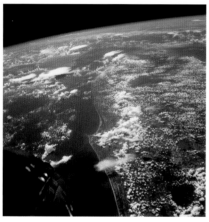

Earth view: Florida's east coast

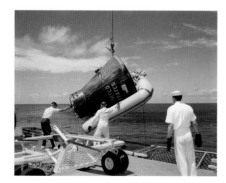

Spacecraft recovery: 11:40 a.m. (EST)

drift in orbit. They conducted operational and experimental tests through the third and fourth days of the mission, but the flight plan was largely out the window.

On the fifth day, more problems cropped up: the orbit attitude and maneuvering system (OAMS) became balky and one thruster quit. Kraft canceled all tests that required fuel, and the crew turned off the electrical system to help reduce the water buildup from the fuel cells. On day six, the entire OAMS became erratic with two failed thrusters. The spacecraft drifted for the rest of the mission (Cooper turned on the system occasionally to stop excessive tumbling). On a limited basis, the astronauts conducted visual acuity and communication tests and terrain photography.

On August 26, the mission became the first US flight to seize the manned space duration record from the Soviet Union set in 1963. During the mission, the Soviets claimed Gemini V was spying on China, Cuba, and Vietnam but offered congratulations at its conclusion.

In the Atlantic, Hurricane Betsy was approaching the planned landing zone, so the mission ended one orbit early as a precaution. Due to faulty data transmitted to the spacecraft from ground computers, Gemini V splashed down in calm seas about eighty-nine miles short of its target. Cooper wanted to stay with the spacecraft until he learned that the carrier was seventy-five miles away. Then he and Conrad took a helicopter to USS *Lake Champlain*.

The astronauts later made a six-nation goodwill tour assigned to them by President Johnson, attending the International Astronautical Federation Congress in Athens, Greece, where they met the crew of Voskhod 2: cosmonauts Alexei Leonov and Pavel Belyayev.

Simultaneous Launch Demonstration manual

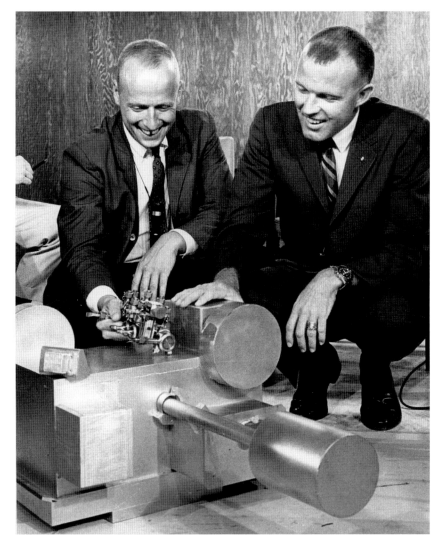

Above: As Cooper (*right*) looks on in Bldg. 6 at MSC, Conrad holds a component next to a full-scale mock-up of the REP, which they would release during their first orbit and try to rendezvous with during the second. Its three antennas, two beacon lights, and radio transponder were essentially identical to those on the Agena target vehicle for future Gemini missions. The mock-up's dipole antenna extends to the right; the large box (*left*) represents a beacon light. The flashing lights exhausted the pod's batteries in about five hours.

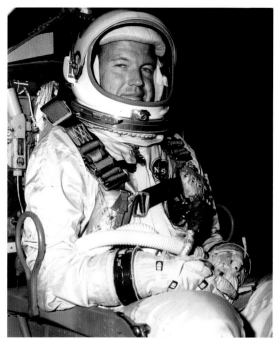

Top: Cooper, strapped to an ejection seat, undergoes weight and balance testing in the Pyrotechnic Installation Building at KSC on July 22, 1965. Next to Cooper's right shoulder is a pyrotechnic mortar, which would eject a metal slug and, in turn, pull out the crewman's pilot and main parachutes in case of emergency ejection from the spacecraft during launch or landing. The entire ejection sequence would take one and a half seconds. The metal loops are elbow restraints.

Bottom: Conrad strikes a comic pose during a 1964 photo session for one of his NASA portraits at MSC. Although many astronauts were known for their sense of humor, Conrad was legendary for his pranks, informality, and comic outlook.

Top left: The first and second stages of Gemini V's Titan II arrive at LC-19 on June 7, 1965, from Hangar U to be rolled into the horizontal erector. The block-house can be seen in the distance (*center*). A WFGA-TV van (a former bread truck) provides facilities for NBC's coverage (*right*). The Jacksonville, Florida, station was the first to air a live launch from Cape Canaveral on October 11, 1958, and provided the on-site transmission facilities for NBC during Mercury and Gemini.

Top right: Gemini V is moved from the Spacecraft Checkout Facility at Cape Kennedy to LC-19 on June 18, 1965.

Bottom left: McDonnell technicians supervise hoisting the spacecraft to the top of the erector on June 28. Its cryogenic storage tanks are visible inside the adapter section.

Bottom right: The spacecraft and its Titan II booster at Pad 19 during the program's first Simultaneous Launch Demonstration on July 22. The test (conducted with Gemini VI's Atlas-ATV (Agena target vehicle) at LC-14) provided experience counting down two vehicles at the same time, which would be necessary for subsequent Gemini missions and their Agena targets. When the test ended, the Titan's erector could not be raised, and the crew was removed with the cherry picker used during Mercury. Cooper had insisted it be kept available for Gemini.

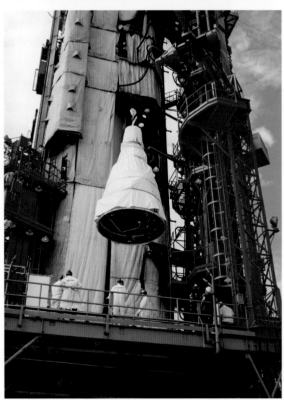

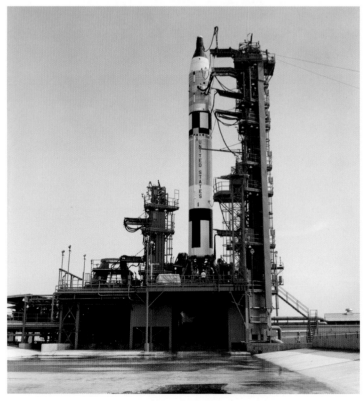

Top left: McDonnell technicians examine the REP (surrounded by gold Mylar insulation) in the rear of Gemini V's adapter section. A fiberglass fabric cover would be attached to the four rods protruding down to provide thermal protection until the pod was released in flight.

Bottom left: Conrad examines a document in the white room at LC-19 as he and Cooper prepare to board Gemini V on launch morning, August 21, 1965.

McDonnell pad leader Guenter Wendt is also pictured (*right*).

Top right: NASA suit tech Clyde Teague removes Cooper's space suit from a storage locker in the MSOB. Teague and colleague Al Rochford covered the "8 Days or Bust" motto on the crew's mission patches at the request of NASA Administrator James Webb in case the flight ended prematurely.

Center right: Conrad in the white room at Pad 19 during a test on August 16, 1965. The Gemini V crewmen wore G4C pressure suits.

Bottom right: Conrad waves to photographers as he follows Cooper into the astronaut transfer van after leaving the suiting trailer at LC-16 on launch morning.

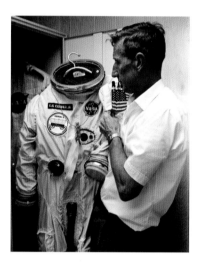

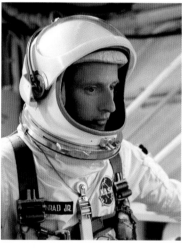

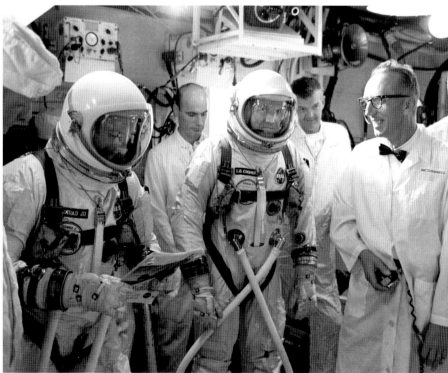

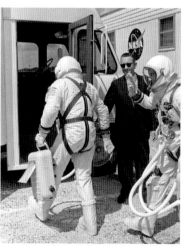

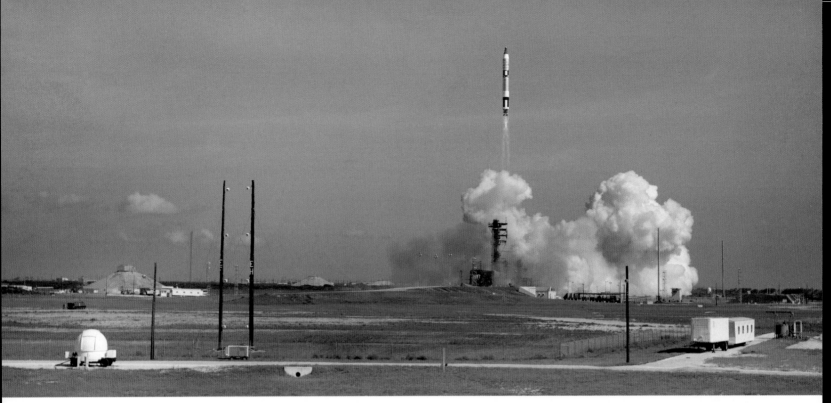

Top: A view of the 109-foot Gemini-Titan II's lift-off at 9:00 a.m. on August 21, 1965, looking north. The LC-19 blockhouse is to the left and the LC-20 and LC-34 blockhouses are in the distance. Poles used to align tracking cameras and a white remote camera pod are pictured to the left.

Center left: Trudy Cooper watches the launch with daughters Janita, fifteen, and Camala, sixteen, from a nearby viewing site. Mrs. Cooper received an aircraft pilot's license before her husband. Mrs. Conrad watched on TV from her home in Timber Cove, Texas.

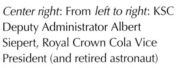

Center right: From *left to right*: KSC Deputy Administrator Albert Siepert, Royal Crown Cola Vice President (and retired astronaut) John Glenn, and NASA Administrator James Webb at the VIP viewing site at Cape Kennedy on launch morning.

Bottom left: Spectators on launch morning line the rocky breakwater at Jetty Park at the north end of the city of Cape Canaveral. This view looks west into Port Canaveral.

Bottom right: A boat from the destroyer USS *Du Pont* with the top half of the first stage of the Titan II 450 miles east-northeast of Cape Kennedy. It was the first booster segment ever recovered and was returned to the Martin Co. for analysis. The second stage remained in low orbit for three days before decaying. A helicopter from the *Du Pont* recovered the crew eight days later.

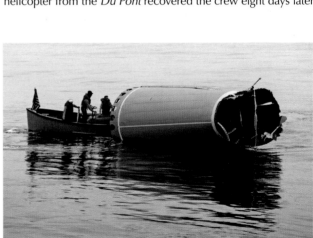

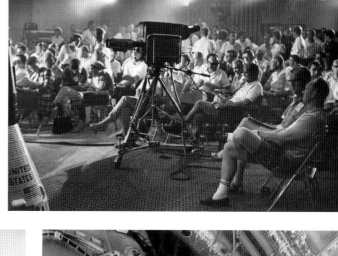

Top right: Journalists wait for the post-launch news conference in the Gemini Room at the Carriage House Motor Lodge in Cocoa Beach. To the left, ABC's Jules Bergman is seated between the man in the madras jacket and Mary Bubb (*right*). Directly behind him stands Sue Butler of the *Daytona Beach Morning Journal*. Butler and Bubb were the first women reporters assigned to the Cape. The resort's bar was named the Press Room Lounge. An RCA TK-31 black-and-white TV camera is also pictured (*center*).

Center left: Gemini V backup astronauts Elliot See (*left*) and Neil Armstrong discuss the flight's fuel cell problems in the MOCR on the afternoon of August 21. See and astronaut Charles Bassett, the original crew for Gemini IX, died on February 28, 1966, when their jet crashed into the McDonnell building in St. Louis where Gemini spacecraft were built.

Center right: Gemini V's two drum-shaped fuel cells are stacked inside the spacecraft's adapter section in this pre-flight photo. To the left is a maneuvering system fuel tank; the sphere at bottom is the crew's primary oxygen supply.

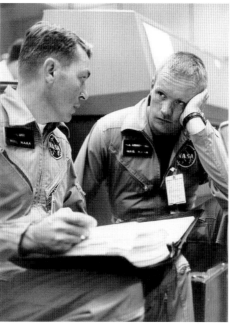

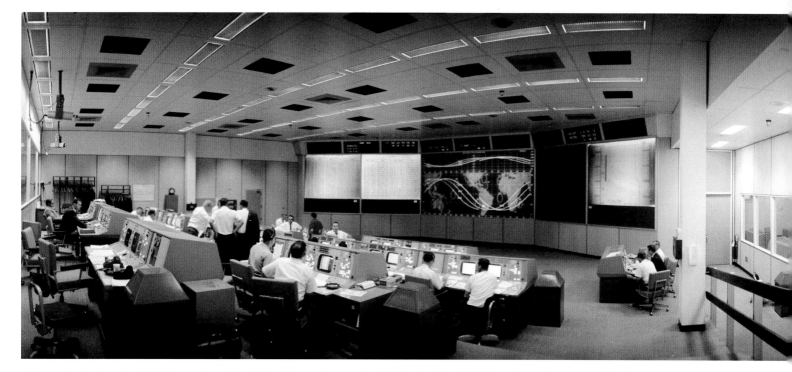

Above: Controllers in MOCR 2 confer at the flight director's console (*left*) during Gemini V. The chart plotters used during Gemini IV and for the Gemini V launch at the front of the room have been removed. The separate console (*far right*) was for maintenance and operations and was responsible for the performance of the MOCR equipment. This was the first Gemini launch that did not use the old Cape Canaveral MCC as a backup.

Cape Kennedy as seen from Gemini V orbiting about one hundred miles high. The launch complexes along Missile Row are visible. During their fifth day in orbit, the astronauts saw a Minuteman missile launch from Vandenberg AFB, California; a rocket sled test as they flew over Holloman AFB, New Mexico; and their prime recovery carrier, the *Lake Champlain*, with a destroyer astern in the Atlantic Ocean.

Above: Conrad works with Experiment D-6 to investigate an astronaut's ability to acquire, track, and photograph terrestrial objects. The window-mounted camera is a 35mm Zeiss Contarex single lens reflex with interchangeable lenses. Although considered successful, cloud cover hampered some observations. He wears a lightweight communication headset first used on this flight.

Right: Jane Conrad (*left*) and Trudy Cooper at the flight director's console in MOCR 2 after splashdown on August 29. They spoke with their husbands while they were on board the recovery carrier *Lake Champlain*. NASA officials are (*from left*) Gemini Test Operations Manager Scott Simpkinson, Flight Director Chris Kraft, Associate Administrator for Manned Space Flight George Mueller, and Gemini Program Director Charles Mathews.

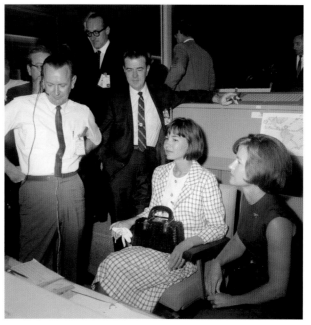

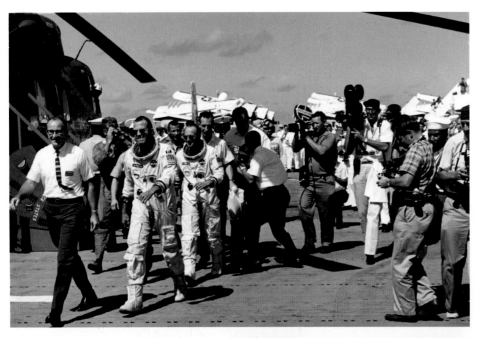

Top left: Cooper and Conrad on the deck of the *Lake Champlain* head toward showers and seven hours of medical exams after eight days in space—a record the Soviets would not break for five years. The TV networks broadcast Polaroid photos of the scene less than a minute later using an ITT data transmission technology dubbed Videx. Leading the way is John Stonesifer (*left*), team leader of MSC's Landing and Recovery Division. NASA's Dr. Howard Minners is behind Conrad.

Center left: Aboard the *Lake Champlain*, Conrad and Cooper speak with President Johnson at his Texas ranch. He told the crew plans were made for them to travel internationally to share their achievements since "our only purpose in space is peace in the world." Four days earlier, Johnson ordered the Department of Defense to proceed with an USAF-manned space laboratory (subsequently canceled) for military reconnaissance.

Center right: Conrad's sketch on the center console of Gemini V's instrument panel of a covered wagon—the flight's symbol—on the edge of a cliff. To the left is the main parachute deploy button cover with a hand-lettered "8 Days or Bust" label, the mission's unofficial motto.

Bottom: Conrad and Cooper cut the sheet cake the *Lake Champlain*'s galley prepared, using ceremonial swords (a military tradition at special events). Conrad had made his first jet aircraft carrier landing on the ship in June 1955. The recovery was the ship's last major assignment and it was scrapped in 1972.

Above: Conrad and Cooper speak in Houston on September 14, 1965, before departing with their families for Washington, D.C., where President Johnson awarded them NASA's Exceptional Service Medal at the White House. He also promoted Cooper to USAF colonel and Conrad to US Navy commander. The crewmen also visited Congress before departing for a tour of Europe and Africa.

Top right: The crewmen each received a stainless steel model of their Gemini-Titan launch vehicle at the event, plaques bearing the Gemini program insignia, and the two brass identification plates from their spacecraft.

Bottom right: At a party at the Cocoa Beach Ramada Inn on October 15, 1965, are (*left to right*) Wally Schirra, Wendt, Conrad, Deputy Director of Launch Operations G. Merritt Preston, Cooper, suit tech Joe Schmitt, Tom Stafford, McDonnell Base Manager Ray Hill, backup Gemini V commander Neil Armstrong, McDonnell engineer Fred Sanders, and Col. John G. Albert, chief of the Gemini Launch Division at the 6555th Aerospace Test Wing at Patrick AFB. Schirra and Stafford were scheduled for launch ten days later aboard Gemini VI.

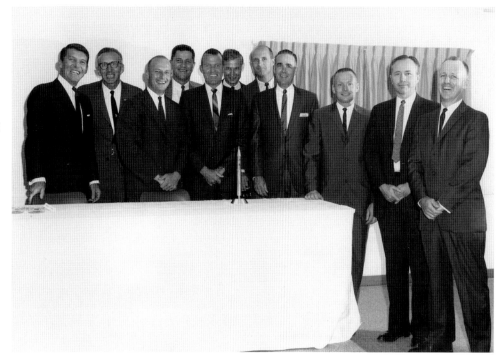

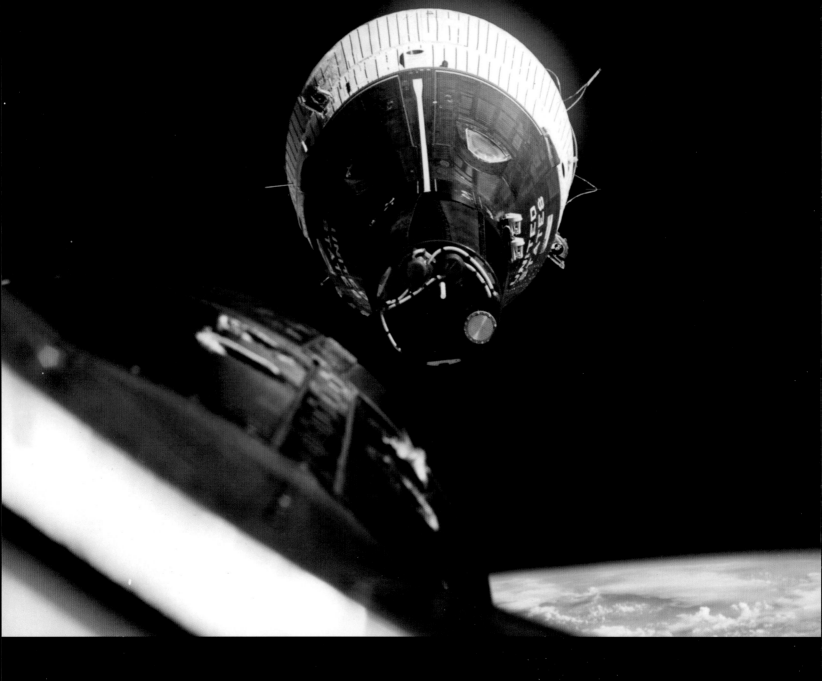

Tom Stafford took this photo of Gemini VII as the two spacecraft made the world's first space rendezvous on December 15, 1965.

Gemini VII and Gemini VI-A

December 4–18, 1965
December 15–16, 1965

Launch: 2:30 p.m. (EST)

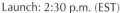

The December 1965 intertwined missions of Gemini VI-A and VII demonstrated NASA's capability and flexibility. Gemini VI—with Mercury veteran Wally Schirra as command pilot and rookie Thomas P. Stafford as pilot—was planned to take the next logical step in the program: draw on the lessons of the previous flights to rendezvous and dock for the first time with an Agena, a fueled upper stage with a rocket engine on one end and a docking port on the other. An Atlas booster would launch it into orbit first and then Gemini VI would launch, catch up to it, dock, and use its engine to maneuver in orbit. These techniques would be essential for Apollo moon landing missions.

The two-day mission (since spacecraft No. 6 was the last battery-powered Gemini) was set to begin October 25, 1965. Schirra and Stafford were strapped into their spacecraft at LC-19 while launch managers also counted down the Atlas-Agena at LC-14. After liftoff, the Agena separated from its launch vehicle. As its engine ignited, however, its fuel tank exploded, leaving the Gemini VI crew with no orbital target. The dejected astronauts took the pad elevator to the ground, not sure what would happen to their mission.

NASA had previously considered flying two Geminis together, but the concept had never gone beyond the planning stage. After a series of meetings and phone calls among NASA officials, President Johnson made the dramatic announcement three days later: Gemini VI—now called VI-A—would attempt to rendezvous with Gemini VII in orbit. Within twenty-four hours, Gemini VI and its Titan II booster had been removed from the pad and the Gemini VII booster erected in its place.

Gemini VII was planned as a two-week endurance flight and it got underway on schedule on December 4, 1965. Two space rookies were aboard: Command Pilot Frank Borman and Pilot James Lovell. Gemini VI-A was set to join them nine days later, and its Titan II launch vehicle and spacecraft were quickly returned to LC-19.

On December 12, Schirra and Stafford were ready for launch, but 1.5 seconds after ignition, the Titan II's two first-stage engines shut down. The crew should have ejected, but Schirra decided to stay put. "OK," he radioed, "we're just sitting here breathing." An electrical plug had disconnected from the booster prematurely and subsequent analysis also found a plastic dust cover had been left in one engine. Three days later, Gemini VI-A finally was successfully launched into orbit for a flight planned for just more than twenty-five hours to demonstrate a rendezvous with Gemini VII.

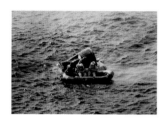

Splashdown: 10:29 a.m. (EST)

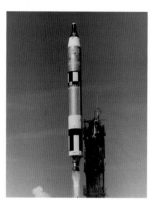

Launch: 8:37 a.m. (EST)

Splashdown: 9:06 a.m. (EST)

Schirra and Stafford, in the active spacecraft, spent six hours catching up with Borman and Lovell. The two spacecraft flew together for more than five hours, coming as close as one foot from each other—nose-to-nose.

Gemini VI-A splashed down on December 16 while Borman and Lovell continued their two-week orbital marathon, which would be the longest space flight for the next five years. They wore a new lightweight version of the Gemini space suit, which could be removed more easily in the cramped confines of their cabin. But after the VI-A crew departed (and with three days left in space), the fun was over and the mission began to drag. Lovell later agreed with astronaut John Young's preflight comparison to spending "two weeks in the men's room."

During 1965, NASA had orbited ten astronauts and achieved most of the Gemini program's goals—a long-duration space flight, an EVA, a rendezvous, and controlled reentries—all critical to the success of Apollo. Although it was not apparent at the time, the United States' lead in the Space Race had become virtually insurmountable. And although the Apollo 11 mission was still almost four years away, the Soviet Union's space program, plagued by technical problems, would offer little competition during that time to land the first person on the moon.

Opposite page, top left: Stafford and Schirra during a portrait session at KSC on October 20, 1965. Both astronauts wear standard G4C space suits.

Opposite page, top right: Stafford holds the first crew emblem for what was originally known as GTA-6 before a weight and balance test at KSC's Pyrotechnics Installation Building on September 27, 1965.

Opposite page, bottom: Gemini VI backup command pilot Gus Grissom samples food prepared for the flight in the MSOB crew quarters on September 25, 1965. Gemini VI carried the same rehydratable and bite-sized food used on previous Gemini flights.

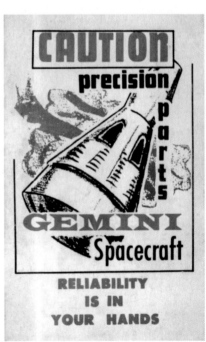

Left: Wally Schirra (*left*) and Stafford take questions at a news conference in Bldg. 6 at MSC on October 28, 1965. A Gemini-Titan II model is pictured at far left.

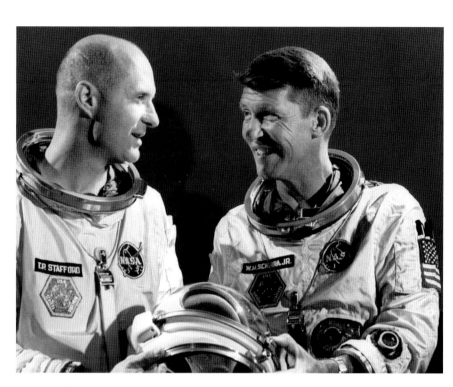

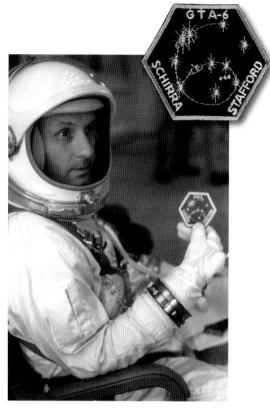

Gemini VII and Gemini VI-A

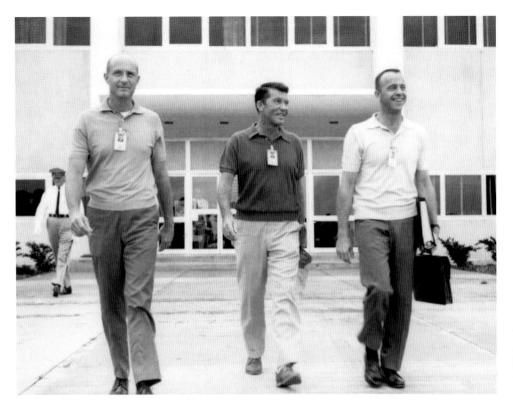

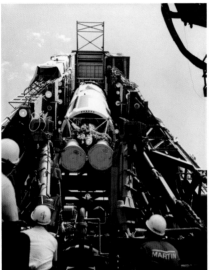

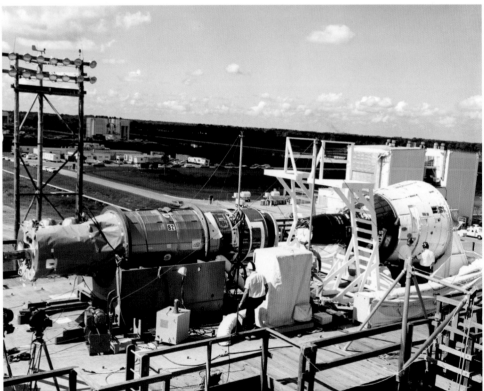

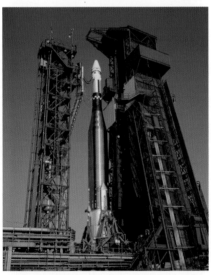

Top left: Stafford and Schirra, accompanied by Alan Shepard, leave the MSOB on October 7, 1965. The men then drove to LC-16's suiting trailer and participated in the CDDT at LC-19.

Bottom left: The radar and communication systems of the ATV and Gemini VI undergo tests at the Merritt Island Launch Area Radar Range Boresight Tower on August 25, 1965. The fifty-foot "Timber Tower" was part of KSC's Radio Frequency Test Systems site.

Top right: Pin of Lockheed's ATV logo

Center right: Martin Co. personnel monitor operations as the first stage of the Titan II (suspended by cables) is lowered from the LC-19 erector onto the gray thrust mount. The stage's twin LR-87–7 engines (built by Aerojet General) burned Aerozine-50 with nitrogen tetroxide as an oxidizer. This stage developed 430,000 pounds of thrust.

Bottom right: The Agena upper stage (Gemini VI's original rendezvous target) is atop its Atlas booster at LC-14 on the morning of October 25, 1965, with the pad's umbilical tower (*left*) and its Mobile Service Structure (*right*).

Above: Martin badge

Top center: Stafford in the suiting trailer at LC-16 on October 25, 1965—the first of three launch attempts for the mission. He wears a set of sterling silver USAF senior pilot wings above the NASA insignia.

Top right: Schirra in the suiting trailer before the countdown rehearsal for the second launch attempt on December 8, 1965

Center right: The first stage of Gemini VI's Titan II is lowered into the erector at LC-19 on October 28. A launch attempt three days earlier was scrubbed after the ATV stage Gemini VI was to dock with exploded six minutes after launch. Following the decision to have two Gemini spacecraft rendezvous instead, Gemini VII's Titan was erected at the pad less than twenty-four hours later.

Bottom center: Following Gemini VII's launch, this spacecraft and booster— now designated Gemini VI-A—were returned to the pad. Its second launch attempt on December 12 (*pictured at right*), however, ended with an abort immediately after the first stage had ignited at 9:54 a.m. (EST). From orbit, the crew of Gemini VII saw the booster come to life and shut down.

Bottom right: Gemini Project Manager William Schneider is interviewed by a TV reporter outside Bldg. 30, the Mission Control Center at MSC, after the aborted Gemini VI launch attempt on December 12.

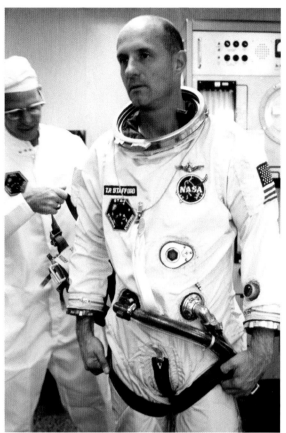

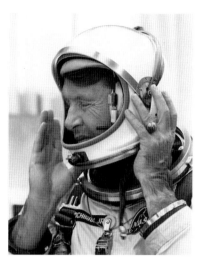

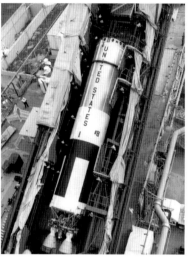

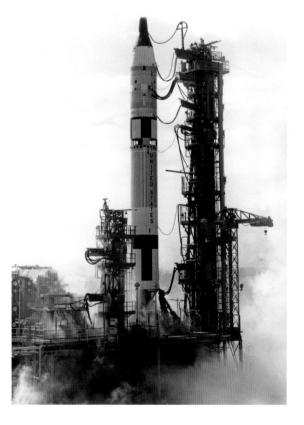

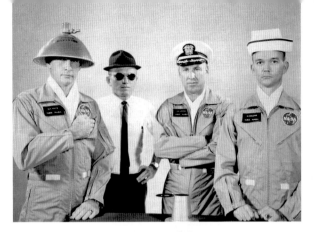

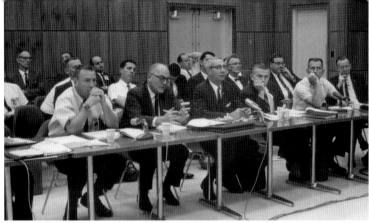

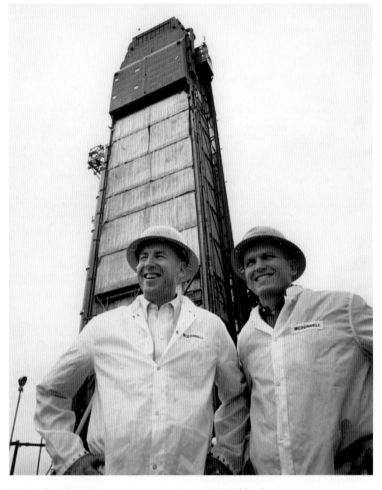

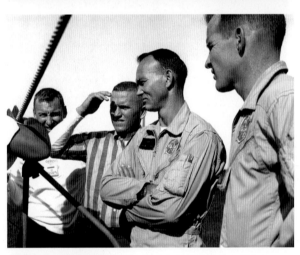

Top left: The prime and backup crews in a comic pose on July 1, 1965, at MSC. *Left to right*: Ed White, backup command pilot; Frank Borman; Jim Lovell; and Mike Collins, backup pilot.

Center left: An MSC representative comes down the slide wire designed for emergency evacuation from the white room at the top of the LC-19 erector on November 23, 1965. It took eighteen seconds to reach the ground, ending five hundred feet from the pad. *Left to right*: Collins, KSC engineer Dick Withrow, Jim Ragusa, Borman, White, Lovell, and a NASA safety man.

Bottom left: Lovell, Borman, Collins, and White are briefed on the slide wire. The steel cable could accommodate three people at a time with an estimated evacuation time of less than five minutes for twenty people.

Top right: The mission review meeting at KSC headquarters on November 18, 1965, set Gemini VII's launch date as December 4. *Front row, left to right*: Lovell; unidentified; Ken S. Kleinknecht, deputy manager of the MSC Gemini Program Office; Borman; Slayton; and Scott H. Simpkinson, Gemini test operations manager at MSC. Kraft (*not seen*) and Haney (*arm up by the door*) had disarmed a teenager on the flight to the meeting from Houston to Melbourne, Florida, who claimed he was hijacking the DC-8 jet to Cuba. He fired eight shots into the cabin floor from two pistols after pointing one at Kraft's head.

Bottom right: Lovell and Borman on the ramp at LC-19 on December 3 after a visit with the backup crew running tests in the spacecraft. Forecasters were optimistic clouds would clear before launch the next day. The Soviets had launched Luna 8 earlier that day—their eleventh unsuccessful attempt at an unmanned moon landing. In February 1966 Luna 9 would succeed—a feat matched by the United States in June with Surveyor 1.

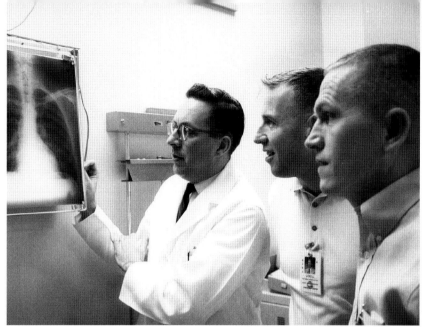

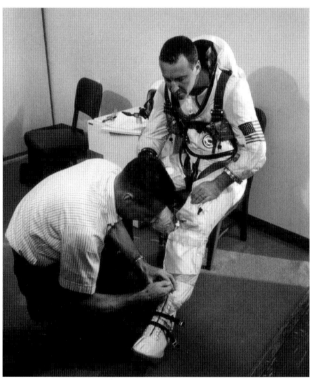

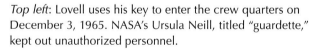

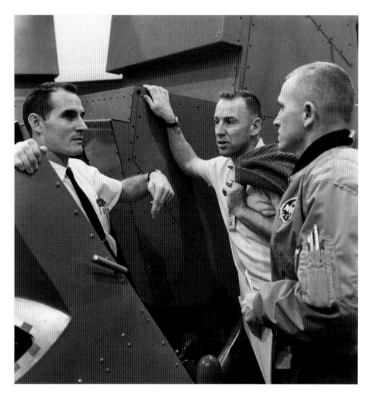

Top left: Lovell uses his key to enter the crew quarters on December 3, 1965. NASA's Ursula Neill, titled "guardette," kept out unauthorized personnel.

Bottom left: Lovell suits up in the old MCC building at the Cape on November 13, 1965, with help from suit tech Clyde Teague before a training run in the Gemini Mission Simulator. He wears a new lightweight G5C suit (used only by this VII crew) with an integral zippered hood and other changes to facilitate in-flight removal.

Top right: Dr. Charles A. Berry, chief of the MSC Medical Operations Office, shows a chest X-ray to Lovell and Borman on December 2, 1965, in the MSOB. Berry was a former USAF physician who had been involved in selecting the Mercury astronauts. He convinced NASA officials to let the crewmen remove their space suits during the fourteen-day mission—a first.

Bottom right: Lovell and Borman chat with a McDonnell instructor next to the simulator on November 13, 1965. Built by McDonnell, this simulator and its twin at MSC operated on a mix of analog and digital data and were part of the transition between the nearly all-analog Mercury equipment and the nearly all-digital Apollo equipment.

GEMINI
SPACECRAFT
GT-7

8
WHITE ROOM
ACCESS

Top left: Lovell adjusts his cloth soft helmet in the LC-16 suiting trailer on November 15, 1965.

Top right: Borman wears a crash helmet used inside the G5C suit with twin microphones mounted on each side as he suits on launch morning, December 4.

Center left: Lovell (*foreground*) and Borman in Gemini VII at LC-19 during a test on November 15.

Below: Robert Mosley's countdown book. Mosley was McDonnell's operations chief at Cape Kennedy and chief test conductor.

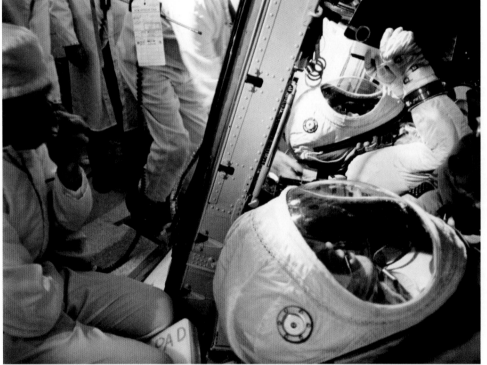

7.6

MASTER COUNTDOWN

MARTIN COMPANY

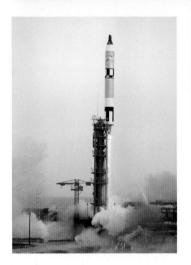

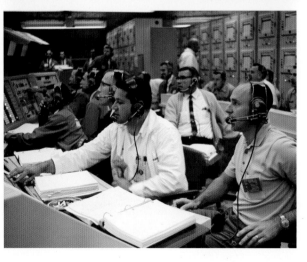

Bottom left: Gemini VII atop its Titan II roars skyward at 2:30 p.m. (EST) on December 4, 1965. This view looks east toward the Atlantic Ocean with the horizontal erector to the right.

Bottom right: The team in the LC-19 blockhouse on launch day. Roy Post, McDonnell systems test engineer (*white jacket*) is flanked by Herman "Fritz" Widick, NASA test conductor (*left*); and astronaut Alan Bean (*right*). Bean counted down the launch for both the Gemini VII and VI-A crews. George Page is center (*wearing tie*). Titan booster personnel wear blue Martin Co. jackets.

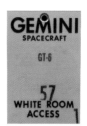

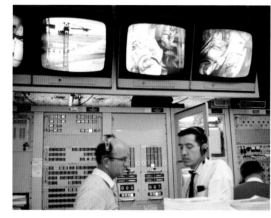

Above: Emergency personnel waited at the "fall-back" area during launch.

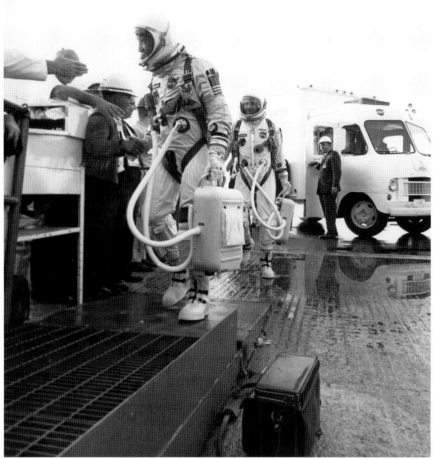

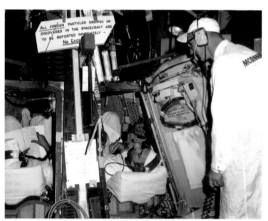

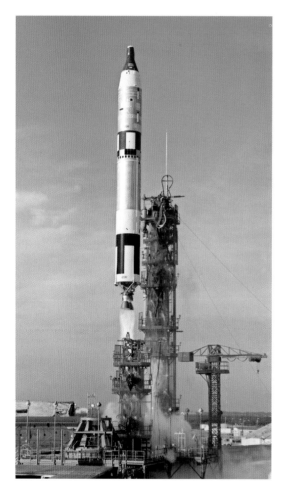

Above: Schirra and Stafford walk up the ramp to the elevator at LC-19 on December 12, 1965, with the crew transfer van to the right. This second launch attempt was scrubbed when the Titan II's first-stage engines shut down moments after ignition because an electrical plug near the tail of the booster disconnected prematurely.

Top right: Engineers in the LC-19 block-house on December 8, 1965, during the full launch rehearsal. The video monitor (*left*) shows a view of the crane in the photo below and the blockhouse; the other two (*right*) show the astronauts and the white room. The crane was used to raise each Gemini spacecraft to ramp level.

Center right: McDonnell pad leader Guenter Wendt (*right*) works with two colleagues in Gemini VI-A's cockpit in the white room on December 7, 1965. The signs reflect the strict monitoring for any foreign objects or possible resulting harm to the spacecraft. The hatch openings are covered with a red sealing material.

Bottom right: Gemini VI-A seconds after launch at 8:37 a.m. (EST) on December 15, 1965, looking west. The gray thrust stand and smaller umbilical tower (*center*) remain from the static test of Gemini I's Titan second stage in 1964.

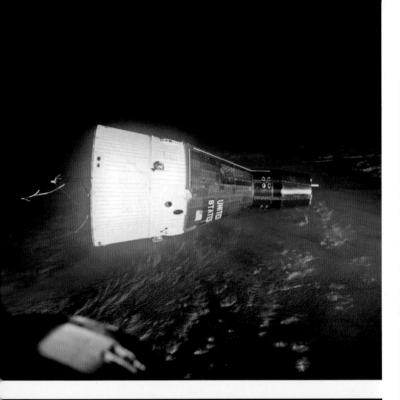

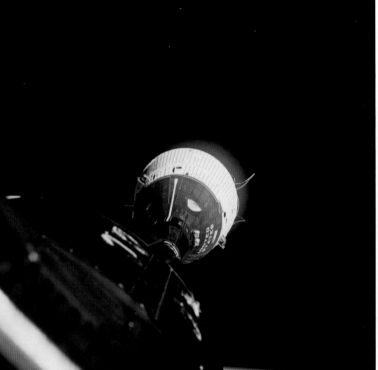

Top left: The Gemini VII spacecraft as photographed by Stafford from Gemini VI-A about 170 miles above the earth on December 15, 1965. Each trails remnants of an explosive cord that severed all connections between the spacecraft and its Titan II when they separated. It took Schirra and Stafford six hours of maneuvering to catch up with Borman and Lovell.

Bottom left: Gemini VII seen from a few feet away. The two spacecraft remained three hundred feet apart or less for more than three revolutions of the earth over five hours. The two small gold protrusions from the white adapter section are cryogenic spectrometer/interferometers, a USAF experiment to obtain spectral irradiance information about terrestrial features and celestial objects.

Top right: Westinghouse Electric Corp. in Baltimore, Maryland, provided the rendezvous radar and transponder system for Gemini.

Center right: Director of Flight Crew Operations Slayton in MOCR 2 on December 12.

Bottom right: Astronaut Elliot See, pictured at the CAPCOM console in MOCR 2 before Gemini VII's launch, served as a CAPCOM throughout the mission. He would lose his life in a jet crash on February 28, 1966.

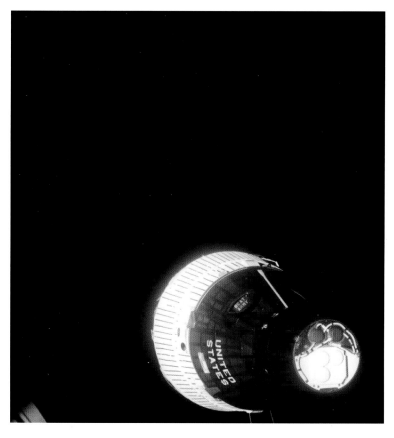

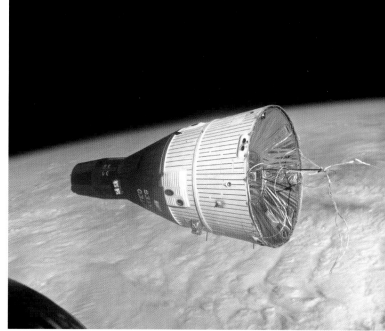

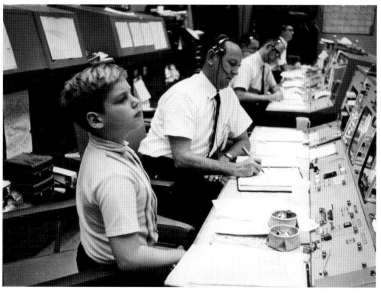

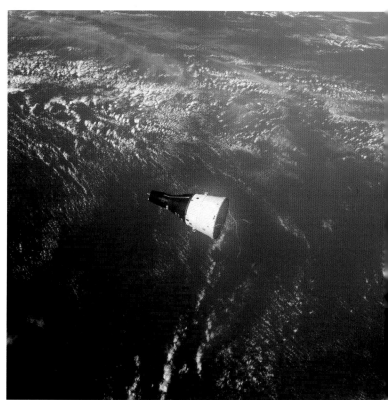

Top left: Aboard Gemini VI-A, Stafford holds a "BEAT ARMY" sign in his window. Stafford and Schirra, and Lovell aboard Gemini VII, were Naval Academy graduates; Borman was a West Point grad. The annual football game between the service academies had ended in a tie weeks earlier.

Bottom left: Lovell's oldest son, James "Jay" Lovell III, sits with Red Team Flight Director Chris Kraft in MOCR 2 on December 11, 1965. He became the executive chef of the Lovell family's restaurant in Lake Forest, Illinois.

Top right: Gemini VII holds its station about forty feet away from Gemini VI-A during the first phase of the rendezvous on Gemini VI-A's sixth orbit.

Bottom right: Gemini VII approximately 122 feet away photographed with a modified 70mm Hasselblad camera during Gemini VI-A's fly-around. During periods of darkness, Schirra and Stafford used the docking light on Gemini VII or its illuminated windows to maintain station-keeping. Once, when its windows weren't visible, they used handheld penlights to light up Gemini VII from about thirty feet away.

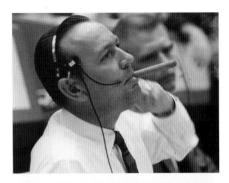

Top left: With White Team Flight Director Gene Kranz (*right*), Kraft celebrates the successful rendezvous at his console in MOCR 2. He wears a Plantronics MS-50 aviation headset, adapted for astronaut use in-flight. It would be Kraft's last Gemini mission: he would then turn his attention to the Apollo program.

Center left: The insulating gold-covered fiberglass on the aft end of Gemini VII's adapter equipment section (ten feet in diameter) shines in the sunlight with its two OAMS engines used for forward translation at top and bottom edges. Gemini VI-A's RCS thrusters are also visible (*lower left*).

Bottom: The gold disc on Gemini VII's nose is its spiral radar transmission antenna. The two black discs above it cover the pilot and drogue parachute mortars. The white stick below them is an ultra high frequency (UHF) stub antenna normally used to transmit and receive voice and telemetry during launch and reentry. The high frequency (HF) whip antenna extending from the adapter section (*left*) was used for voice communication during the mission.

Below: Martin card

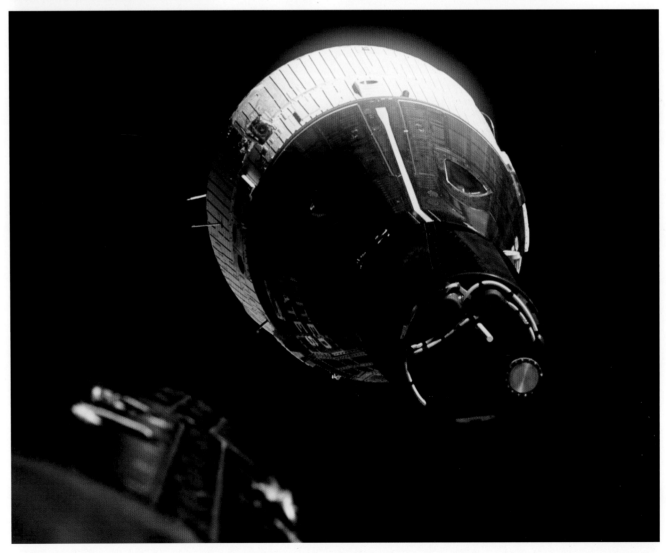

Top right: Aboard USS *Wasp*, Stafford speaks briefly by radiotelephone with his wife, Faye. President Johnson did not call the crew.

Center right: Schirra relaxes shipboard with the Honer Little Lady harmonica he used to play "Jingle Bells" shortly before reentry, as Stafford reported an apparent Santa Claus sighting.

Bottom right: Stafford and Schirra head for medical tests after a welcoming ceremony at the Cape Kennedy Skid Strip on December 17, 1965. Public Affairs Officer Jack King (*second from right, background*) and reporter Mary Bubb (*far left, background*) are also pictured. Some four hundred Cape workers turned out to greet them as they arrived from Bermuda.

Bottom left: Schirra waits in the spacecraft after splashing down within eight miles of the target northeast of Turks and Caicos in the Atlantic Ocean on December 16, 1965. It was the first reentry controlled by the crew and the first to be televised live through a transportable satellite uplink developed by ITT on the deck of the *Wasp*. Intelsat I, the first commercial satellite in geosynchronous orbit, relayed the signal.

Inset: The harmonica and bells are on display at the National Air and Space Museum in Washington, D.C.

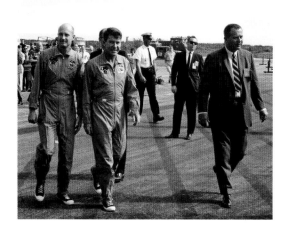

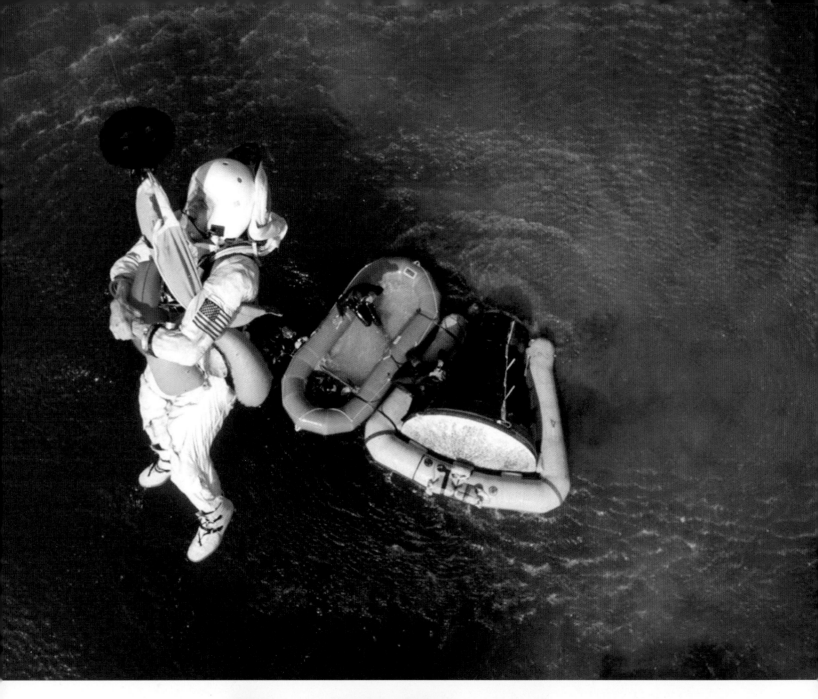

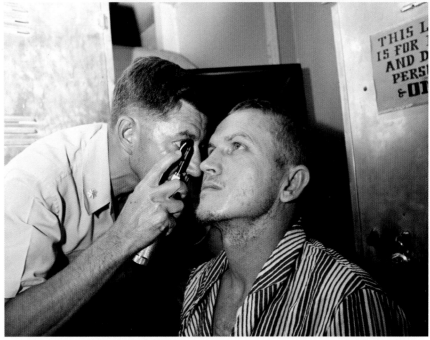

Above: Borman is raised by a sling into a recovery helicopter on December 18, 1965, as navy swimmers from UDT-21 remain with the spacecraft. The heat of reentry left the capsule's ablative heat shield a streaked light gray. Gemini VII landed just more than seven miles from its splashdown target, which was about seventy-five miles northwest of Gemini VI-A's target.

Left: Dr. Howard Minners examines Borman in the *Wasp*'s sick bay. He had secretly slipped a 1793 US large cent into Gemini VII's in-flight medical kit before launch and retrieved it aboard the *Wasp* for a Minneapolis, Minnesota, coin dealer who sold it for $15,000 in 1972.

Chapter 10

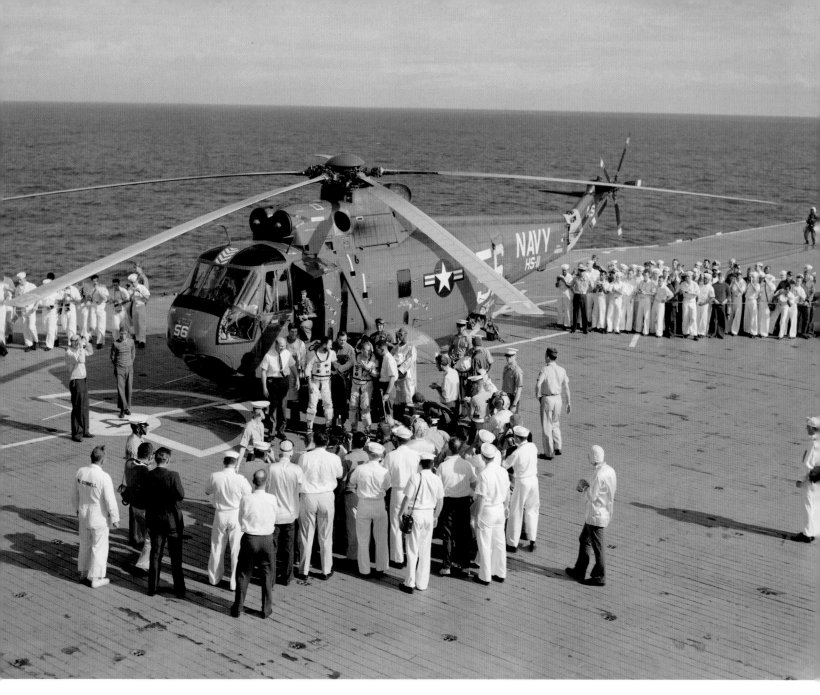

Above: Lovell and Borman arrive on the deck of the *Wasp* at 9:37 a.m. (EST), just thirty-two minutes after splashdown, with the SH-3A *Sea King* helicopter behind them and the news media in front of them. Borman speaks to Minners as Dr. Donald Stullken, chief of NASA recovery operations, stands left of Lovell. Between the two astronauts is Bennett James, NASA public affairs officer.

Near right: Notice for a dinner-dance for Cape workers with both crews in Cocoa Beach on January 21, 1966

Far right: Martin lapel pin

GEMINI VII/VI LAUNCH TEAM

RENDEZVOUS

With

Colonel Frank Borman Captain Walter M. Schirra

Captain James A. Lovell Lt. Colonel Thomas P. Stafford

Friday
January 21, 1966

CAPE COLONY CONVENTION HALL

Dinner Dance

MARK WAYNE QUARTET

Cocktails 6:30 p.m/Dinner 7:30 p.m.

Dancing 9:30 p.m.

Dress: Semi-Formal $ 5.50 Per Person

TICKETS: Lola Morrow, Room 3431, MSO Building 867-6666

Jeri Yannotta, Room 1426, MSO Building 867-6263

June Carson, Room 3373, Hqs. Building 867-7453

- -

Please advise your choice of Club Ticket sales end Wednesday afternoon
Steak or Fish when purchasing ticket. January 19, 1965. All sales final.

SPIRIT of 7&6

GEMINI

MARTIN CANAVERAL

Gemini VII and Gemini VI-A

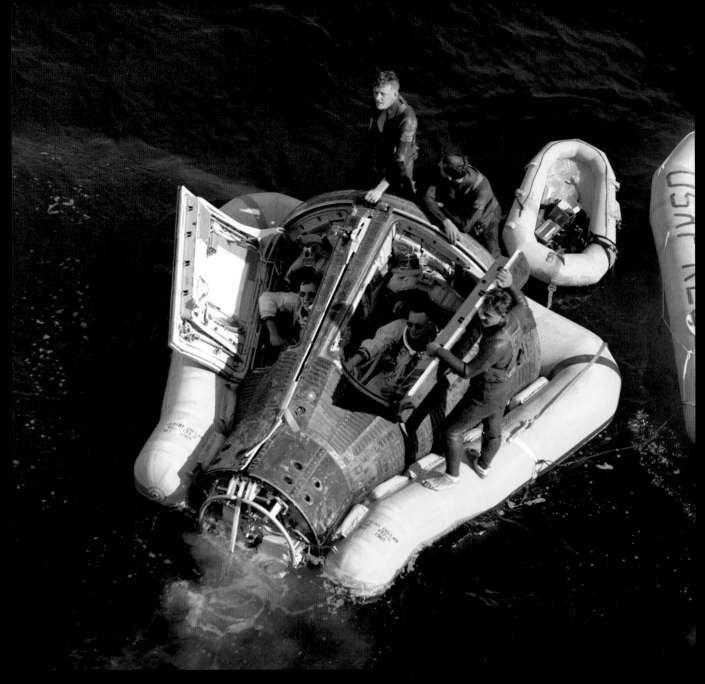

David Scott and Neil Armstrong wait aboard Gemini VIII in calm Pacific waters for USS *Leonard F. Mason* to arrive. The three air force rescue crewmen (*left to right*: S. Sgt. Larry D. Huyett, Airman First Class Eldridge M. Neal and Airman Second Class Glenn M. Moore) parachuted from a HC-54D cargo aircraft based on Okinawa. The astronauts ate lunch and enjoyed the sun, according to another pilot.

Gemini VIII

March 16, 1966

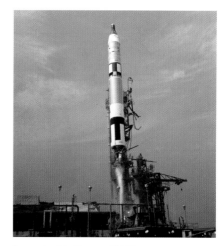

Launch: 11:41 a.m. (EST)

Gemini program managers hoped to finally achieve a docking with an Agena during Gemini VIII. The ATV was launched from LC-14 on its Atlas booster at 10:00 a.m. (EST) on March 16, 1966—an hour and forty-one minutes before Gemini VIII. Just more than five minutes later, the ATV separated and its main engine sent the target into a 185-mile circular orbit.

Gemini VIII's launch from LC-19 at 11:41 a.m. was uneventful. During the first six hours of flight, the astronauts maneuvered to catch up with the ATV from their initial elliptical orbit of 100 to 169 miles up. The two spacecraft docked at 5:14 p.m. for a space first and things seemed just fine for the next twenty-six minutes.

As the docked spacecraft passed over the Indian Ocean (temporarily out of contact with the ground), Scott suddenly noticed his attitude director/indicator showed a roll to the left. Armstrong used the OAMS thrusters to stop the roll, but it started again. Thinking something was wrong with the ATV, Scott turned off its attitude control system. The two spacecraft stabilized, and the problem seemed to be over.

Four minutes later, the rolling began again. Armstrong reported that the OAMS propellant had dropped below 30 percent, a sign that one of the thrusters might be the cause. The astronauts realized that they'd have to undock to figure out what was going on. Scott pushed the undocking button and Armstrong fired the thrusters to separate.

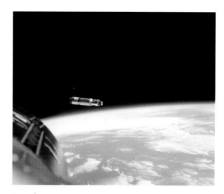

Docking: 5:16 p.m. (EST)

The suspicion about a bad thruster was confirmed when Gemini VIII then began to roll even faster—reaching one revolution per second. The astronauts became dizzy and experienced blurry vision. Armstrong knew he likely only had the RCS left to regain control. After the crewmen switched out the OAMS and cut in the RCS, Armstrong stopped the roll at 6:06 p.m. He then carefully reactivated the OAMS and found that a roll thruster on the adapter section had been stuck open.

But stabilizing the spacecraft had used up 75 percent of the RCS fuel, and mission rules dictated an immediate landing. Blue Team Flight Director John Hodge ordered a rapid deorbit to the secondary landing site in the Pacific Ocean. Scott's planned EVA and other activities were canceled.

Some key personnel were out of touch—something they vowed wouldn't happen again. A NASA aircraft had left Florida for Texas with several senior McDonnell engineers to serve as troubleshooters during the mission. In the future, so many company managers would not be traveling at the same time during a mission.

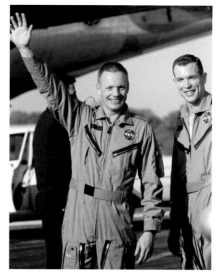

Cape Kennedy return: March 19

George Mueller had also left the Cape for Washington, D.C., and the annual Robert H. Goddard Memorial Dinner (where President Johnson was to receive the Goddard Trophy). When his NASA pilot heard what was happening by radio, the plane returned to the Skid Strip where Merritt Preston met Mueller's party with a motorcycle escort to the old Mission Control Center, arriving in time for retrofire.

At the Goddard dinner, NASA Deputy Administrator Robert Seamans was called to the phone to learn what had happened. He immediately called Mission Control and was told the spacecraft had stopped spinning.

The retro-rockets were fired at 9:45 p.m., and Gemini VIII splashed down in the Pacific Ocean about five hundred miles west of Okinawa at 10:22 p.m. (EST), which was during the day at the splashdown site. Their mission only lasted ten hours and forty-one minutes. The crew was picked up by the *Leonard F. Mason* three hours later on March 16—the only Gemini Pacific recovery.

Their Agena's mission, however, continued. During the next three days, ground controllers started and stopped its main engine eight times, changed its orbital altitude six times, changed its angle to the equator twice, and fired its secondary propulsion engines ten times, using up most of its fuel. Then they waited to see how long the batteries would hold out: eight days. Gemini X would pay the now-dead Agena a visit four months later.

Below: Scott and Armstrong (*left*), the prime crew for Gemini VIII, take reporters' questions in Bldg. 6 at MSC on February 26, 1966, with backup crewmen Pete Conrad and Richard Gordon (*right*). That morning, a Saturn IB launch vehicle successfully orbited the first unmanned Block I Apollo command/service module from LC-34. Two days later, the prime crew for the next Gemini mission, Elliot See and Charles Bassett, would die in a plane crash.

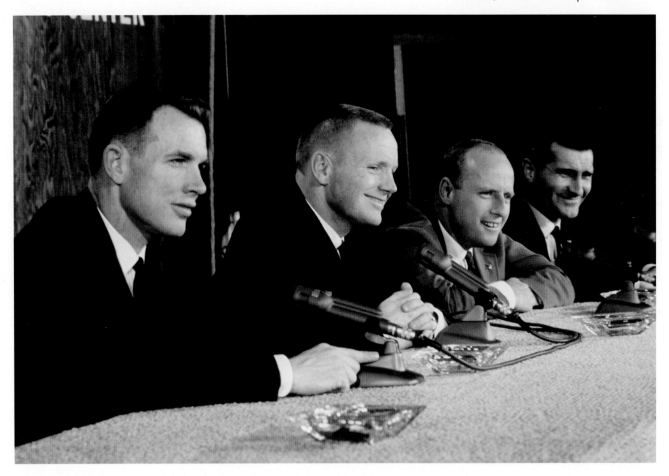

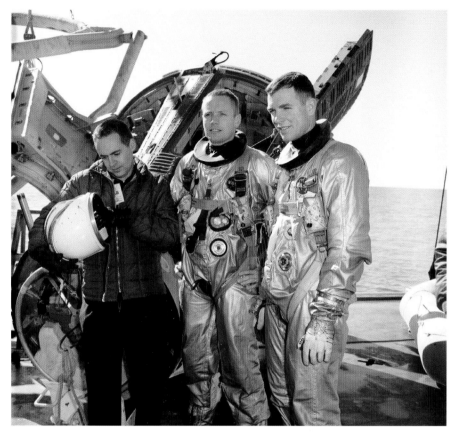

Above: Dr. Kenneth N. Beers of MSC's Flight Medicine Branch checks a helmet as Armstrong and Scott prepare for water egress training aboard MV *Retriever* in the Gulf of Mexico on January 15, 1966. The crewmen wore G4C space suits with minor modifications; here their rubber neck dams are in place. The Gemini reentry module behind them, Static Article No. 5, was used for water training and has its single-point hoist loop deployed at top.

Top right: Thirty-six-year-old Command Pilot Armstrong during weight and balance testing at the Cape on February 21, 1966. The first civilian named to a flight crew, he was a former X-15 test pilot who joined NASA in 1962. Armstrong had flown seventy-eight missions during the Korean War as a US Navy ensign. After three years at Edwards AFB, he was selected in 1958 for the US Air Force's Man in Space Soonest program.

Bottom right: Thirty-four-year-old pilot Scott on launch morning, March 16. The air force was in Scott's blood. Born at Randolph AFB in San Antonio, Texas, his father was a retired USAF general and his wife, Lurton, was the daughter of a retired USAF brigadier general.

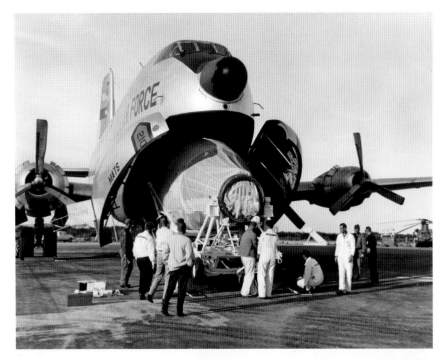

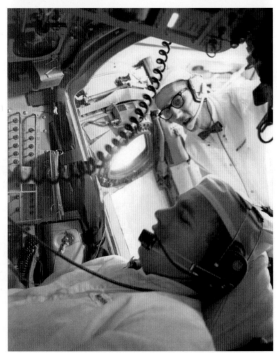

Top left: McDonnell Aircraft engineers off-load the Gemini VIII spacecraft (minus its rendezvous and recovery and RCS sections) from a Douglas C-124 *Globemaster II* at the Cape Kennedy AFS Skid Strip after arriving from Lambert Field in St. Louis, Missouri, on January 8, 1966. Both Titan II stages arrived the week before.

Center left: Workers prepare to install the engine in Gemini VIII's Agena target vehicle at Lockheed Missiles and Space Co. in Sunnyvale, California. The engine, produced by Bell Aerosystems Co. of Buffalo, New York, was modified after the Gemini VI failure on October 25, 1965.

Top right: Gemini VIII, covered in a plastic shroud, is lifted into position on the northwest side of the launch stand at LC-19 on January 31, 1966, with a five-ton bridge crane at the top of the white room. The spacecraft was then swung in through the side door of the white room above the booster.

Bottom right: Scott in the pilot's couch during a communications check while the spacecraft is in the white room at LC-19. Guenter Wendt peers in to the right. The twenty-four-hour clock is in the upper left. The switch and circuit breaker panel (*center left*) includes controls for the Agena's power and lights; a portion of the emergency release button is at the left edge of the frame (*bottom left*).

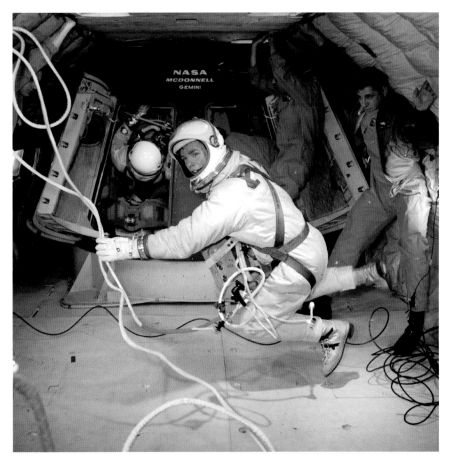

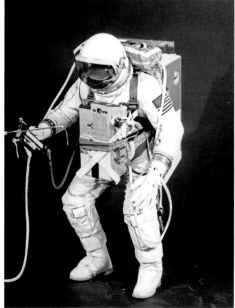

Above: Fred Spross of the MSC Crew Systems Division models Scott's complete EVA gear on January 18, 1966, including the first use of the ELSS, the extravehicular support pack (ESP) on his back and an HHMU similar to Ed White's on Gemini IV. The ESP evolved into the Astronaut Maneuvering Unit used on the next flight.

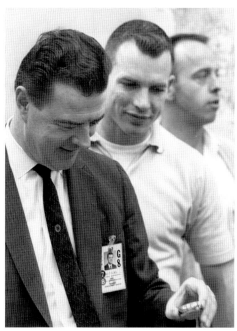

Top left: Scott tests out the initial stages of his planned two-hour-and-forty-minute EVA while weightless aboard a modified USAF Boeing KC-135 *Stratotanker* on February 18, 1966. He wears an extravehicular life support system (ELSS) on his chest connected to a tether supplying oxygen and electricity. The training flights were based at Ellington AFB.

Bottom left: Scott and Armstrong after their final preflight news conference at MSC on February 26, 1966

Above: Gemini Program Manager Charles Mathews, Scott, and Shepard at the launch readiness review in the MSOB on March 15, 1966, that cleared the launch for the following morning

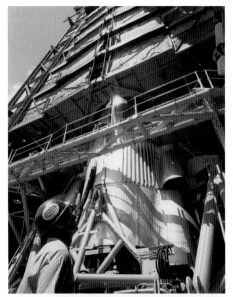

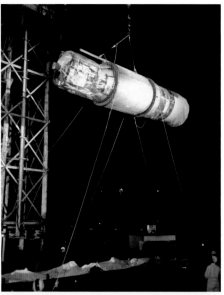

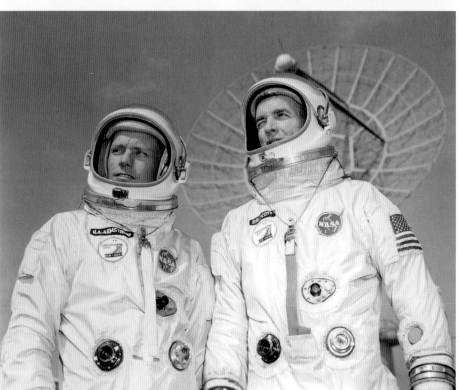

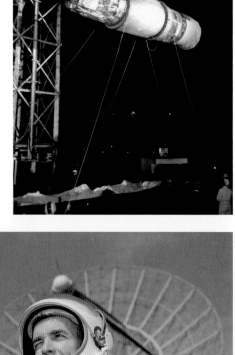

GEMINI TARGET
G-VIII

SERVICE

25

Top left: A General Dynamics worker at LC-14 with the Agena's Atlas SLV3 booster on its launcher with the service tower in place on March 14, 1966.

Top center: Gemini VIII's Agena D is raised onto the "Timber Tower" at the KSC Boresight Range on January 24, 1966, for radio frequency checks. Agena was first developed in the late 1950s as an upper stage for the first American reconnaissance satellites, the Corona series.

Top right: The ATV atop its Atlas at LC-14 on March 4, 1966. The nose fairing has not yet been mated. Complex 14 underwent extensive modifications beginning immediately after Cooper's MA-9 launch in May 1963, for its role during Gemini, including adding a new umbilical tower with a retractable boom (*left*). The Mercury Service Structure (*right*) was also modified.

Above: Armstrong and Scott pose near the former Mission Control Center at Cape Canaveral AFS on March 11, 1966. They'd just passed a lengthy medical exam, and would spend the afternoon in the Gemini simulator. Britain's Prince Phillip, on an eleven-day US tour, dropped by the MOCR for about thirty minutes. He also successfully docked twice with an Agena in an MSC mock-up with Jim McDivitt.

The crew has breakfast on launch morning in the crew quarters in the MSOB. *Clockwise from left*: Slayton, Armstrong, Curt Michel, Walt Cunningham, Shepard (*hidden*), Scott, and Roger Chaffee. Michel, a scientist-astronaut, would resign in 1969 without a space flight.

Armstrong and Scott depart the MSOB on launch morning. Behind Armstrong are Cunningham and Charles Buckley.

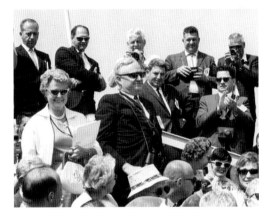

Armstrong's parents, Viola and Stephen Armstrong, at the VIP viewing site after the launch. A longtime state auditor, Armstrong was assistant director of the Ohio Department of Mental Hygiene and Correction. The street in front of their home in Wapakoneta would be renamed Neil Armstrong Drive after the mission.

Reporters and NASA personnel at the Press Site follow Gemini VIII's late morning launch. The spacecraft would be in orbit one hundred miles above the Atlantic in just more than six minutes.

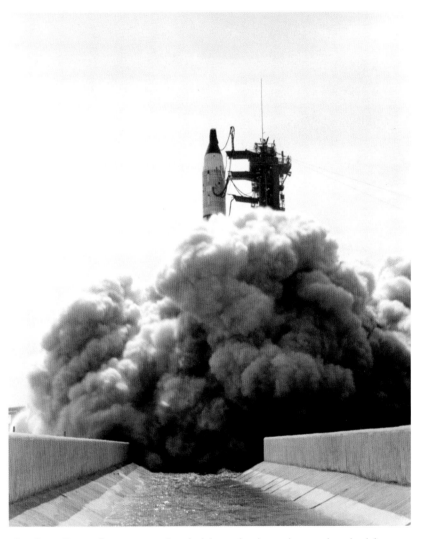

The Titan II's two first-stage engines belch smoke down the two-hundred-foot-long concrete flume after ignition at 11:41 a.m. (EST) on March 16, 1966, in this view looking south. The flume leads directly to the obscured flame bucket and can handle 25,000 gallons of water per minute sent through the bucket for cooling and propellant residue neutralizing. Robert Goddard successfully launched the first liquid-fueled rocket forty years to the day earlier from a relative's Auburn, Massachusetts, farm.

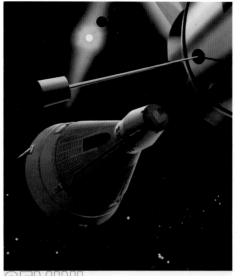

Left: McDonnell promotional brochure

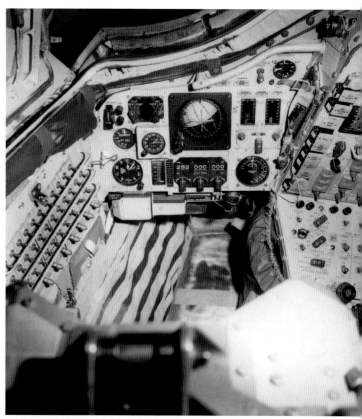

Above: The commander's side of the instrument panel (in this photo after recovery on March 16) is dominated by the attitude director/indicator (*center*). Below it is the incremental velocity indicator, flanked to the left by a rectangular propellant quantity indicator and the circular altimeter, and to the right by the range and range rate indicator.

Center left: Blue Team Flight Director John Hodge, at his console in MOCR 2 at MSC, watches the Atlas-Agena launch from LC-14 at 10:00 a.m. (EST) on March 16. Hodge would move to the Apollo program after Gemini VIII, where he was first lead flight director other than Chris Kraft.

Bottom left: After rendezvousing with the ATV at about 4:40 p.m. (EST), the target is approximately forty-five feet from the nose of Gemini VIII with its engine to the left and the docking cone to the right. The L-band dipole antenna is extended near the cone. The crew docked at 5:14 p.m. after about thirty-six minutes of station-keeping.

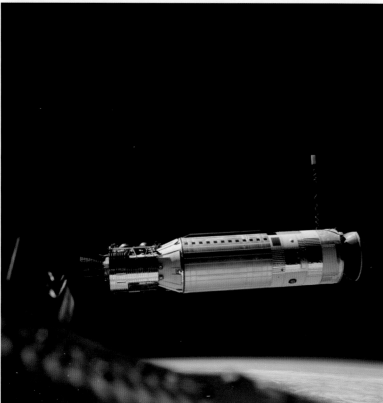

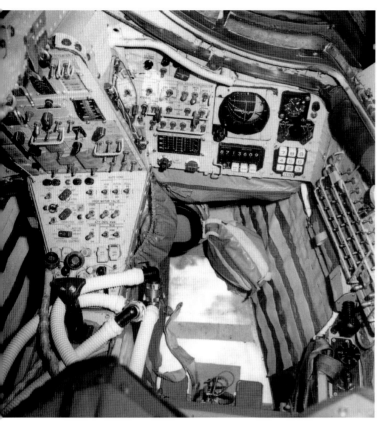

Top left: The center panel and pedestal (*left*) contain radio and gyro controls. The pilot's side includes the large attitude director/ indicator, the data input keypad and readout, and fuel cell and power systems monitors. Note the OAMS switch (*first switch in the bottom row of three on the pedestal*) left off by Armstrong to help regain control of the spacecraft after the No. 8 thruster malfunction. The suit hoses, now connected, are draped around the attitude hand controller. In Scott's footwell is the black-and-white video monitor fed by a camera in the adapter section to study whether such a low-light system could pick up sea and land features.

Bottom left: The ablation pattern on Gemini VIII's heat shield (March 20) shows the spacecraft's slightly offset center of gravity, which provided some lift once in the atmosphere. This force allowed the crew to control the spacecraft's roll and therefore its flight path during reentry. The ablative material was a paste-like Dow Corning silicone elastomer, which hardened after being poured into a fiberglass honeycomb form.

Top right: Gemini VIII is moved on Okinawa Island on March 20. It would undergo deactivation at Naha Air Facility and then RCS safing at adjacent Naha Air Base on March 20 before it was flown to St. Louis on a C-130 aircraft. The forward equipment bay access door has been removed, exposing a cold plate, a liquid-cooled radiator-type system that absorbed excess heat from the spacecraft electronics; wiring bundles; and relays.

Bottom right: With Gemini VIII behind it on a trailer, its rendezvous and recovery section with the pilot parachute still attached is lowered from the destroyer at Naha Port. It was found one hundred yards away from the spacecraft.

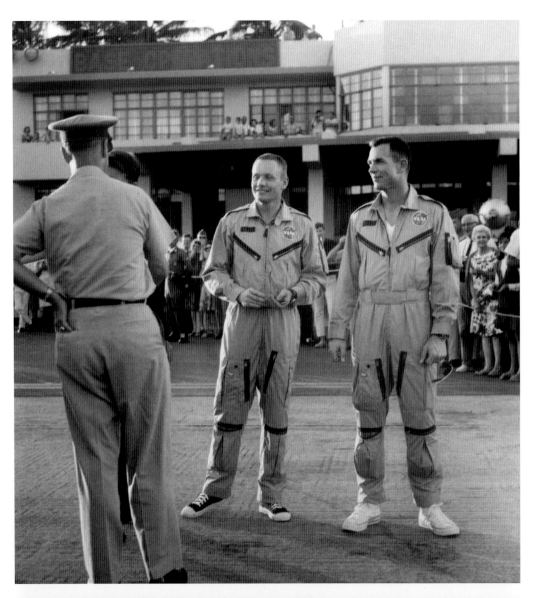

Opposite page, top: Armstrong and Scott at Hickam AFB, Hawaii, on March 17, 1966. They had debarked USS *Leonard F. Mason* at Naha's restricted military harbor, crowded with US ships being loaded for Vietnam. The two were then flown by helicopter seventeen miles north to Kadena AFB, where they boarded a military C-135. They stopped for ten hours at Hickam en route to Cape Kennedy. Wally Schirra, who had met them on Okinawa, is left of Armstrong (*partially obscured*). The crew spent the day at Tripler Army Hospital near Honolulu.

Opposite page, bottom: Glynn Lunney, George Low, Paul Purser, and Paul Haney in MOCR 1 after recovery. Lunney would first serve as a flight director for Gemini IX. Purser was a member of NACA and the Space Task Group and helped develop the Little Joe booster for unmanned Mercury tests. At MSC, he was executive assistant to Robert Gilruth through 1968 and was instrumental in the design and construction of MSC, and in establishing its organizational and operating structures.

Top right: Scott with daughter Tracy, four, and son Douglas, two, after the crew arrived at Ellington AFB on March 21, following nearly three days of debriefings.

Bottom right: *Aviation Week* writer Pete Bulban asks Scott to autograph a photo after the crew's postflight news conference at MSC on March 26, 1966. Armstrong is behind Scott as Associated Press photographer Ed Kolenovsky looks on. The astronauts had each just received the NASA Exceptional Service Medal. A docked Gemini-Agena model is on the desk.

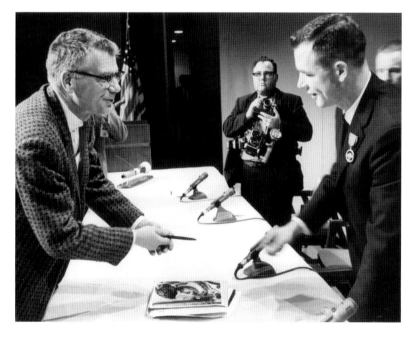

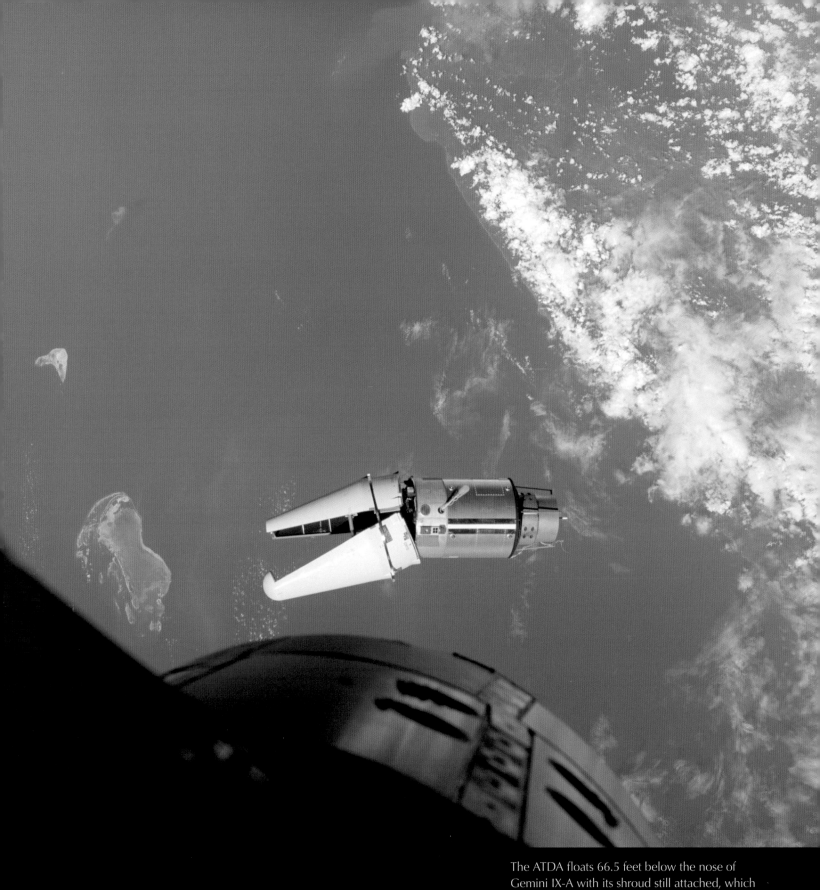

The ATDA floats 66.5 feet below the nose of Gemini IX-A with its shroud still attached, which prevented the two spacecraft from docking. Tom Stafford dubbed it an "angry alligator."

Gemini IX-A

June 3–6, 1966

The flight plan for Gemini IX was the most ambitious to date (keeping with the program's approach of building upon previous accomplishments and failures). The mission had two major goals: (1) dock with an Agena and use its engine to change orbits for the first time and (2) test an EVA maneuvering unit built into a backpack.

USAF Maj. Thomas P. Stafford was chosen as command pilot, with rookie astronaut Eugene A. Cernan, a US Navy lieutenant commander, as his pilot. On May 17, 1966, the crewmen were waiting in their spacecraft at Cape Kennedy as an Atlas booster was launched from LC-14 six thousand feet to the south at 10:15 a.m. (EST). Three minutes later, a malfunction sent the combined Atlas-Agena into the Atlantic. Stafford and Cernan's launch (planned for an hour and twenty-four minutes later) was called off. NASA quickly rescheduled the Gemini IX launch for May 31 and announced it would attempt to dock with a smaller augmented target docking adapter (ATDA), which was built in case Gemini VIII's Agena hadn't been ready in time. The ATDA, however, lacked its own rocket engine and could only be used to practice docking. The manned mission would be renamed Gemini IX-A.

The target launch date slipped to June 1 when an Atlas successfully put the ADTA into orbit that morning with Gemini IX-A to follow. But telemetry signals suggested that the launch shroud covering the ATDA's docking port had only partially opened. In the meantime, at LC-19 Gemini IX-A's launch was scrubbed because of a ground computer problem.

The mission finally got underway on June 3. Four hours later, the astronauts caught up with the ATDA and were disappointed to find out that the telemetry was correct: the cone-shaped fiberglass shroud had failed to separate (although it did split open). The problem meant a primary mission objective—practicing docking—would be impossible. Stafford and Cernan, however, carried out three types of rendezvous maneuvers, including one simulating an Apollo command module meeting up with a lunar module in a lower orbit.

Their second day in space was consumed with various experiments. At the beginning of flight-day three, they prepared for Cernan's spacewalk to test the USAF's Astronaut Maneuvering Unit (AMU) mounted in Gemini IX-A's adapter section. The hatch was opened on the morning of June 5, forty-nine hours and twenty-three minutes into the flight.

Cernan, attached to a twenty-five-foot tether, was to make his way to the rear of the spacecraft, don the AMU, release it from the adapter section, and

Launch: 8:39 a.m. (EST)

EVA: June 5

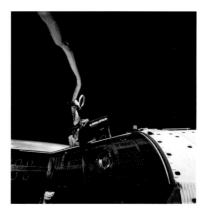

Splashdown: 9:00 a.m. (EST)

try moving around using its sixteen small hydrogen peroxide jets. He was then to leave it in orbit and climb back inside the spacecraft.

After his Gemini IV spacewalk, Ed White noted that handholds were a must, but Cernan found that those installed on Gemini IX-A were inadequate. Everything took much longer than he expected. He kept floating out of control and could not maintain his position.

When he reached the AMU, one of two floodlights mounted nearby didn't work and his radio communication with Stafford was poor. Cernan struggled to get into position and finally was almost ready to fly the AMU, but heat from his exertions was overwhelming his suit's cooling system. His visor repeatedly fogged up, and he realized if he did test the backpack it would be almost impossible to later free himself with one hand while holding onto the spacecraft with the other. With Cernan's limited visibility, the astronauts decided to cancel the rest of the EVA and Mission Control agreed. When he was back inside the spacecraft, Cernan realized he was overheated and spent. He'd been outside for three hours.

After getting some sleep, the astronauts splashed down on June 6 within a mile of their target in the Atlantic Ocean and about four miles from the primary recovery ship, the aircraft carrier USS *Wasp*. The crew remained with the spacecraft, which was hoisted aboard less than an hour after landing.

FINAL

GEMINI IX-A
FLIGHT PLAN

PREPARED BY
MISSION OPERATIONS BRANCH
FLIGHT CREW SUPPORT DIVISION
NASA, MSC, HOUSTON

MAY 21, 1966

FINAL

Below: From *left to right*: Gene Cernan, Lovell, Tom Stafford, and Buzz Aldrin, the prime and backup crews for Gemini IX, pose with a scale model of an astronaut wearing the Astronaut Maneuvering Unit (AMU) following a news conference in Bldg. 6 at MSC on April 23, 1966.

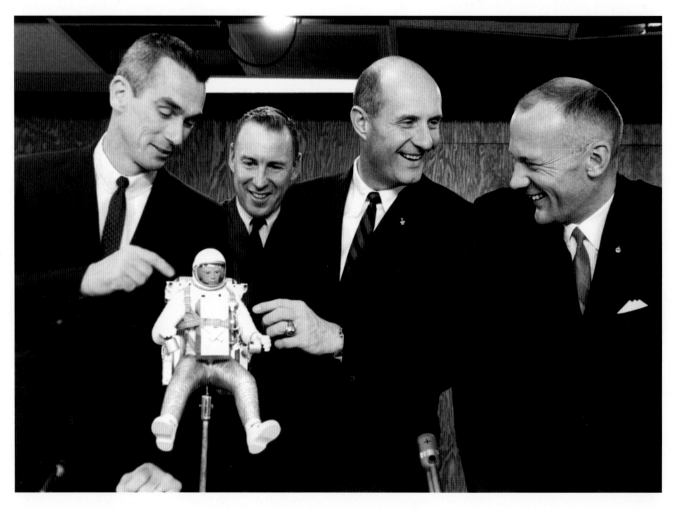

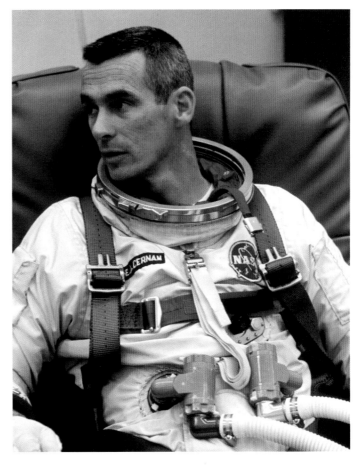

Above: Deke Slayton (*right*) chats with Stafford and Col. John G. Albert, chief of the Gemini Launch Division at Patrick AFB, on May 30, 1966, as they wait for the launch of *Surveyor 1* from LC-36A. The unmanned craft made the first US soft landing on the moon, paving the way for manned landings during Apollo.

Top right: Cernan prepares for a test of the AMU on February 19, 1966, at MSC. The gray plastic T-connectors allowed simultaneous connections to both his EVA chest pack (ELSS) and the spacecraft's environmental control system when he switched between them in orbit.

Bottom right: Charles Bassett II prepares for a suit test in January 1966 at MSC. Selected by NASA in 1963 as part of the third group of astronauts, he was named as Gemini IX's pilot on November 8, 1965. Bassett and Elliot See, the flight's command pilot, died on February 28, 1966, when their jet crashed in bad weather after striking the McDonnell plant in St. Louis, where their spacecraft was being prepared for the mission.

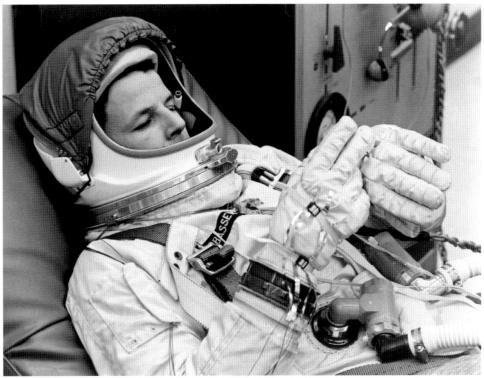

Top right: Each Gemini astronaut carried Fliteline medallions as mementos.

Top left: The first stage of Gemini IX's Titan II is unloaded from the *Pregnant Guppy* aircraft, a converted Boeing B-377 *Stratocruiser*, at the Cape Kennedy Skid Strip on March 8, 1966, after arriving from Baltimore. The stage, on its own USAF trailer, was rolled out onto the Cargo Lift Trailer with a hydraulically operated flatbed. The *Guppy* was built and had been operated for NASA since 1963 by Aero Spacelines, Inc., primarily to carry Saturn S-IVB stages from California to Florida.

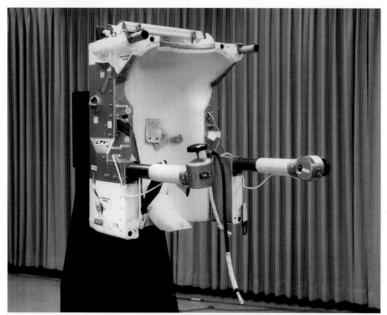

Center left: A display model of the AMU at MSC. The knob on the left control arm regulated movements up or down and forward or backward. The right-hand knob controlled pitch, roll, and yaw. The pipelike extensions at top left and right were added to prevent thruster exhaust plumes from impinging on Cernan's space suit at the shoulders. The hose (*right*) connected the AMU's oxygen supply to Cernan's chest pack. The AMU's battery pack runs across the top. The AMU was manufactured by Ling-Temco-Vought (LTV) of Dallas.

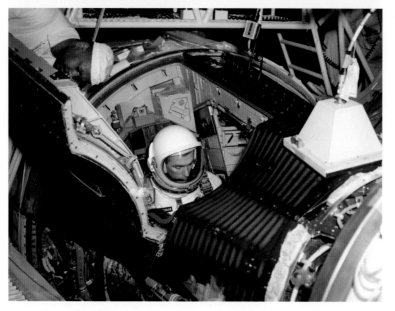

Bottom left: Cernan in the pilot's seat of Gemini IX during spacecraft testing in the thirty-foot altitude chamber at McDonnell in St. Louis on February 8, 1966. The aft stowage compartment above his head would hold cameras and other equipment. Cernan was the backup pilot at the time, as the prime pilot, Bassett, would die three weeks later.

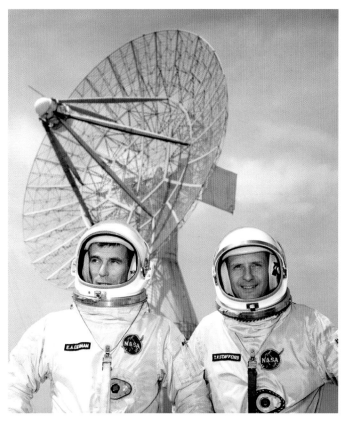

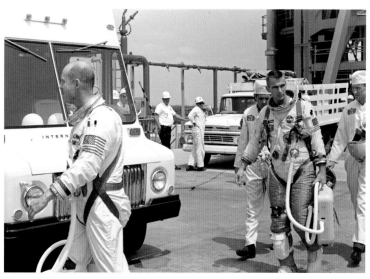

Above: Stafford (*left*) and Cernan head for the astronaut transfer van at LC-19 on May 17, 1966, after their launch was scrubbed. Their rendezvous target, an Agena upper stage, had plunged into the Atlantic shortly after launch that morning when its Atlas booster malfunctioned. Suit tech Clyde Teague is also pictured (*right*).

Left: With faceplates open, Cernan and Stafford pose with the radar tracking and communication antenna at the former MCC at Cape Kennedy AFS.

Right: In the white room at LC-19, Cernan and Stafford prepare to enter Gemini IX-A on the morning of June 3, 1966: their launch day. Backup Pilot Aldrin is behind Stafford, with backup Command Pilot Lovell and McDonnell pad leader Guenter Wendt to the right. The legs of Cernan's suit are covered with Chromel-R, a cloth woven from stainless steel fibers to protect the astronaut and suit from the hot exhaust thrusters of the AMU. A blue cover protects his EVA helmet visor. Beginning with this mission, Gemini helmets were made from multiple layers of epoxy-impregnated fiberglass cloth and visors were made of polycarbonate, providing far better impact protection than Plexiglas used previously. Each crewman has two gray life preservers on his parachute harness.

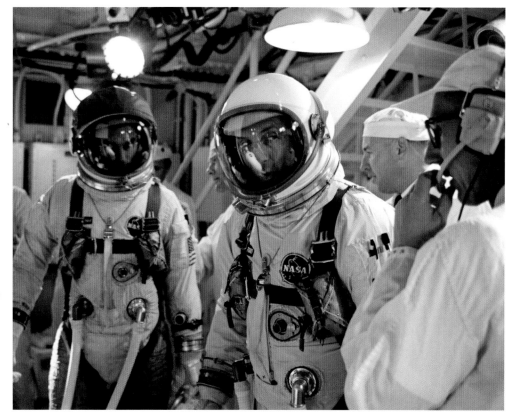

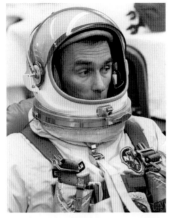

Far left: Stafford wears the Gemini G4C pressure suit as he dons his gear in the suiting trailer at LC-16 on launch morning, June 3.

Second left: Cernan prepares for the May 17 launch attempt. The new helmet visor for both crewmen allowed Cernan's EVA visor to have only one layer for sunlight protection.

Direct left: Ray D. Hill was the McDonnell base manager at Cape Kennedy AFS.

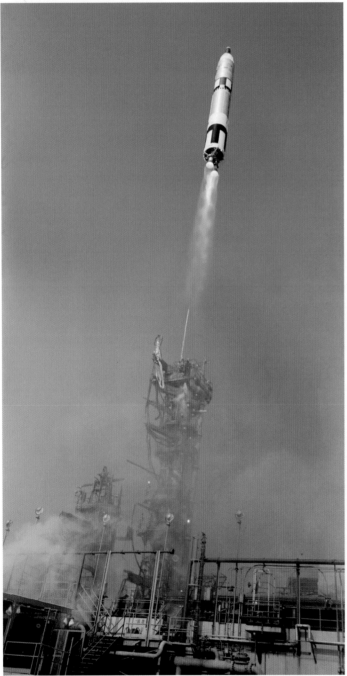

Above: Gemini IX-A powers skyward from LC-19 after launch at 8:39 a.m. (EST). The pad's miles of plumbing routed various fuels, gases, and fluids to the spacecraft, booster, and ground support equipment.

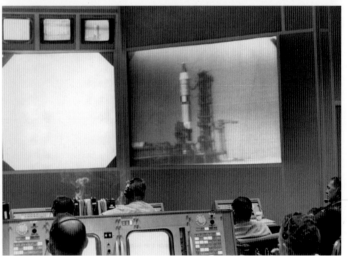

Center right: Supreme Court Chief Justice Earl Warren and Rocco Petrone, KSC assistant director for program management, at the VIP viewing site for the May 17 launch attempt. Warren would retire less than two years later. Petrone was instrumental in developing the Saturn launch facilities at KSC. Only about two hundred reporters were on hand.

Bottom right: The Gemini IX-A countdown is monitored in MOCR 2 on June 3. The blank projection screen (*left*) would plot the rocket's trajectory against its expected course; the projection screen (*right*) shows live video from LC-19.

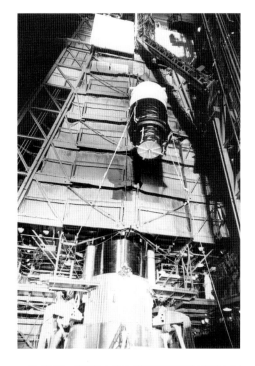

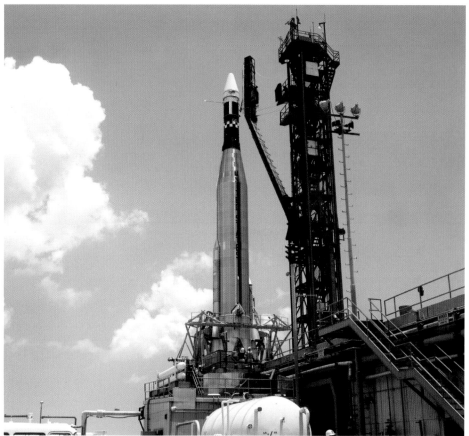

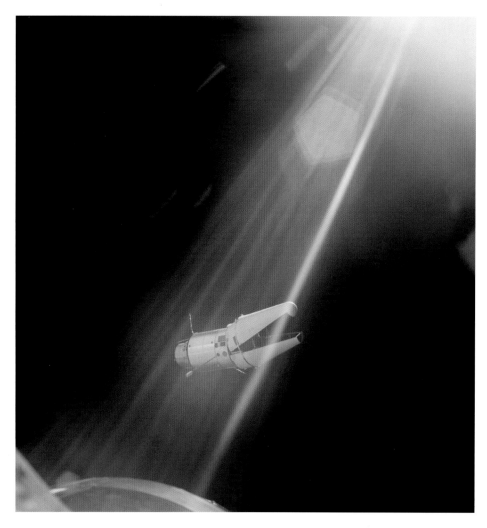

Top left: The ATDA is raised to the top of the service gantry at LC-14 on May 23, 1966, to be mated to its Atlas booster (*visible at bottom*).

Top right: The Atlas with the ATDA at top awaits launch at LC-14. Although it reached orbit as planned on June 1, Stafford and Cernan's launch set for a few hours later was scrubbed with less than three minutes to go after ground computers were unable to transmit their spacecraft's updated azimuth (launch angle) information.

Bottom left: The fiberglass shroud remained attached to the ATDA in orbit because of a prelaunch processing mix-up between Douglas, which built the shroud, and McDonnell, which installed it. Here the spacecraft are twenty-three feet apart.

Bottom right: Sunlight creates a lens flare in this photo of the ATDA from eighty feet with the Gemini's nose in the lower left. Both this photo and the one above were taken June 4.

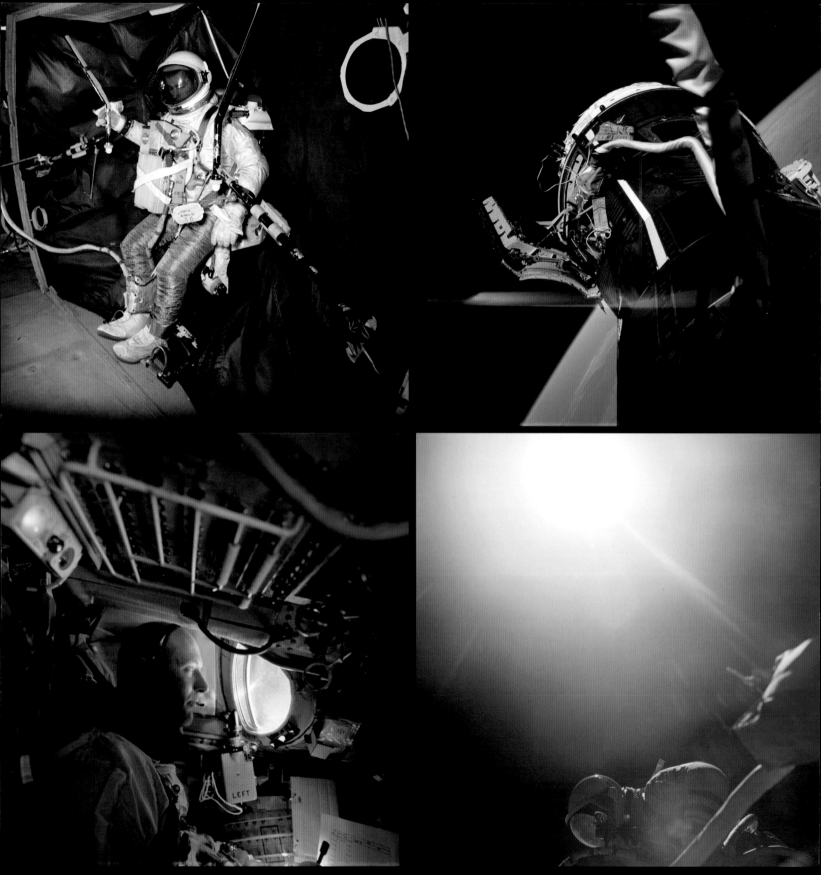

Top left: Cernan, wearing an ELSS chest pack, practices donning the AMU at the aft end of a mock-up of a Gemini adapter section during a flight aboard a modified KC-135 aircraft used to simulate weightlessness.

Bottom left: Cernan's photo of Stafford on June 5. The panel above his head includes switches and circuit breakers for the spacecraft's thrusters and cabin environmental controls.

Top right: Cernan's photo of Gemini IX-A shows his twenty-five-foot umbilical snaking back into his open hatch. The white objects to the right are two horizon scanners, which provided data for the space-craft's orientation by detecting the difference in infrared intensity between space and the edge of Earth's atmosphere.

Bottom right: Stafford captures Cernan during his EVA to test the AMU in space on June 5 using a new 70mm still camera. Gemini IX-A and the earth are reflected in his visor.

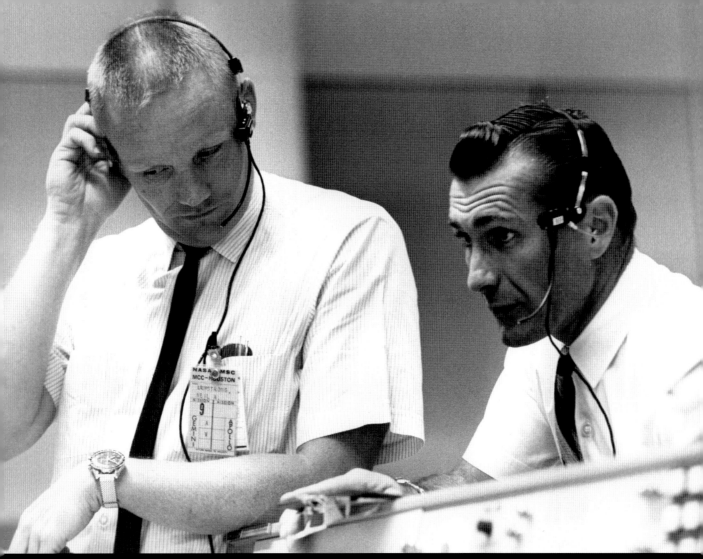

Above: Armstrong and Gordon, both CAPCOMs, in MOCR 2 on June 4

Right: Gemini IX-A Flight Director Kranz with models of a Gemini and the ATDA at an MSC news conference on June 4, 1966—the day the crew first rendezvoused with the target. Built by McDonnell, the ATDA was composed of a forward docking section of an Agena and a reentry control section of a Gemini spacecraft. Lacking the standard ATV's engine, it could not be used to change the Gemini's orbit while docked.

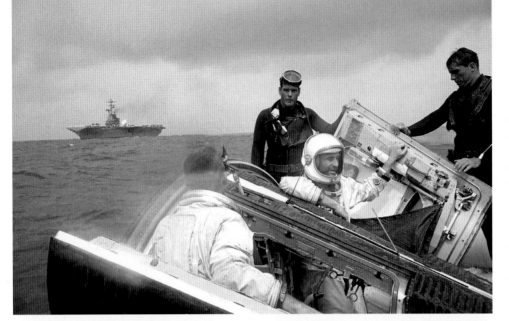

Top: Navy divers assist Stafford after Gemini IX-A splashed down in the Atlantic north-northwest of the Bahamas. The landing was the closest of any manned space flight to a recovery ship, with the aircraft carrier USS *Wasp* less than four miles away (which also meant the first live TV coverage of a manned parachute descent and splashdown). The astronauts stayed in their spacecraft until it was hoisted onto the *Wasp*'s deck.

Center: After a shave and shower aboard the *Wasp*, the crewmen speak with President Johnson at his Texas ranch via ship-to-shore telephone at 11:00 a.m. (EST) with USMC honor guards behind them.

Bottom: A McDonnell technician inspects Cernan's helmet aboard the *Wasp* on June 6, 1966.

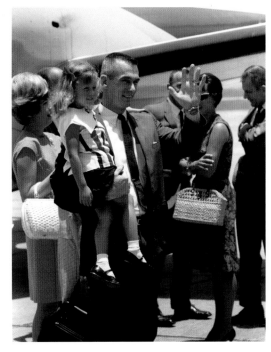

Above: Cernan holds his daughter, Tracy, after the crewmen landed at Ellington Field on June 10, 1966. Wife Barbara Cernan is in the orange dress. To the right are Alan Shepard, astronaut office chief, and Slayton, director of flight crew operations.

Right: John Stonesifer prepares to escort Stafford and Cernan to sick bay minutes after they stepped from their spacecraft. *Wasp* Capt. Gordon E. Hartley is the taller officer behind Stonesifer.

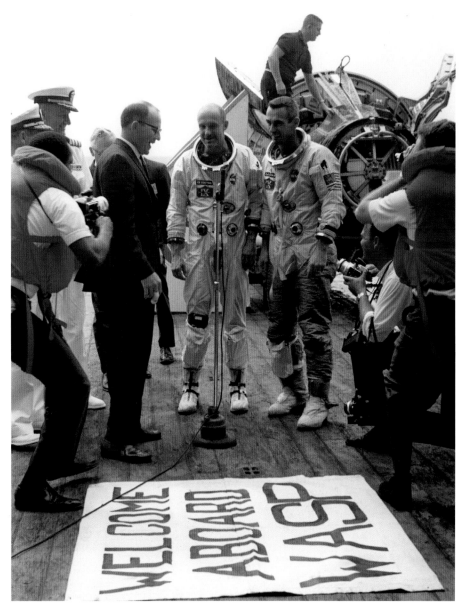

Gemini X clears the umbilical tower four seconds after liftoff in a time exposure showing the LC-19 erector being lowered in a ten-minute sequence of images beginning one hour before launch. White pipes forming an "L" along the tower and the test stand deck carry water for the pad's water deluge system (triggered two minutes before launch).

Gemini X

July 18–21, 1966

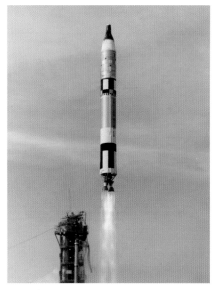

Launch: 5:20 p.m. (EST)

Gemini X, like the previous two missions, was a complex flight with multiple objectives, which had begun to pile up after the string of problems that had plagued the program. Only three flights were left, and despite Gemini VIII's brief Agena docking, key goals remained: using an ATV to change the Gemini spacecraft's orbit, testing the AMU backpack, and understanding and adapting to the rigors of EVA.

The AMU was dropped for Gemini X and XI (and eventually XII), but Cmdr. John Young and his rookie pilot, Mike Collins, were to accomplish the rest of the goals as well as rendezvous with Gemini VIII's ATV. Collins would also conduct experiments, retrieve packages from both the spacecraft and the old ATV, and test an HHMU.

The ATV was launched on its Atlas booster at 3:40 p.m. (EST) on July 18, 1966, and Gemini X followed at 5:20 p.m. The astronauts caught their target after almost five and a half hours, docking thirty minutes later. They'd used more OAMS fuel than expected, however, so several docking practice runs were canceled and they relied on the ATV's propulsion system for maneuvering.

Just before 1:00 a.m. (EST) on July 19, the ATV's main engine was fired for fourteen seconds to boost Gemini X's apogee to 474 miles—a manned spaceflight record at the time. A second burn at 3:58 p.m. brought the docked spacecraft into the same orbit as Gemini VIII's ATV, which was good training for the rendezvous skills that would be needed for Apollo.

About forty-five minutes later, Collins opened his hatch and stood in his seat—the first ever "stand-up" EVA. He conducted some photography experiments, but the work was cut short because of watery eyes. Both men experienced the problem for more than an hour, which was apparently caused by an inadvertently high oxygen flow through their helmets; they could not see clearly for several minutes at a time. The hatch was closed at 5:33 p.m.

The following afternoon, July 20, Gemini X undocked from its ATV at 2:00 p.m. (EST) and was later parked in a higher orbit. A series of maneuvers using Gemini X's thrusters then brought it within fifty feet of Gemini VIII's lifeless ATV about three hours later.

At 6:01 p.m., Collins again opened his hatch for his umbilical EVA over the Pacific. He first plugged in the line from his HHMU to a pressurized nitrogen valve in Gemini X's adapter section and then propelled himself toward the old ATV less than ten feet away. Despite problems because of no handholds on the target, he removed two experiment packages from it.

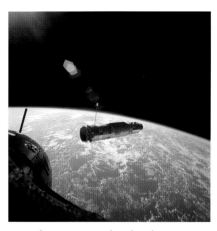

On orbit: ATV at eighty-five feet

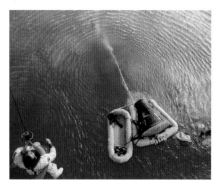

Splashdown: 4:07 p.m. (EST)

But Young, concerned that Collins might get hung up on some loose pieces of the ATV, told him to return to the cabin. Gemini X was also running low on OAMS fuel used to station-keep with the target.

Collins abandoned attaching a new micrometeorite collection package and the spacewalk was cut short after twenty-five minutes. He had also retrieved a micrometeorite collection box (Experiment S012) from the spacecraft adapter and placed the package inside the cabin, but it was lost later when it floated out. Collins had also lost his 70mm Hasselblad camera—one of the reasons the crew brought back no photos or film of Collins's umbilical EVA. The other was that Young was too busy to remove and stow the optical sight so that the general purpose 70mm still camera could be positioned in the window.

Collins had trouble getting back into his seat because he was entangled in his umbilical. Young helped untangle things to allow the hatch to close, which was latched at 6:40 p.m. It was briefly reopened again at 7:53 p.m. to jettison EVA and other equipment before reentry.

The next day, July 21, the crewmen fired their retro-rockets on their forty-third orbit at 3:30 p.m. (EST), with splashdown at 4:07 p.m. in the western Atlantic, 545 miles east of Cape Kennedy. Young and Collins were picked up by helicopter and taken to the recovery ship USS *Guadalcanal* at 4:34 p.m., and the spacecraft was aboard the amphibious assault ship at 5:01 p.m. The crewmen flew back to Cape Kennedy on July 22.

GEMINI 10 MISSION

JOHN F. KENNEDY SPACE CENTER, NASA

Below: John Young and Mike Collins during their preflight news conference in the MSC News Center in Bldg. 6 on July 2, 1966. "Frankly," Young told reporters, "the mission has everything in it but the kitchen sink." Even so, the crew was among the most silent for any US space flight.

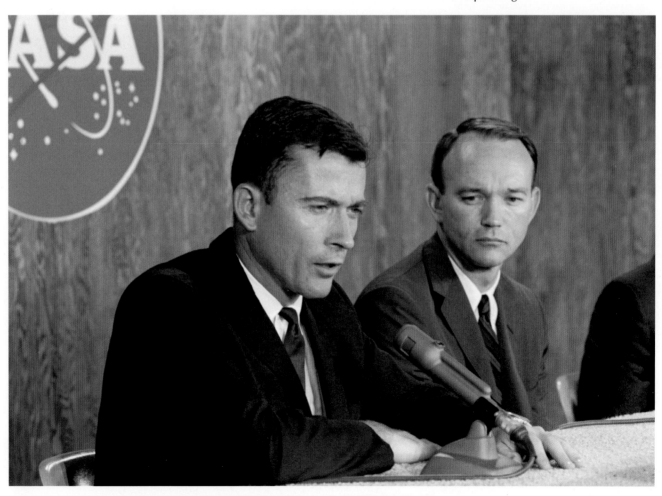

Right: Collins goes over the 16mm Maurer sequence cameras and lenses on July 15, 1966, as Deke Slayton (*center*) looks on at KSC. Collins would film his EVA with one of the two onboard Maurers.

Center right: Rookie Collins, Gemini X pilot, during weight and balance tests on June 15, 1966. The thirty-five-year-old USAF major had been chosen in the third group of astronauts three years earlier after a career as a test and fighter pilot.

Bottom right: Gemini X would-be US Navy Cmdr. Young's first spaceflight as commander. Thirty-five-year-old Young said in a preflight interview he had "left the best job in the navy to get the best job in the world" when he joined NASA in 1962. Here he undergoes weight and balance testing on June 13.

Bottom left: Collins and Young during the photo session for their crew portrait at MSC in late June 1966. Young's wife, Barbara, a former commercial artist, designed the mission insignia on their suits depicting the two spacecraft rendezvousing.

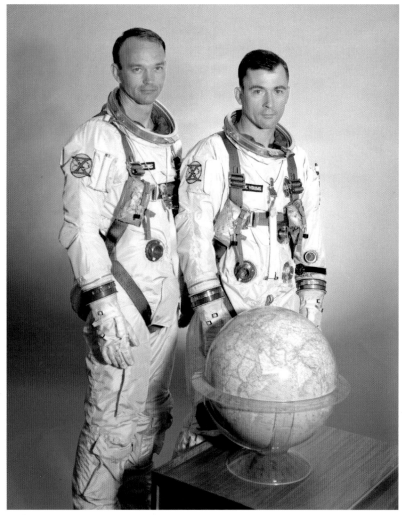

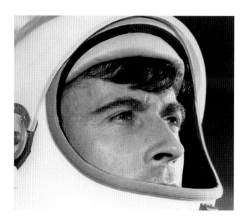

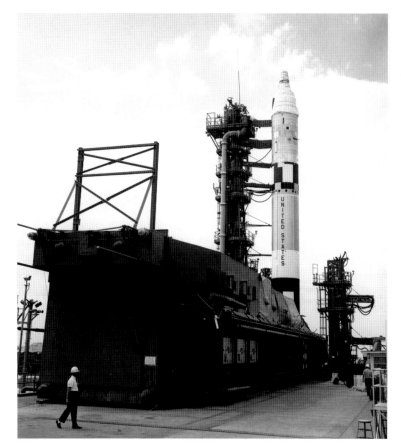

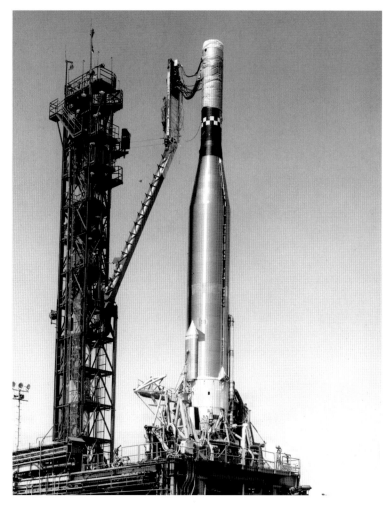

Opposite page, top left: The new Aero Spacelines 377SG *Super Guppy*'s fuselage swings open to reveal Gemini spacecraft No. 10 after arrival on May 13, 1966, at Cape Kennedy Skid Strip from St. Louis. The aircraft had entered service in March.

Opposite page, top right: The first stage of Gemini X's Titan II is off-loaded from the rear of the *Super Guppy* at the Skid Strip on May 18; the second stage arrived two days later. Both were taken to Hangar L for processing.

Opposite page, bottom: Personnel from Martin's Canaveral Division load the Titan II's first stage up temporary ramps and into the erector through the white room's open roof at LC-19 on June 8, 1966 (with the umbilical tower in the background to the left). The second stage was loaded several hours later. Each stage was moved through the white room on its "transtainer" trailer, then the stage was suspended and immobilized by cables and the trailer removed. The man near the roof is standing just above the attach point for the positioning cable, which would lower the stage five feet onto the launch stand after the erector was upright. Both stages were in place within twelve hours.

Top: Personnel on the test stand deck after Gemini X (still in its protective wrapping) was mated with its launch vehicle and the erector lowered on July 5, 1966.

Bottom: The Atlas-Agena at LC-14 during the first week of July (with the ATV under wraps and minus its nose fairing). The fueling and electrical umbilicals from the gantry boom are connected.

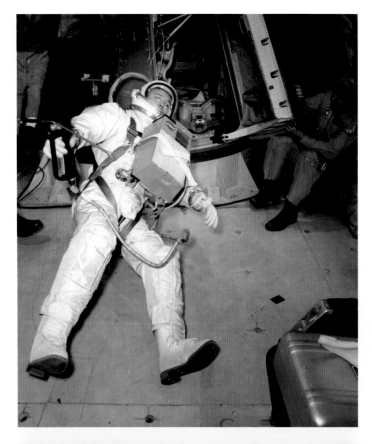

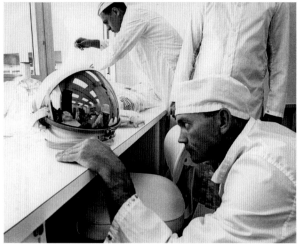

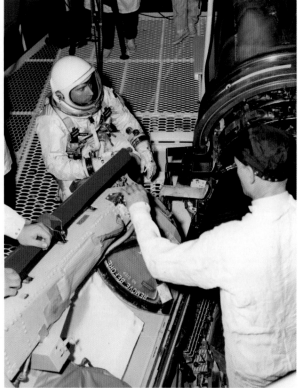

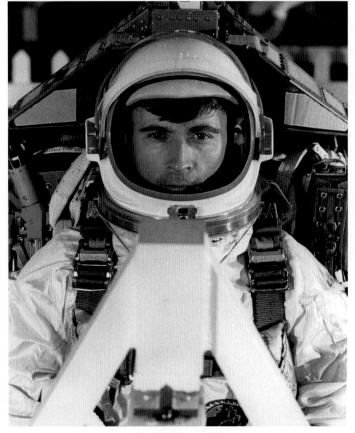

Above: Young in his ejection seat during exacting weight and balance tests in KSC's Pyrotechnic Installation Building on June 15, 1966. As with aircraft, knowing a spacecraft's exact weight and balance point, or center of gravity, is critical to successfully controlling the craft after liftoff.

Top left: Collins trains for what NASA termed his "umbilical EVA" (in contrast to his stand-up EVA) aboard a USAF KC-135 over Wright Patterson AFB, Ohio, on April 1, 1966, with his ELSS chest pack and HHMU. The pilot's hatch is open in the Gemini mock-up behind him.

Top right: Collins examines his EVA visor at Cape Kennedy on July 15, 1966. Like Cernan's helmet on Gemini IX, Collins's used a single-layer EVA visor, but it was attached using Velcro straps rather than the aluminum locking mechanism used previously. Collins later reported at least 30 percent of the visor's gold coating flaked off before his EVA from contact with the inside of the spacecraft.

Bottom right: A McDonnell technician leans over the command pilot's hatch to help Young ingress for a training session in McDonnell's altitude chamber in St. Louis on April 14, 1966. The chamber, built in 1964, was a thirty-foot-diameter horizontal cylinder.

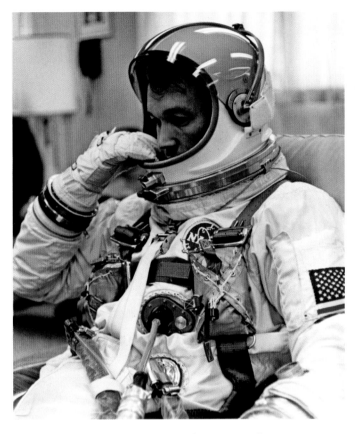

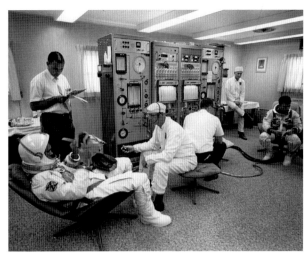

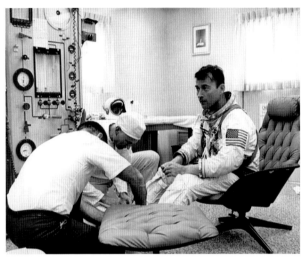

Above: Collins adjusts his helmet in the suiting trailer at LC-16 around 2:00 p.m. (EST) on launch day, July 18, 1966. His gloves have red fingertip lights to prevent interference with nightside low-light photography and he had an antifogging agent for his EVA visor.

Top right: Collins holds his EVA visor (its cover on his thigh) as suit tech Jim Garrepy assists in the suiting trailer during the simultaneous launch demonstration on July 12, 1966. His gloves are on the table to the left. To the right, Young suits up, with Joe Schmitt sitting on the table.

Second right: Schmitt and an unidentified suit tech assist Young on launch day.

Third right: With Slayton and Guenter Wendt (*left*), Young holds an oversized pair of pliers from the pad crew after arriving in the white room; he'd earlier said he'd like to bring pliers on the flight to help with a troublesome electrical utility cord. Collins (*back to camera*) was given an oversized monkey wrench because he'd had problems with the nitrogen hookup line for the HHMU he would use during his EVA.

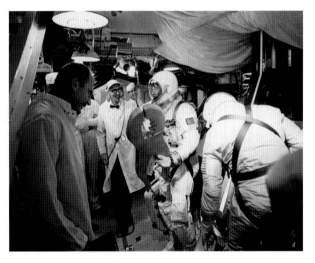

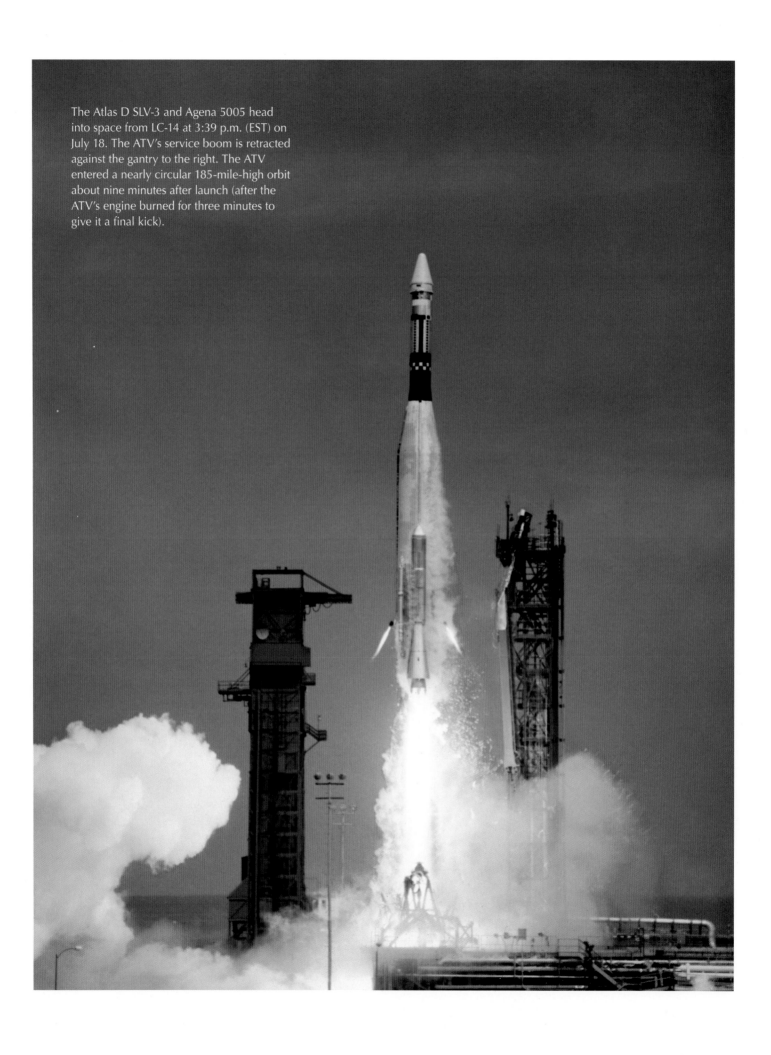

The Atlas D SLV-3 and Agena 5005 head into space from LC-14 at 3:39 p.m. (EST) on July 18. The ATV's service boom is retracted against the gantry to the right. The ATV entered a nearly circular 185-mile-high orbit about nine minutes after launch (after the ATV's engine burned for three minutes to give it a final kick).

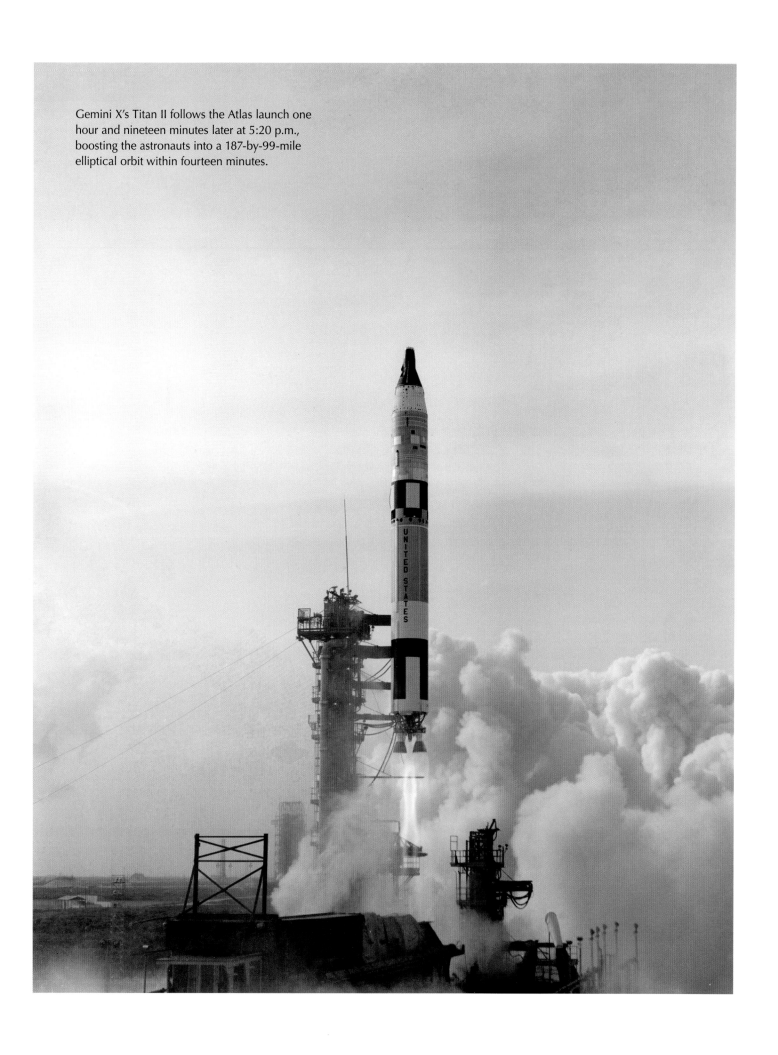

Gemini X's Titan II follows the Atlas launch one hour and nineteen minutes later at 5:20 p.m., boosting the astronauts into a 187-by-99-mile elliptical orbit within fourteen minutes.

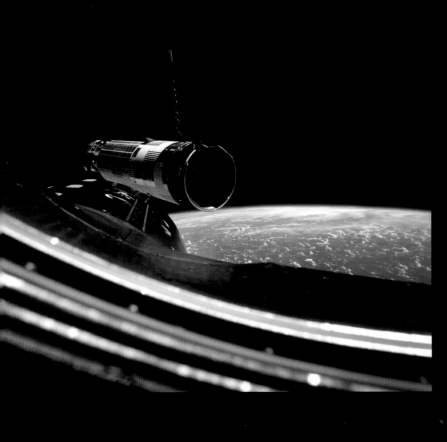

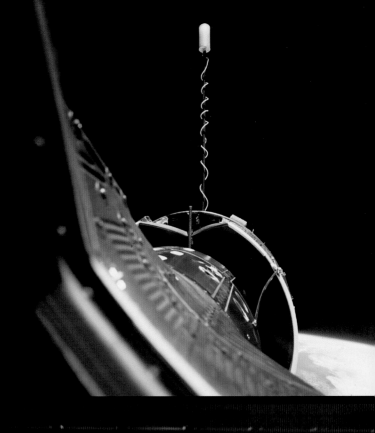

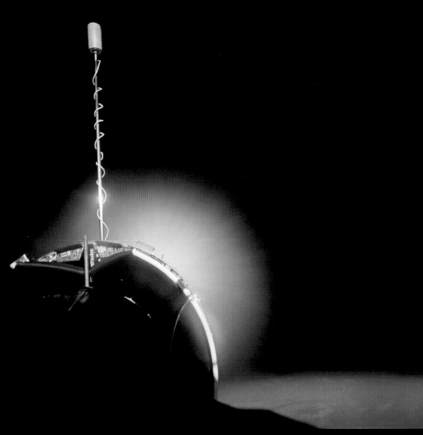

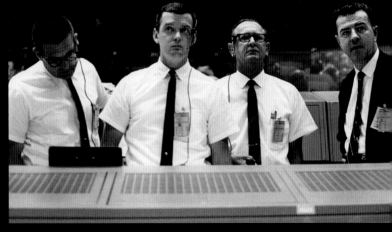

Above: The ATV's display panel is visible behind the Gemini's docking bar in the ATV's alignment notch as the Agena's main engine is fired for fourteen seconds just before 1:00 a.m. (EST) on July 19 over Hawaii to boost Gemini X's apogee to 474 miles—a new record for manned flight. "That was really something," Young told CAPCOM Buzz Aldrin. "When that baby lights there's no doubt about it."

Top left: The ATV about twenty-four feet in front of Gemini X over the Indian Ocean during the astronauts' fourth orbit around 10:40 p.m. (EST) on July 18 in this photo by Collins.

Top right: Collins's photo of the two spacecraft after docking at 11:15 p.m., six hours into the flight over the Pacific Ocean west of Hawaii.

Bottom right: Mission Director Bill Schneider, Black Team Flight Director Glynn Lunney, Chris Kraft, and Charles Mathews monitor the rendezvous in MOCR 2 on the night of July 18. This was twenty-nine-year-old Lunney's second mission as a flight director; Gemini IX-A was his first.

Inset right: Young with his faceplate open (the normal flight configuration) on July 19. The ring pulls (*upper right*) control cabin ventilation, and the panel (*upper left*) includes switches for the recovery beacons and cabin lights. A Maurer 296 16mm camera is also pictured (*lower right*). Earlier in the day, France conducted its first aircraft-dropped nuclear weapon test over the South Pacific atoll of Moruroa—an hour before Gemini X passed far overhead.

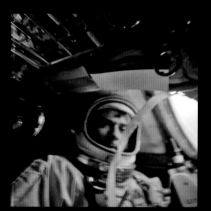

Far right: The Coppername Nature Preserve, established in 1966, is in the lower center of this photo of Suriname's north Atlantic coast, with the capital city of Paramaribo on the Suriname River to the right.

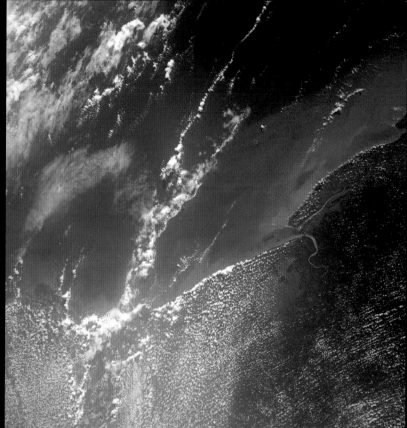

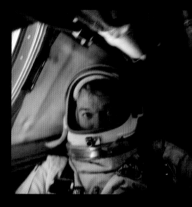

Inset left: Young's photo of Collins after his stand-up EVA was cut short at 5:30 p.m. because of watery eyes. Both men experienced the problem for more than an hour (apparently because of an inadvertently high oxygen flow through their suits) and at times each astronaut could not see clearly for several minutes.

Above: The Mentawai Islands off the west coast of the Indonesian province of West Sumatra. The Indian Ocean is to the left. The Synoptic Terrain Photography Experiment (S005) conducted on all Gemini flights produced some 1,300 usable 70mm Kodak Ektachrome images of the earth's surface. They became a huge stimulus to remote sensing from orbit partly because they were released to the public (and showcased by *Life* magazine) without restriction (unlike civilian and military satellite photos). Gemini photography was the central evidence the US Geological Survey used when proposing its Earth Resources Observation Satellite (EROS) in 1966, which became the Earth Resources Technology Satellite launched in 1972 and later renamed Landsat.

Above: Collins's photo of an eight-inch square titanium plate he held in front of him on a three-foot rod during his stand-up EVA on July 19 to see whether existing film reproduced colors accurately in space. Experiment 410's results showed that it did.

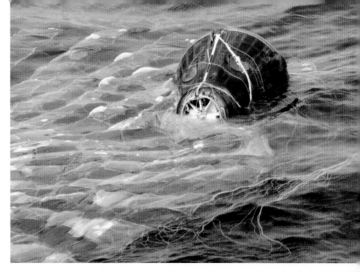

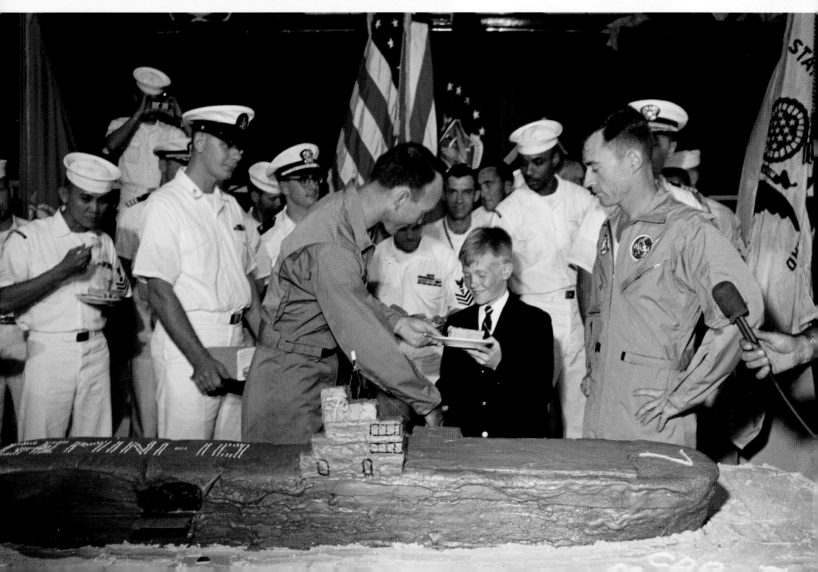

Opposite page, top left: A navy diver underneath Gemini X with the flotation collar inflated after splashdown in the Atlantic at 4:07 p.m. (EST) on July 21, 529 miles east of Cape Kennedy and less than 4 miles from its recovery vessel, USS *Guadalcanal*, an amphibious assault ship. Impact forces were less than for Mercury—even with that spacecraft's landing bag.

Opposite page, top right: The spacecraft is covered with its bridle and parachute lines after the eighty-four-foot-diameter main chute settled around the spacecraft because of the lack of wind.

Opposite page, center right: Young autographs his floatation device for a sailor on the hangar deck of the *Guadalcanal* on July 21. That same day, Wernher von Braun told the Alabama Bar Association that "a Mars landing by 1985 is within our grasp."

Opposite page, bottom: Bill Doyle, son of Lt. Cmdr. William J. Doyle IV of Virginia Beach, Virginia, receives a piece of cake and a handshake from Collins aboard the *Guadalcanal*. He represented forty-one boys, ages twelve to sixteen, who witnessed the recovery with their naval fathers or close relatives—the first time dependents were permitted aboard a recovery ship. Doyle received the honor as the youngest. Note the spacecraft with flotation collar made of icing in the "water" near the front of the ship.

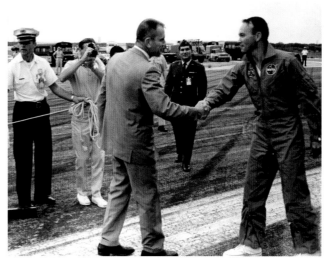

Top right: Under light rain, Slayton greets Collins after he and Young arrived at the Skid Strip in separate helicopters at 11:40 a.m. (EST) on July 22 after an hour-and-a-half flight from the *Guadalcanal*. More than two hundred people were on hand, including several members of the US House Manned Space Flight Subcommittee.

Second right: The crewmen take reporters' questions during their postflight news conference at MSC on August 1, 1966, in Bldg. 1. As had become standard practice, they began by showing film clips from the mission on the projection screen.

Third right: Young, Collins, and Robert Gilruth at the conference. The astronauts both wear NASA's Exceptional Service Medal they'd received earlier that day.

Bottom right: Collins uses a chalkboard to help explain how he retrieved a small experiment (No. S010) on micrometeoroid impact from the Gemini VIII ATV on July 20. He had trouble maintaining his grasp on its docking cone on the first try, but after Young maneuvered Gemixni X within twelve feet, Collins was successful the second time by using the HHMU and then grabbing surfaces between the collar and the ATV's body. The experience again showed how a lack of designed handholds hampered EVAs.

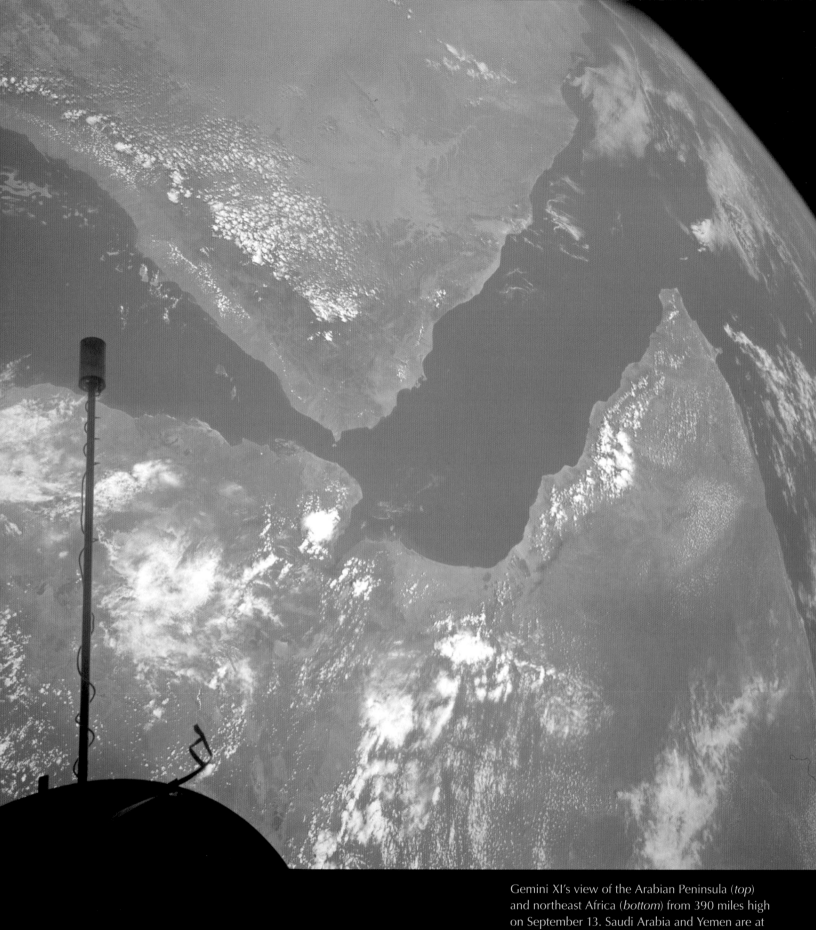

Gemini XI's view of the Arabian Peninsula (*top*) and northeast Africa (*bottom*) from 390 miles high on September 13. Saudi Arabia and Yemen are at the bottom of the peninsula. At the center top of the African coast are Ethiopia and Eritrea. Djibouti (known at the time as French Somaliland) is in the center just beneath the narrow inlet. The Red Sea is to the left, the Gulf of Aden is in the center, and the Indian Ocean is to the right. The docked ATV's seven-foot-long L-band dipole boom antenna is extended to the left.

Gemini XI
September 12–15, 1966

Launch: 9:42 a.m. (EST)

Two Gemini flights remained, but EVAs were still not going well and the astronauts had not yet repeatedly docked and undocked with an ATV. Both were in Gemini XI's flight plan for mission Command Pilot Pete Conrad and his rookie pilot, US Navy Lt. Cmdr. Richard Gordon. They were also to complete a rendezvous and docking with their ATV on their first orbit (experience which might be needed during Apollo).

The mission's first launch attempt on September 9, 1966, was scrubbed because of a small leak in the Titan II's first-stage oxidizer tank. The next day, a second launch attempt was scrubbed because the ATV's launch was also canceled; one of its Atlas booster's engines apparently wasn't responding to the rocket's autopilot.

The faulty signal in the blockhouse, however, was traced to an unusual combination of wind direction and vibration from the rapid opening and closing of the Atlas's fuel valves. Two men stood for hours at the eighty-foot level of the Atlas umbilical tower and pushed against the booster, simulating the wind as other technicians operated the valves. This combination duplicated the problem. To make sure, the technicians performed the same test on the Atlas-Centaur for Surveyor 2 at LC-36 with the same results; the autopilot had been operating properly.

On September 12, the ATV was launched at 8:05 a.m. (EST) from LC-14. To meet the target on the first orbit, Gemini XI was launched ninety-seven minutes later within a two-second window—the briefest of the Gemini program. Conrad and Gordon met up with the ATV as planned just one hour and twenty-five minutes after their launch, with a docking nine minutes later at 12:16 p.m. Both crewmen then practiced docking (a first for a Gemini pilot).

The next morning, they prepared for Gordon's EVA, and he opened his hatch at 9:44 a.m. His main goal was to unpack a one-hundred-foot Dacron tether on the ATV and attach the end to Gemini XI's docking bar. Gordon, with an ELSS, was out on a thirty-foot umbilical—shorter than Collins's—and handholds had been added to the target's docking cone. Even so, Gordon struggled against his pressurized suit to keep from drifting and had one hand to twist a knob to clamp the tether. He succeeded after six minutes but the entire EVA had left him overheated, fogging his faceplate. He and Conrad decided to abandon the other tasks, and the EVA lasted about thirty minutes (rather than the planned one hour and forty minutes).

On September 14, the ATV's engine was fired at 3:02 a.m. to raise the high point of the orbit of the two docked spacecraft to 853 miles for

On orbit: ATV at fifty feet

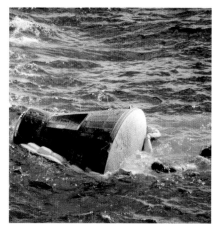

Splashdown: 8:59 a.m. (EST)

two revolutions, setting a manned altitude record not broken until Apollo 8 left for the moon two years later. "Whoop-de-doo, look at it go!" radioed Conrad. "That's the biggest thrill of my life." The crewmen, struck by their view, took hundreds of photographs. The Agena was fired again to lower the orbit back to 189 miles.

After a meal, the men prepared for the second hatch opening: a stand-up EVA starting at 7:49 a.m. Gordon found the two hours, including snapping photos, much more relaxing than his umbilical EVA (so much so that at one point both astronauts briefly fell asleep).

At about noon, Gemini XI undocked from the ATV to begin tests with the tether. The idea was to stretch the line taut between the two spacecraft and have them revolve around the center point of the tether, like two points on a wheel, to try to simulate gravity.

Although it was tricky to get the slack out of the tether and get the right motion going, the two spacecraft stabilized after about twenty minutes. It was a challenge to keep the line between taut, but the astronauts finally succeeded.

After dinner, Houston asked them to increase the spin rate again, and they demonstrated a tiny amount of artificial gravity by releasing a camera (which did drift back toward the rear of the cockpit). After about three hours of tests, the docking bar was jettisoned, releasing the tether and ATV.

Early the next morning, September 15, the crew made a second rendezvous with the ATV just less than five hours before reentry. After retrofire, bringing the spacecraft down automatically for the first time tested its guidance system. Gemini XI splashed down at 8:59 a.m. (EST) in the Atlantic Ocean, about 720 miles southeast of Cape Kennedy (slightly more than 2 miles from USS *Guam*).

Several astronauts had recently begun EVA training in a private high school's swimming pool near Baltimore, Maryland, using a new approach: simulating weightlessness underwater. It was a breakthrough that, combined with all the lessons learned so far, would make Gemini XII a success.

Opposite page, top left: Gordon (wearing an ELSS chest pack) trains for his EVA on the right side of a mock-up Gemini's adapter section aboard a USAF KC-135 over Wright Patterson AFB, Ohio on August 11, 1966. He practices tightening an instrumented bolt with a hand tool. He would have just finished testing the battery-powered impact ratchet in the box to the left by tightening and loosening the larger bolts above. The tool's reactive torque was virtually eliminated to minimize transmitting motion to Gordon. The D016 experiment was a casualty, however, of an overly ambitious EVA timeline.

Opposite page, top right: Gordon and Conrad pose with a Gemini model for news photographers after the news conference; Gordon is reaching into what would be his side of the spacecraft. On August 23, MSFC was reported to be in negotiations with McDonnell on a contract to convert a Saturn I second stage, an S-IV, into a manned space station. In 1973 Conrad would command the first crew to what would become Skylab.

Opposite page, bottom: Gordon and Conrad aboard MV *Retriever* in the Gulf of Mexico on July 13, 1966. The two were born months apart, had first met at the US Naval Test Pilot School in Patuxent River, Maryland, in 1958, and both served in Fighter Squadron 96 at the Miramar, California, Naval Air Station when they applied at NASA. Gordon, a Navy LCDR, had set a transcontinental speed record in 1961 and was selected as an astronaut trainee in 1963—a year after Conrad. He would be making his first space flight.

Left: Command Pilot Pete Conrad and Pilot Dick Gordon during their preflight news conference in Bldg. 6 at MSC on August 20, 1966. The two longtime navy cohorts were named as the prime crew on March 21, as was the crew for Apollo 1 (scheduled for a December launch). The previous month, Robert Seamans told a news conference that thousands of people would be phased out of the space program after NASA's budget peaked within the next year because of the cost of the Vietnam War, affecting Apollo and Saturn programs and workers at Cape Kennedy. NASA also began daily public bus tours of Cape Kennedy and LC-39 during July.

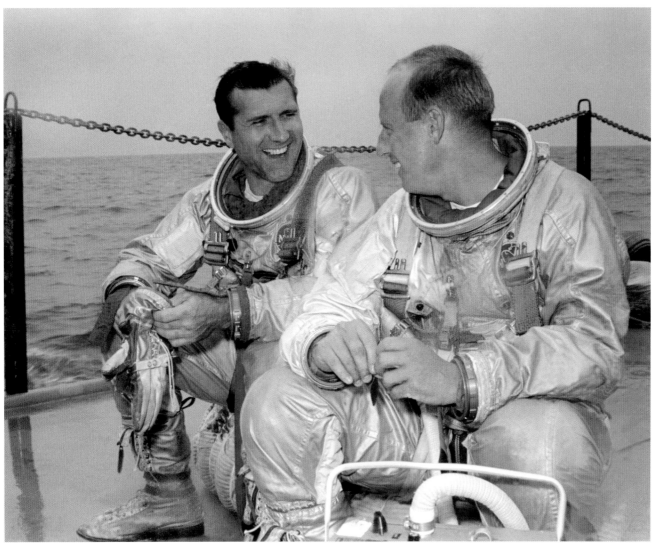

Opposite page, top left: McDonnell workers in the Pyrotechnics Installation Building on July 2, 1966, bolt Gemini spacecraft No. 11 to a support ring needed for Timber Tower tests.

Opposite page, top right: The Titan II's first stage is lowered by overhead crane into position inside the erector at LC-19 on July 22. The steel spider truss for the two Aerojet LR87-AJ-7 engines is attached to the stage at four longerons spaced ninety degrees apart (which also serve as the stage's attach points to the pad's thrust mount).

Opposite page, bottom: Martin workers prepare to roll the Titan II's second stage on its wheeled transtainer into the erector on July 22. The first stage is in place to the right.

Top left: Martin launch badge

Top right: Gordon practices attaching a J. A. Maurer 16mm sequence camera to a bracket behind the hatch of a Gemini mock-up in the MSOB on August 22, 1966. The camera would film his first EVA, when he attached a tether to the ATV.

Center right: Gordon perches on Gemini XI's rendezvous and recovery section as Conrad sits on the scaffold behind him at the Timber Tower during communication and radio frequency checks on July 25, 1966.

Bottom right: Conrad, sitting on Gemini XI's nose, ponders the alignment notch in the ATV's docking cone as the two spacecraft are docked on July 25. The Agena's L-band antenna is extended to the left, with the flat spiral L-band antenna to its right. The two spacecraft communicated via L-band frequencies, but both primarily used longer-wave UHF for radio links to the ground.

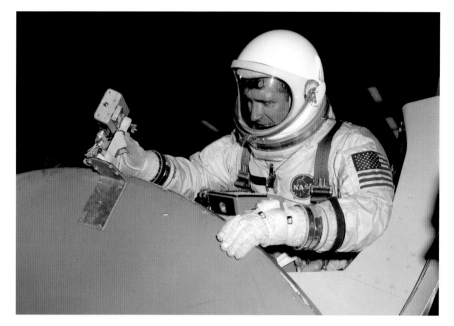

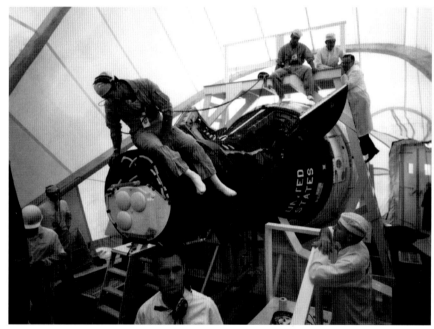

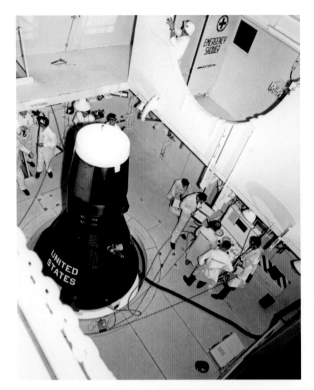

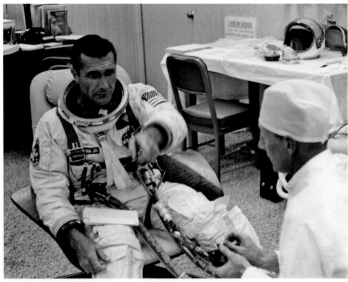

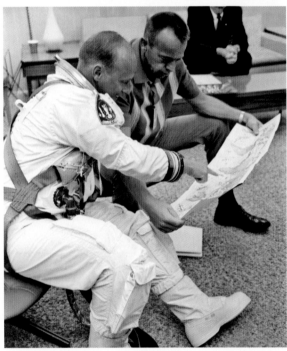

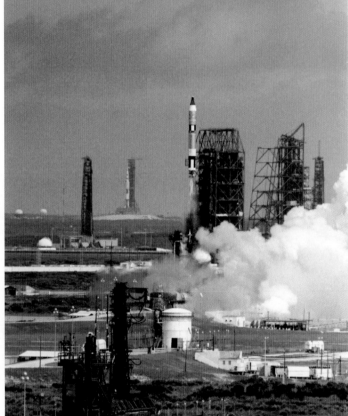

Top left: After resolving a problem closing Conrad's hatch, the work platforms at the top level of the white room are hinged upward and latched as McDonnell technicians check cabin pressurization before clearing the pad just after 7:00 a.m. on launch morning, September 12. The spacecraft's external power umbilical stretches across the floor; it will be disconnected three seconds before launch, as will a similar umbilical powering the adapter section.

Bottom left: Conrad looks over a mission orbit chart with Alan Shepard in the suiting trailer on September 10.

Top right: NASA suit tech Clyde Teague helps Gordon suit up in the suiting trailer around 6:00 a.m. (EST) at LC-16 before the September 10 launch attempt. Gordon's gloves, helmet, and EVA visor are on the table (*right*).

Bottom right: Gemini XI lifts off from LC-19 at 9:42 a.m. (EST) during its two-second launch window—the shortest of the Gemini program—to rendezvous with the ATV on the first orbit. The Saturn V checkout vehicle, AS-500F, is more than nine miles away at LC-39A on Merritt Island in the distance. This view looking north also captures the LC-34 gantry and service structures (*right*) and LC-15 and LC-16 (*bottom*). The gantry at LC-37 where an unmanned Saturn IB had been launched two months earlier to test the S-IVB's engine restart capability is also pictured (*center left*).

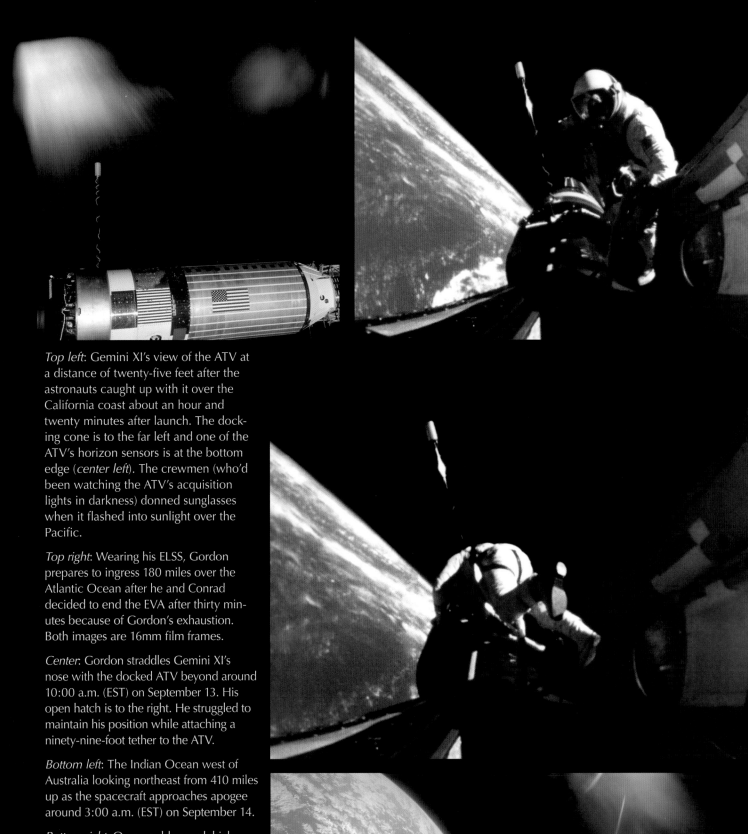

Top left: Gemini XI's view of the ATV at a distance of twenty-five feet after the astronauts caught up with it over the California coast about an hour and twenty minutes after launch. The docking cone is to the far left and one of the ATV's horizon sensors is at the bottom edge (*center left*). The crewmen (who'd been watching the ATV's acquisition lights in darkness) donned sunglasses when it flashed into sunlight over the Pacific.

Top right: Wearing his ELSS, Gordon prepares to ingress 180 miles over the Atlantic Ocean after he and Conrad decided to end the EVA after thirty minutes because of Gordon's exhaustion. Both images are 16mm film frames.

Center: Gordon straddles Gemini XI's nose with the docked ATV beyond around 10:00 a.m. (EST) on September 13. His open hatch is to the right. He struggled to maintain his position while attaching a ninety-nine-foot tether to the ATV.

Bottom left: The Indian Ocean west of Australia looking northeast from 410 miles up as the spacecraft approaches apogee around 3:00 a.m. (EST) on September 14.

Bottom right: On a world record–high manned flight altitude of 850 miles, the western coast of Australia is visible from Perth (*far left*) to Darwin on the Timor Sea (*far right*), a distance of more than 1,500 miles. The two high-apogee orbits were over Australia to minimize crew exposure to radiation from the Van Allen belts, which was comparatively low there.

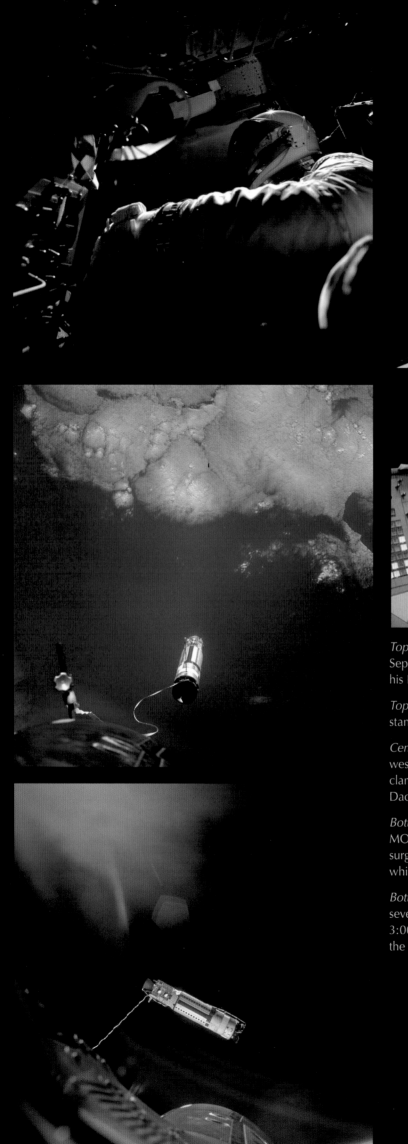

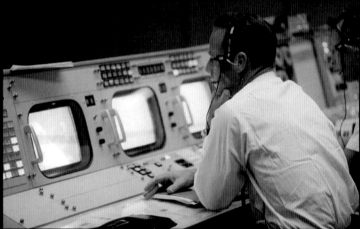

Top left: Gordon opens his hatch just after 11:00 a.m. (EST) on September 12 to jettison his ELSS and a bag of equipment used during his EVA earlier that morning.

Top right: Gordon's photo of the docked spacecraft during his two-hour stand-up EVA early on September 14, 1966.

Center left: The tethered ATV floats 160 miles above the Pacific Ocean west of Mexico on the afternoon of September 14. The knob of the clamp Gordon used to attach the two-inch wide, one-hundred-foot Dacron tether is on Gemini XI's docking bar (*lower right*).

Bottom right: Scott Carpenter mans the booster systems console in MOCR 2 during launch. He would return to the navy within a year after surgery in October failed to restore full functionality to his left arm, which had been injured in a 1964 motorcycle accident in Bermuda.

Bottom left: The tether is wrapped around the ATV—here less than seventy feet away—after it was cut loose from Gemini XI around 3:00 p.m., when the crew fired a small pyrotechnic charge to blow off the docking bar. The two spacecraft were tethered for about three hours.

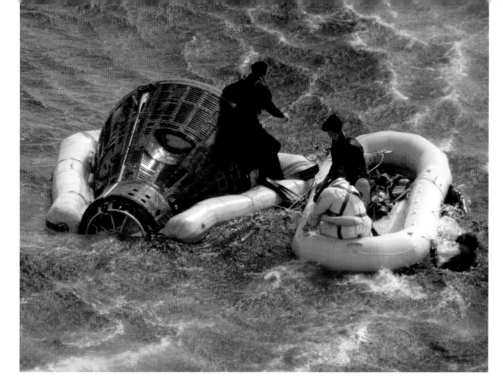

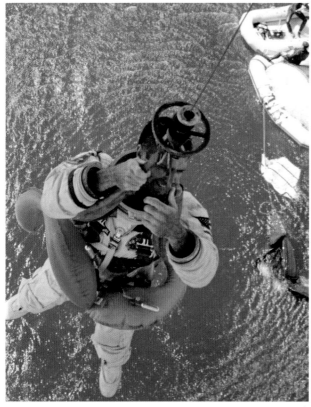

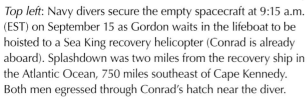

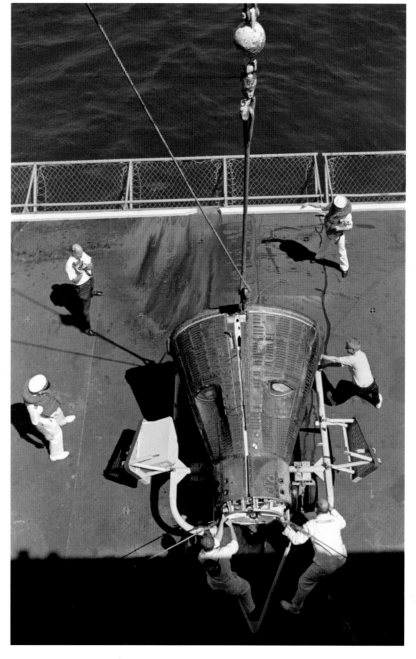

Top left: Navy divers secure the empty spacecraft at 9:15 a.m. (EST) on September 15 as Gordon waits in the lifeboat to be hoisted to a Sea King recovery helicopter (Conrad is already aboard). Splashdown was two miles from the recovery ship in the Atlantic Ocean, 750 miles southeast of Cape Kennedy. Both men egressed through Conrad's hatch near the diver.

Bottom left: Gordon is raised to the chopper using a rescue sling.

Bottom right: Trailing marker dye, the Gemini XI reentry module is guided onto its trailer on the fantail of USS *Guam* by McDonnell and NASA personnel. NASA's Gene Edmonds records the scene with a Bell & Howell 16mm camera (*upper left*).

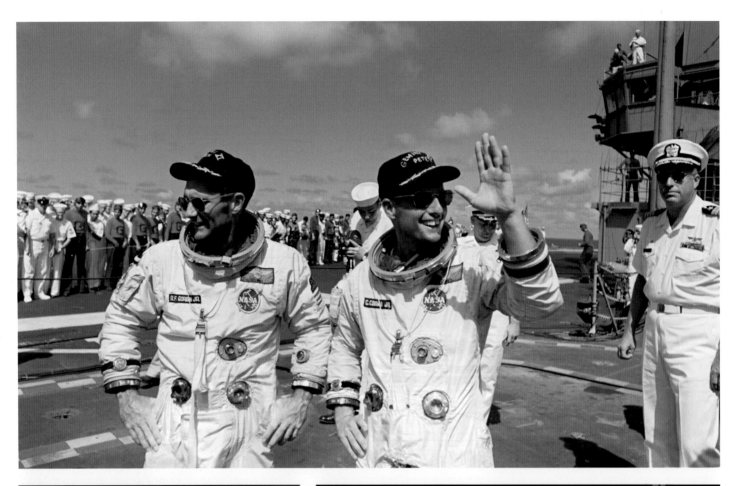

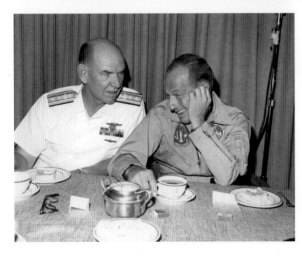

Opposite page, top: Gordon and Conrad arrive aboard the *Guam,* an amphibious assault ship, thirty minutes after splashdown. To the right is *Guam* Capt. Stephen De La Mater. Vice President Hubert Humphrey sent a congratulatory radiogram and the crewmen spent the night aboard the ship.

Opposite page, center left: Astronauts Alan Bean, nightside CAPCOM; John Young, dayside CAPCOM; and backup pilot Bill Anders go over events in MOCR 2 after splashdown. Gemini XI was the first all-navy crew, and Young and Bean were also naval officers.

Opposite page, bottom left: Rear Adm. Roy G. Anderson chats with Conrad over coffee and cake aboard *Guam* on September 15. Anderson was commander of Task Force 140.3, which was composed of Amphibious Group 4, including *Guam.*

Opposite page, bottom right: Chris Kraft, with MSC Deputy Director George Low, gestures toward the display screens in MOCR 2 after splashdown.

Top: Conrad and Gordon, welcomed by Shepard, approach photographers at the Cape Kennedy Skid Strip on September 16. The two astronauts left the *Guam* at 8:00 a.m. (EST) and arrived at 9:53 a.m. Gordon's helicopter is behind them; Conrad arrived in No. 63, which had pulled them both from the Atlantic. A crowd of about two hundred workers and reporters greeted them. Gemini XII's Titan would be stacked later that day.

Center: Prof. Edward P. Ney of the University of Minnesota's School of Physics and Astronomy examines 16mm film from the S-30 Dim Light Photography/Orthicon Experiment with Conrad and Gordon on September 23 during postflight debriefings at MSC. The experiment aimed to photograph such astronomical phenomena as airglow and zodiacal light by filming an onboard video monitor fed by a camera in the retrograde section. Ney was a pioneer in putting experiments aboard spacecraft.

Bottom: Conrad demonstrates the tethered flight experiment with Gordon during their postflight news conference at MSC on September 26. Gordon said he was shocked at how difficult the EVA was and called for better hand and foot restraints for future spacewalkers.

Gemini XI

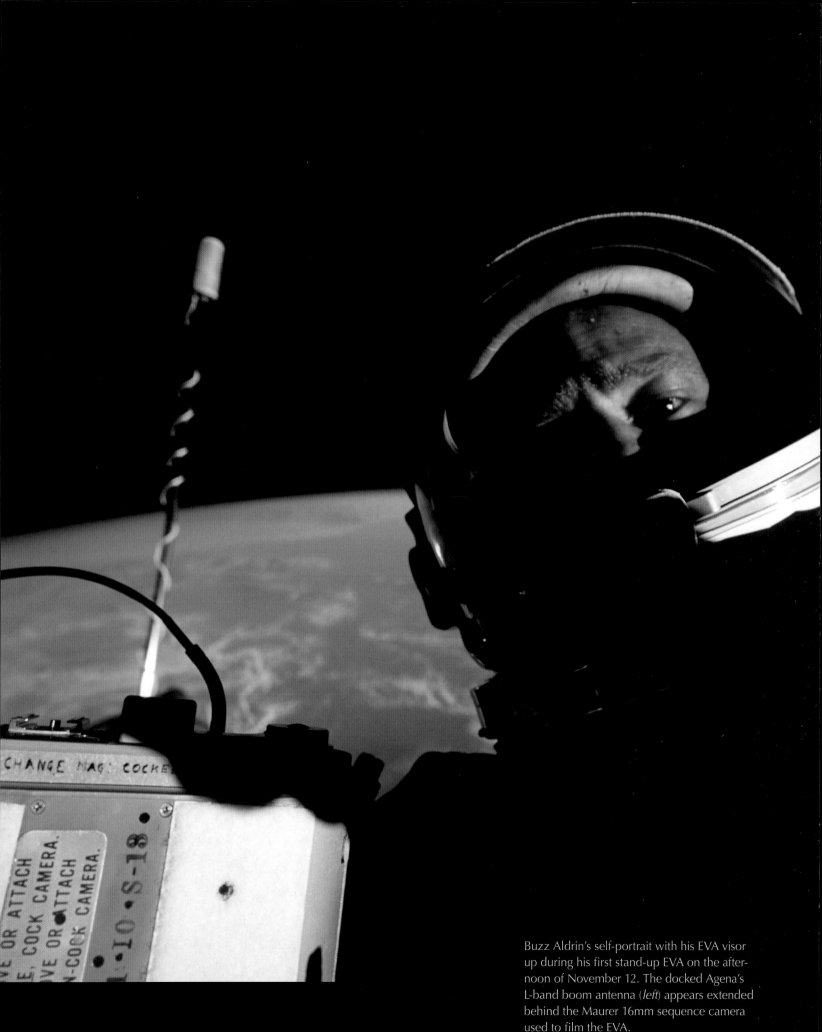

Buzz Aldrin's self-portrait with his EVA visor up during his first stand-up EVA on the afternoon of November 12. The docked Agena's L-band boom antenna (*left*) appears extended behind the Maurer 16mm sequence camera used to film the EVA.

Gemini XII

November 11–15, 1966

Gemini XII was the program's curtain call and the last chance for a successful EVA as planned from start to finish. Command Pilot Jim Lovell would be joined by rookie Edwin "Buzz" Aldrin Jr., a USAF major, as pilot. After the final Gemini rendezvous, docking, and engine tests with an ATV, Aldrin was to conduct three carefully planned EVAs totaling about five hours.

Two stand-up EVAs would bracket a nearly two-hour umbilical EVA. His every movement would be made deliberately with breaks to make sure he didn't become fatigued or overheated.

NASA headquarters had ordered the flight's AMU to be removed in September. Plans for its repeated use and development during Gemini had proved wildly ambitious, and with only one flight left, NASA Associate Administrator George Mueller ordered more work instead on EVA fundamentals. Aldrin would install a handrail to help him move to the docked ATV, he would not be encumbered by an HHMU, and he would have portable handholds and new personal tethers available. At the back of the adapter section, he'd tackle a panel of small tasks installed in place of the AMU. Finally, Aldrin had some underwater practice—an EVA training technique that would become standard for Apollo and Skylab.

On November 11, 1966, as with the previous four missions, the ATV was launched from LC-14 about ninety minutes before Gemini XII's liftoff from LC-19 at 3:46 p.m. (EST). They were the final launches from the two historic pads.

Lovell and Aldrin were inserted into a 100-by-168-mile-high orbit. They rendezvoused with the ATV at 7:32 p.m., docking twenty-eight minutes later on their third orbit. But the Agena, which had proven itself on Gemini X and XI, was disappointing on its final outing as a target. Prudence about a pressure drop in its main engine before it reached orbit meant the astronauts would not be able to use it to boost the docked spacecraft to 460 miles. Instead, the astronauts used the ATV's thrusters to get in position to photograph a solar eclipse over South America at about 9:20 a.m. the next morning.

The next day, November 13, Aldrin began his umbilical EVA at 10:34 a.m. using an ELSS and the same twenty-five-foot umbilical used by Gene Cernan on Gemini IX-A with modifications. He made his way along the handrail he'd installed previously to the ATV's docking cone. He then attached a pair of two-foot tethers (used for the first time) to keep from drifting away or out of position. The tethers attached to his parachute harness near the waist, with hooks that snapped into rings in the Gemini adapter section or on the ATV.

Launch: 3:46 p.m. (EST)

On orbit: Baja California, November 14

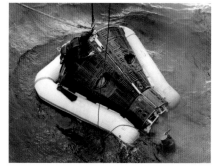

Splashdown: 2:21 p.m. (EST)

After completing a series of small tasks at the ATV and resting, Aldrin moved back to Gemini XII and then went hand-over-hand along a handrail deployed on the side of the adapter section to the rear of the spacecraft. He attached his tethers and slipped his boots into a pair of new fiberglass foot restraints and found he could relax and lean to either side or backward.

Working during a nighttime pass, he got to work in the busy box using penlights for illumination, where he performed seventeen simple tasks: removing, installing, and tightening bolts, operating connectors and hooks, and cutting cables. No photographs were obtained, however, because the 16mm Maurer camera failed after Aldrin mounted it and turned it on.

With rest periods, he returned to the ATV and tested a torque wrench while tethered. He finally attached the ATV's one-hundred-foot tether to Gemini XII's docking bar and returned to the cabin. Aldrin closed the hatch at 12:40 p.m. after more than two hours.

At 3:09 p.m. that afternoon, the astronauts undocked from the ATV and began their tethered tests similar to those on Gemini XI. The line tended to remain slack, but the two craft slowly stabilized. The tether was released at 7:37 p.m.

On November 14, the hatch was opened at 9:52 a.m. for fifty-five minutes for Aldrin's second stand-up EVA, which included nighttime and sunrise photography, additional experiments, and jettisoning unneeded equipment.

The next day, the automatically controlled reentry began with retrofire at 1:46 p.m. After fifty-nine orbits and four days, Project Gemini came to an end with splashdown at 2:21 p.m. in the western Atlantic, three and a half miles from the recovery ship USS *Wasp*. NASA anticipated launching its first manned Apollo mission into Earth orbit in the next two or three months.

Left: USAF Maj. Aldrin, Gemini XII pilot; Jim Lovell, command pilot; and Gene Cernan, Aldrin's backup (*far right*) before their preflight news conference in Bldg. 1 at MSC on October 22, 1966. Thirty-six-year-old rookie Aldrin flew sixty-six combat missions near the end of the Korean War. He received a doctorate in astronautics from MIT in 1963, with his thesis on manned orbital rendezvous. When he was chosen as an astronaut later that year, he had been stationed at MSC with the USAF working on DOD experiments for Gemini.

Opposite page, left: The prime crew poses with backups Cernan and Gordon Cooper on September 8 at MSC after their mission portraits were taken.

Opposite page, top right: Lovell before a run in the Gemini Mission Simulator in Bldg. 5 at MSC on September 6, 1966. He completed more than 153 hours in the simulator.

Opposite page, bottom right: Lovell and Aldrin during the Mission Review meeting in the MSOB on November 7, which cleared them for a November 9 launch attempt.

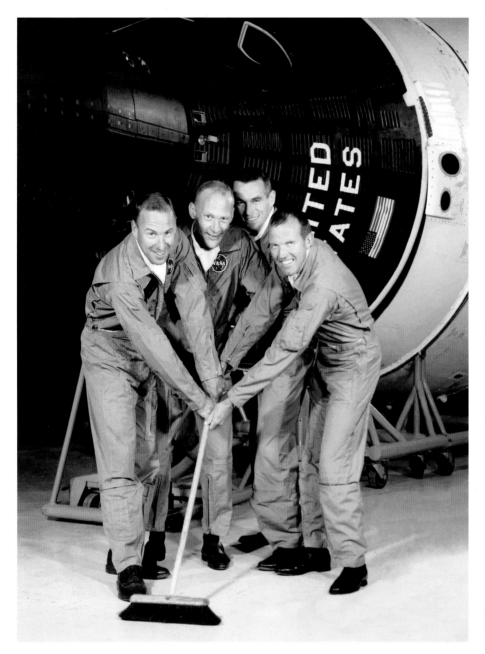

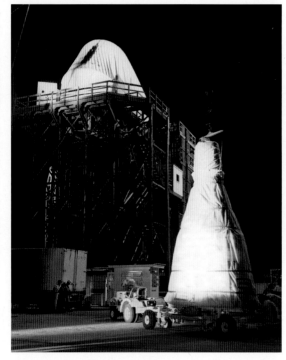

Opposite page, top: The Gemini XII spacecraft at McDonnell on September 6, 1966—the day it was shipped to Cape Kennedy. *Left to right*: Ken Warren, Jerry Kalk, unknown, unknown, unknown, Al Eaton, Joe Bobik, and Terry Spence.

Opposite page, bottom left: Target docking adapter (TDA) 7A in a cleanroom environment in Hangar H before it was mated to ATV 5001 on September 12. The red-striped silver label covers an acquisition light.

Opposite page, bottom right: Gemini XII is prepared for hoisting to the top of the sixty-five-foot Timber Tower on September 19 for two days of radio frequency and radar tests with the ATV. The flight's Titan II was erected the same day at LC-19.

Top: Aldrin evaluates an AMU while wearing an ELSS chest pack in McDonnell's thirty-foot altitude chamber on August 15, 1966. An AMU was installed in Gemini XII's adapter section, but removed on September 26 after Mueller decided to have Aldrin focus more on EVA fundamentals instead. The two orange connectors allowed him to switch the electrical connection on his umbilical between the spacecraft or the AMU (depending on which was supplying oxygen to the ELSS).

Far right: Lovell's parachute harness is inspected before weight and balance tests in the Pyrotechnics Installation Building September 28, 1966.

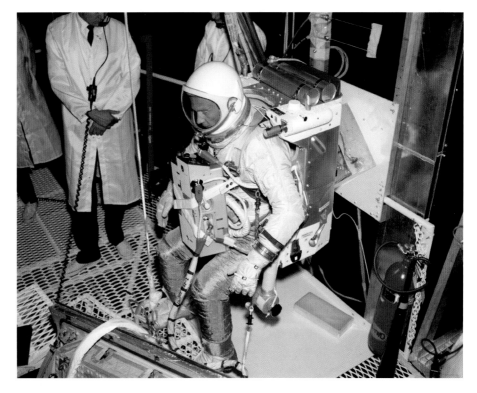

Above: Wearing an ELSS, Aldrin inserts his umbilical into an extendable guide on a mock-up of the Gemini adapter section aboard a USAF KC-135 on October 13, 1966 (one of a series of EVA aids added for the mission).

Right: Lovell examines a Maurer 70mm still camera, which could be used with any of three lenses: standard, low-light, and ultraviolet. Aldrin would use it during his stand-up EVAs on board for a variety of scientific photography objectives. The Maurer cameras malfunctioned a number of times, however, as they had on several previous flights.

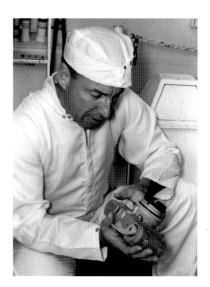

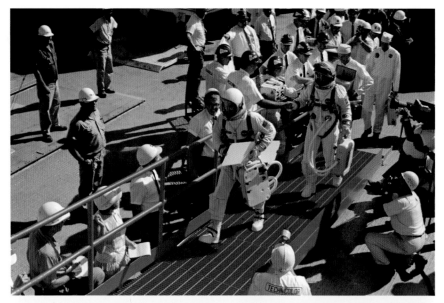

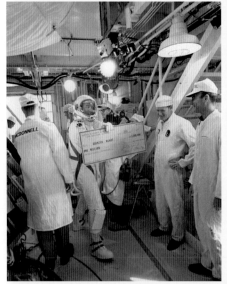

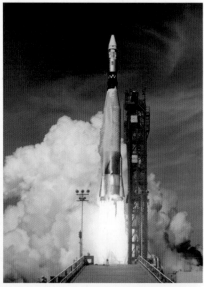

Top left: Lovell leads Aldrin up the ramp to the elevator at LC-19 at 12:40 p.m. Lovell carries an "admit one: Ferris wheel" ticket he'd just received from the ground crew; Joe Schmitt follows Aldrin carrying a box with an oversized check Lovell would give Wendt in the white room. To the right is an early CBS-TV portable camera serving as the pool. Pool reporters (*left*) include Mary Bubb and Howard Benedict.

Top right: Lovell and Aldrin stop to speak with United Nations Undersecretary for Special Political Affairs Ralph Bunche after leaving the MSOB at 11:30 a.m. on launch day, November 11. Bunche watched the launch with members of the U.N. Committee on the Peaceful Uses of Outer Space.

Center left: Lovell displays the check from the crew in the white room for Guenter Wendt drawn on the "Bank of Pad 19" for one million Deutsch marks for "employment compensation." Wendt later arranged for the two crewmen to be "arrested" for passing a bad check.

Center right: An Atlas-SLV3 boosted Agena D No. 5307 into a roughly 180-mile-high orbit within five minutes of launch at 2:08 p.m. The trouble-free countdown culminated with the final launch from LC-14. Gemini XII would dock with the ATV in less than six hours.

Bottom left: Aldrin still wears his half of a "THE END" message the crewmen attached to their suits for the final Gemini mission. Aldrin also has Alfred E. Neuman's face on the front of his visor cover with the *MAD* magazine mascot's catchphrase, "What, me worry?" His backup, Cernan, looks in (*right*) as Schmitt prepares the cockpit for crew ingress.

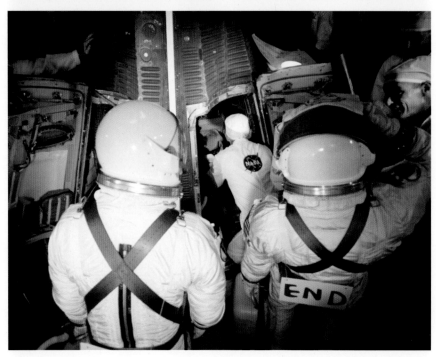

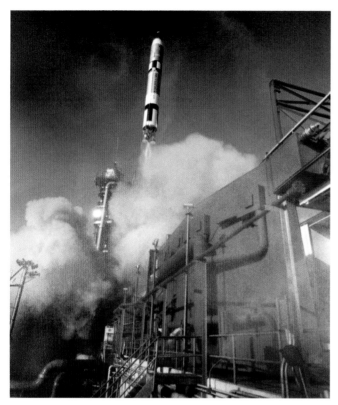

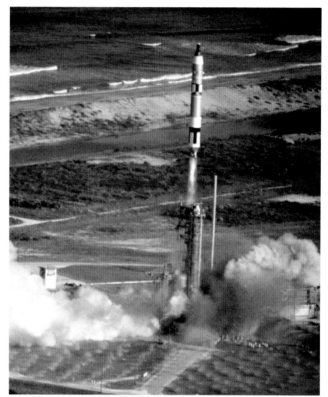

Top photos: Gemini XII lifts off at 2:47 p.m. (EST) on November 11 from LC-19. The photo at right shows launch as seen from a helicopter looking east-southeast (the pad just 350 yards from the Atlantic). To the right of the umbilical tower is one of two one-hundred-foot-tall vent stacks which dispelled vapors from the pad's fuel system. The Gemini and Agena launches wrapped up a busy launch period at the Cape: a Delta (communications satellite) and an Atlas (Centaur upper-stage test) were launched on October 26. The unmanned Gemini II spacecraft was relaunched on a suborbital flight by a Titan IIIC on November 3 as part of the air force's Manned Orbiting Laboratory program, and Lunar Orbiter 2 was launched by an Atlas-Agena on November 6 (the multipurpose Agena sending the spacecraft toward the moon).

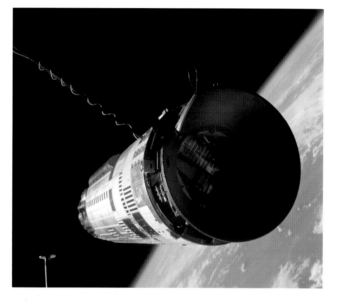

Center right: Just more than four hours after launch at 8:00 p.m., Gemini XII was within twelve feet of the ATV over Madagascar. Aldrin slipped the loop (center) over the Gemini's docking bar (bottom left) to secure the tether.

Bottom right: Aldrin snapped this photo of the Maurer 16mm camera he mounted just behind his open hatch. The Maurer had a variable-speed drive and took eighty-foot film magazines. An umbilical attach loop on the adapter section can be seen to the right of the camera. At the center is the attach point for the handrail to the ATV Aldrin would install shortly.

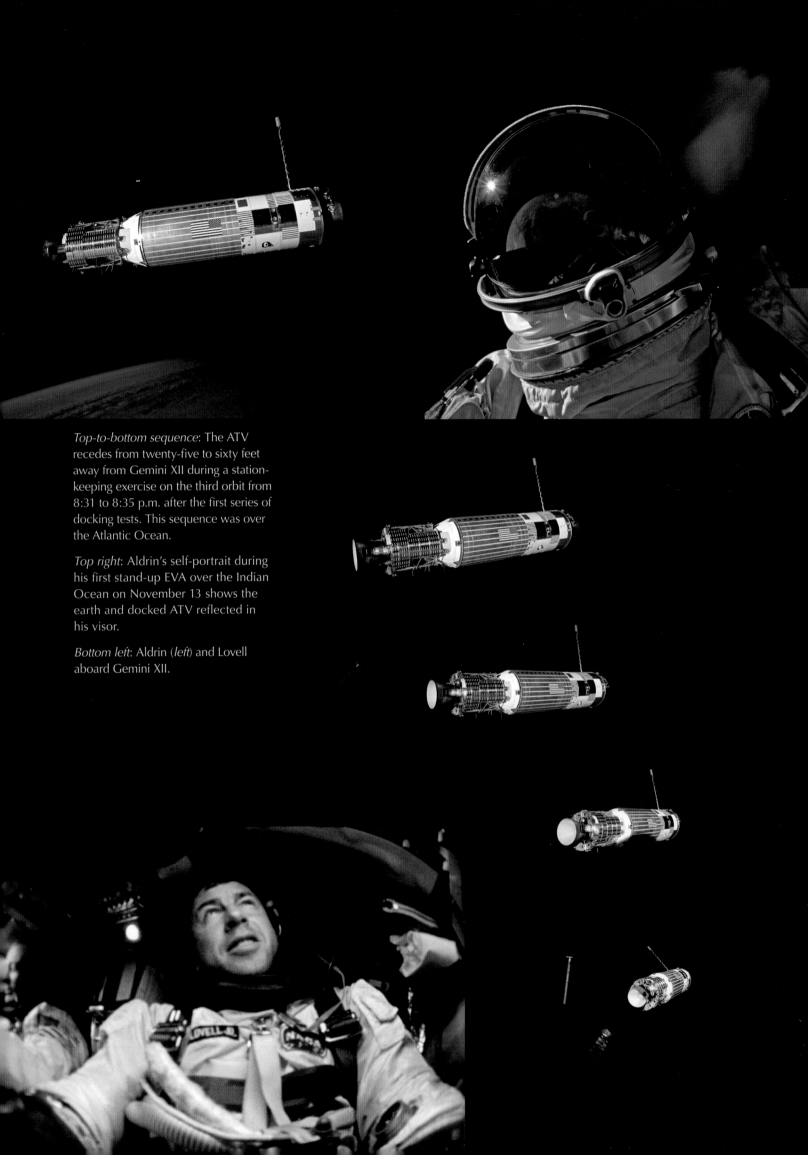

Top-to-bottom sequence: The ATV recedes from twenty-five to sixty feet away from Gemini XII during a station-keeping exercise on the third orbit from 8:31 to 8:35 p.m. after the first series of docking tests. This sequence was over the Atlantic Ocean.

Top right: Aldrin's self-portrait during his first stand-up EVA over the Indian Ocean on November 13 shows the earth and docked ATV reflected in his visor.

Bottom left: Aldrin (*left*) and Lovell aboard Gemini XII.

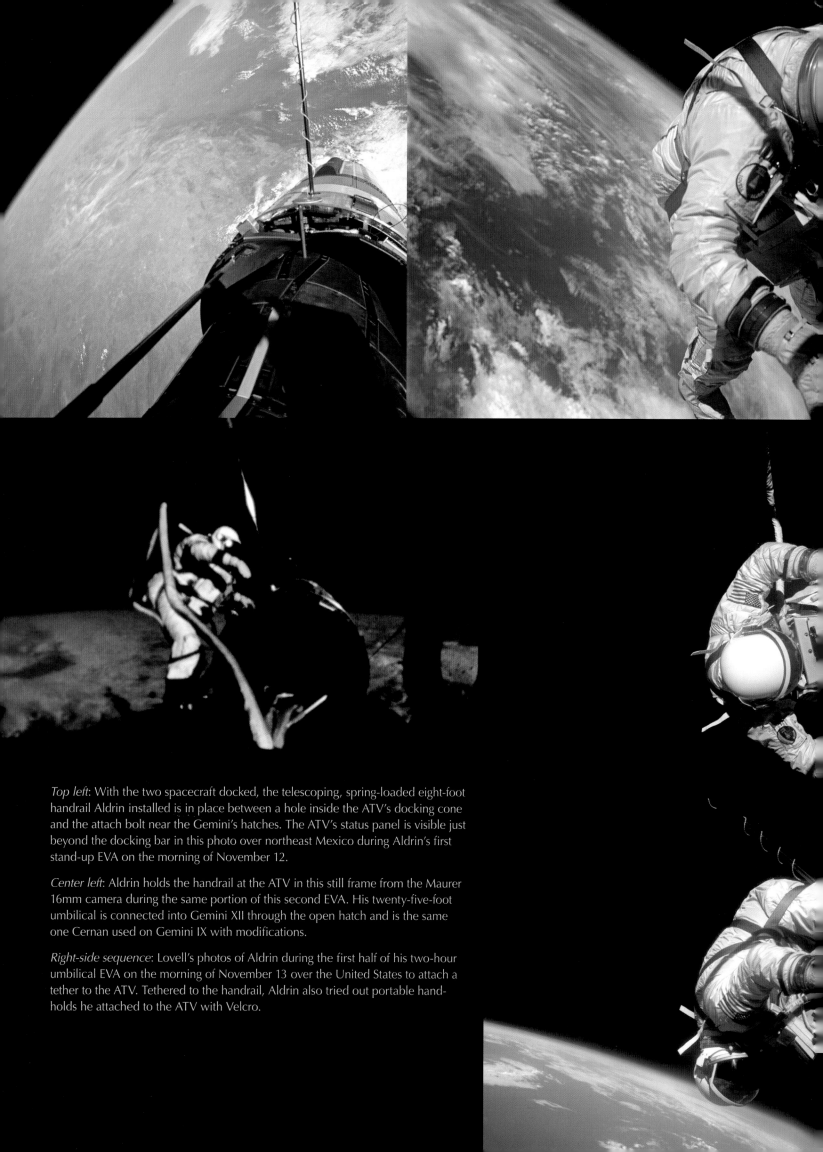

Top left: With the two spacecraft docked, the telescoping, spring-loaded eight-foot handrail Aldrin installed is in place between a hole inside the ATV's docking cone and the attach bolt near the Gemini's hatches. The ATV's status panel is visible just beyond the docking bar in this photo over northeast Mexico during Aldrin's first stand-up EVA on the morning of November 12.

Center left: Aldrin holds the handrail at the ATV in this still frame from the Maurer 16mm camera during the same portion of this second EVA. His twenty-five-foot umbilical is connected into Gemini XII through the open hatch and is the same one Cernan used on Gemini IX with modifications.

Right-side sequence: Lovell's photos of Aldrin during the first half of his two-hour umbilical EVA on the morning of November 13 over the United States to attach a tether to the ATV. Tethered to the handrail, Aldrin also tried out portable hand-holds he attached to the ATV with Velcro.

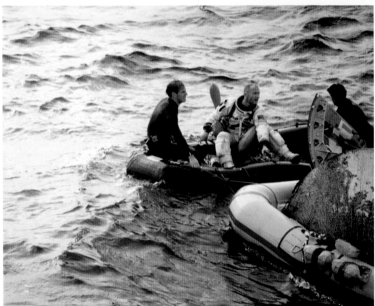

GEMINI GTA-12
RECOVERY SHIP

E.F. STIFEL

NASA
MC DONNELL REP.

NASA MSC
MCC-HOUSTON
SLAYTON,
DONALD K.
MISSION MISSION
12
GEMINI A APOLLO
V

Top left: Gemini XII hits the Sargasso Sea seven hundred miles southeast of Cape Kennedy at 2:21 p.m. (EST) on November 15 a little over three miles from USS *Wasp*.

Top right: Navy Lt. (j.g.) Dennis W. Bowman leaps from a SH-3A recovery helicopter moments after splashdown—his fifth Gemini recovery. The spacecraft's HF antenna is deployed (which, at thirteen feet, was still three feet shorter than its on-orbit whip antenna). Lovell went back inside the cabin to retract it after egressing.

Center left: Aldrin waits to be hoisted into the SH-3A "Search 3" helicopter (No. 66) following Lovell. Both men were aboard the chopper twenty-five minutes after splashdown.

Bottom: Robert Gilruth, Alan Shepard, John Glenn, and Pete Conrad in MOCR 2 following splashdown. Conrad, the CAPCOM for the landing, told the crewmen as they came down on the main parachute, "We've got you on the boob tube!" Glenn was still a Royal Crown Cola executive.

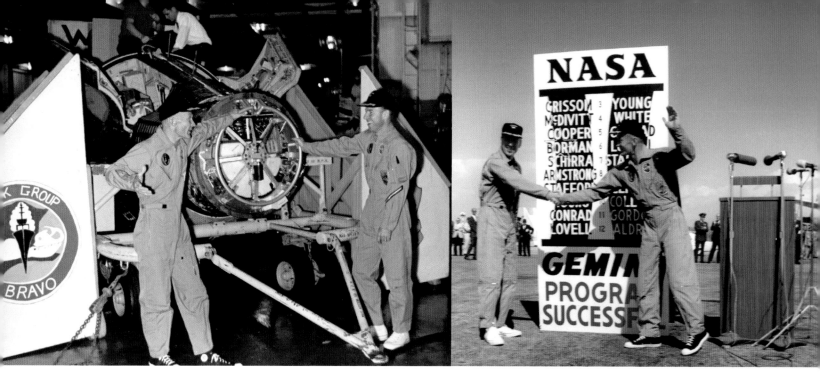

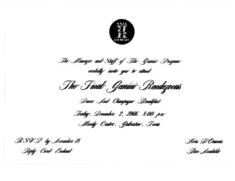

Top left: Aldrin and Lovell hold Gemini XII's parachute riser guard ring in the *Wasp*'s Hangar Bay 3 after their medical exams before dinner. Lovell wears a yellow stripe on his jumpsuit sleeve marking his second *Wasp* recovery (the first after Gemini VII).

Top right: Lovell and Aldrin shake hands after remarks following their arrival in separate planes from the *Wasp* at the Cape Kennedy Skid Strip at 11:00 a.m. on November 16.

Second right: A chief petty officer cuts a piece of cake after a ceremony honoring Lovell and Aldrin in the *Wasp*'s Hangar Bay 2 following dinner.

Third right: With Robert Seamans (*left*), Aldrin, and Gilruth (*right*) looking on, Lovell demonstrates the tethered test during the postflight news conference at MSC in the Bldg. 1 auditorium on November 23, 1966. The crewmen then flew to President Johnson's ranch in Stonewall, Texas, to receive NASA Exceptional Service Medals.

Bottom: The Final Gemini Rendezvous dance and breakfast at the Moody Civic Center in Galveston, Texas, on December 2.

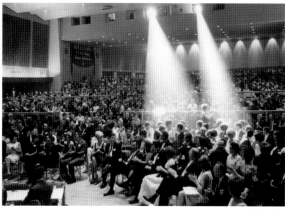

Abbreviations

AFB	Air Force Base
AMU	Astronaut Maneuvering Unit
ASTP	Apollo-Soyuz Test Project
ATDA	augmented target docking adapter
ATV	Agena target vehicle
CAPCOM	capsule communicator
CDDT	countdown demonstration test
ELSS	extravehicular life support system
EST	Eastern Standard Time
EVA	extravehicular activity
GLV	Gemini launch vehicle
GT	Gemini-Titan
HHMU	Hand-Held Maneuvering Unit
KSC	Kennedy Space Center
LOD	Launch Operations Directorate
LOX	liquid oxygen
LC	Launch Complex
MA	Mercury-Atlas
MCC	Mercury, or Mission Control Center
MOCR	Mission Operations Control Room
MR	Mercury-Redstone
MSC	Manned Spacecraft Center
MSFC	Marshall Space Flight Center
MSOB	Manned Spacecraft Operations Building
NASA	National Aeronautics and Space Administration
OAMS	orbit attitude and maneuvering system
RCS	reaction control system
REP	Rendezvous Evaluation Pod
TDA	target docking adapter
UHF	ultra high frequency
USAF	United States Air Force
USMC	United States Marine Corps

Bibliography

Barton, Elmer E. Interview by Rebecca Wright. Houston: Johnson Space Center Oral History Project, April 12, 2000.

Blair, Don. *Splashdown! NASA and the Navy*. Paducah, KY: Turner Publishing Company, 2004.

Butler, Sue. Interview by Dr. Patrick Moore. Indian Harbour Beach, FL: KSC Oral History Project, Kennedy Space Center, June 25, 2002.

Donnelly, Paul C. Interview by Dr. Orville Butler. Indian Harbour Beach, FL: KSC Oral History Project, August 23, 2003.

Gemini 5 Press Kit, Washington, D.C.: National Aeronautics and Space Administration, 1965.

Gemini 8 Press Kit, Washington, D.C.: National Aeronautics and Space Administration, 1965.

Gemini 9-A Press Kit, Washington, D.C.: National Aeronautics and Space Administration, 1966.

Gemini 10 Press Kit, Washington, D.C.: National Aeronautics and Space Administration, 1966.

Gemini 11 Press Kit, Washington, D.C.: National Aeronautics and Space Administration, 1966.

Gemini 12 Press Kit, Washington, D.C.: National Aeronautics and Space Administration, 1966.

Gemini Agena Target Press Handbook. Sunnyvale, CA: Lockheed Missiles & Space Company, 1966.

Gemini Mission Commentary Transcripts. Houston, TX: Public Affairs Office, Johnson Space Center, 1965–1966.

Gemini Program Mission Reports. Houston, TX: Manned Spacecraft Center, 1965–1966.

Gemini-Titan II Air Force Launch Vehicle Press Handbook. 2nd ed. Baltimore, MD: Baltimore Division, The Martin Company, 1966.

Grimwood, James M. *Project Mercury: A Chronology*. Washington, D.C.: Office of Science and Technical Information, National Aeronautics and Space Administration, 1963.

Grimwood, James M., and Barton C. Hacker. *Project Gemini Technology and Operations—A Chronology*. Washington, D.C.: Scientific and Technical Information Division, National Aeronautics and Space Administration, 1969.

Hacker, Barton C., and James M. Grimwood. *On the Shoulders of Titans: A History of Project Gemini*. Washington, D.C.: Scientific and Technical Information Office, National Aeronautics and Space Administration, 1977.

Koons, Wayne E. Interview by Rebecca Wright. Houston: Johnson Space Center Oral History Project, October 14, 2004.

Kozloski, Lillian D. *US Space Gear: Outfitting the Astronaut*. Washington, D.C.: Smithsonian Institution Press, 1994.

Lunney, Glynn S. Interview by Carol Butler. Houston: Johnson Space Center Oral History Project, January 28, 1999.

Mercury Project Summary, Including Results of the Fourth Manned Orbital Flight. Washington, D.C.: Manned Spacecraft Center, National Aeronautics and Space Administration, 1961.

O'Reilly, W. J. "Evaluation of Astronaut Extravehicular Life Support System for Project Gemini." Washington, D.C.: National Aeronautics and Space Administration, 1967.

Press Reference Book—Gemini Spacecraft Number Twelve. St. Louis, MO: External Relations Division, McDonnell Company, 1966.

Project Gemini Familiarization Manual. St. Louis, MO: McDonnell Aircraft Corp., 1965.

Project Mercury Familiarization Manual. St. Louis, MO: McDonnell Aircraft Corp., 1959.

Results of the First US Manned Orbital Space Flight. Washington, D.C.: Manned Spacecraft Center, National Aeronautics and Space Administration, 1962.

Results of the First US Manned Suborbital Space Flight. Washington, D.C.: National Aeronautics and Space Administration, 1961.

Results of the Second US Manned Orbital Space Flight. Washington, D.C.: Manned Spacecraft Center, National Aeronautics and Space Administration, 1962.

Rigell, Ike. Interview by Dr. Henry Dethloff and Dr. Lee Samples. Indian Harbour Beach, FL: KSC Oral History Project, Kennedy Space Center, June 18, 2001.

Stonesifer, John C. Interview by Kevin M. Rusnak. Houston: Johnson Space Center Oral History Project, April 16, 2002.

Swenson, Loyd S. *This New Ocean: A History of Project Mercury.* Washington, D.C.: Office of Policy and Plans, NASA History Office, National Aeronautics and Space Administration, 1998.

TRW Space Log: 1957–1982. Vol. 19. Edited by Madeline W. Sherman. Redondo Beach, CA: TRW, 1983.

USS Wasp (CV/CVS/CVA-18). Paducah, KY: Turner Publishing Co., 1999.

The Photographers

Although the most well-known images in the history of US manned space flight were taken by space photographers named Neil Armstrong, Bill Anders, and Jim McDivitt, a far longer list of photographers documented the earthbound activities of the people, machines, and facilities behind America's march to the moon. As primary centers for US manned space flight, KSC and MSC had the most NASA and contracted photographers assigned to cover various aspects of the program.

The contracted photographers at Cape Canaveral and KSC in these years worked for RCA and Technicolor. Although more than two hundred photographers were assigned to the Cape at the beginning, they were narrowed down to about thirty "qualified and dependable" still and motion picture photographers.

The Cape/KSC photo team was responsible for documenting launch complex and related facility construction (from air and ground), launch vehicle preparation, launch team activities, astronaut training, and launch day activities including still photo and long-range tracking cameras. They also photographed a wide variety of Cape employee activities and visits from various US politicians and world dignitaries.

Photographers included Paul Bamforth, Alex Bosmeny, Bob Breland, Jim Brugh, Ray Buchanan, Jerry Cannon, Dean Cockeham, Dick Crowe, Bruce Darlin, Don DeFillips, Paul Douglas, Fred Graham, Hal Harman, Bruce Hoover, Russ Hopkins, Bob Maranda, Jim McNearney, Mike Miller, Bob Nelley, George Neven, Ed Newman, Dick Roberts, Chuck Rogers, Louie Roquevert, Fred Santmassino, Bob Special, Ed Thomas, and Klaus Wilckens.

MSC photographers in the 1960–1975 time frame were NASA civil servants. They were responsible for documenting construction of MSC, astronaut training, spacecraft development and testing, and employee activities, as well the processing and distribution of images (handled by contractors in Florida). Their ranks included Precilano "Benny" Benavides, Bill Blunck, Tom Brahm, John Brinkman, Jose Cambiaso, Eugene Edmonds, Bobby Gray, John Holland, Jack Jacob, James Moncrief, Taylor Moorman, Nick Nelms, Jack Ottinger, Carlos Ramirez, Victor Rhoder, Johnny Salinas, Charles Shrimplin, Clarence "Pete" Stanley, Carmelo Sustaita, Pete Vasquez, James Weaver, and Francis "Gunny" Williamson.

Of the many talented photographers at NASA centers across the country, three bear special mention: William "Bill" Taub and Andrew "Pat" Patnesky, who both used Leica cameras, and Larry G. Summers, a motion picture cameraman.

Taub was based out of NASA Headquarters in Washington, D.C. He had worked at NACA (National Advisory Committee for Aeronautics) before becoming NASA's head photographer in 1958. From Mercury through ASTP (he retired in 1975), he saw it all. Taub was also known for his tireless travel schedule that often required him to be at various NASA centers on short notice—a result of his talent and trust gained from agency officials.

Patnesky, stationed at Ellington AFB, came to NASA in 1962 from the military. He went to work at the new MSC and stayed on the job until 1997. The early astronauts trusted Patnesky, an important asset when working in tight quarters with delicate equipment. He was a fixture in Mission Control, always carrying two Leicas (one with black-and-white film, the other color).

Summers was a Cape/KSC cameraman who often worked side by side with Taub using his 16mm cameras to capture the history in movies. He started with RCA in 1955 and retired in 1989. Summers was the only movie photographer for astronaut suiting on launch day through 1975.

Opposite page, top left: Al Bransford at the Cape in 1959 at a Mark 51 camera tracking mount, with a 35mm Mitchell camera at left and 16mm Mitchell camera at right. Both have telephoto lenses and are slow-motion capable, useful for engineering analysis.

Bottom left: Technicolor photographers Larry Summers and Don J. DeFillips pose with John Glenn at LC-14 on January 22, 1962.

Top right: Steve Pantano, Bob Nelley, Walt Langston, and Alex Bosmeny on Grand Turk Island in 1962 for Glenn's MA-6 mission. (Bosmeny collection)

Center right: Photographers pose with astronaut Scott Carpenter on May 25, 1962, on Grand Turk Island after an impromptu news conference. *Standing, left to right*: Ron Carmen, Jack Kenney, unknown, Carpenter, Bob Breland, Larry Summers, and Steve Pantano. *First row, left to right*: Alex Bosmeny, James McNearny, and Walt Langston.

Bottom right: Photographer Marion "Ed" Thomas (*left*) loans his Yashica Pentamatic 35mm camera to astronaut Gordon Cooper at the Gemini V post-flight party in Cocoa Beach on October 15, 1965. Thomas spent five years as a photographer at White Sands Missile Range, New Mexico, before coming to Florida in 1958, retiring in 1980.

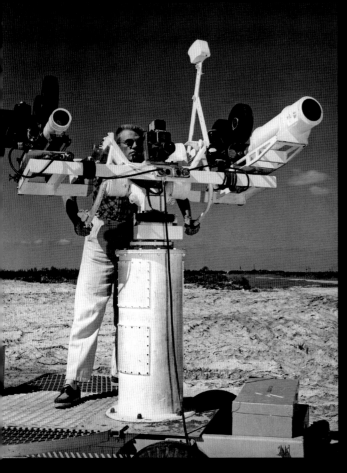
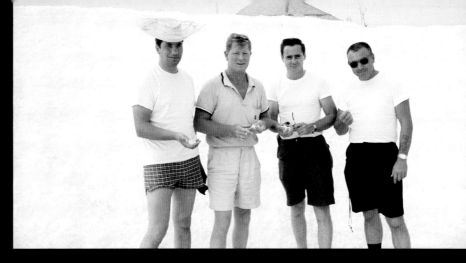

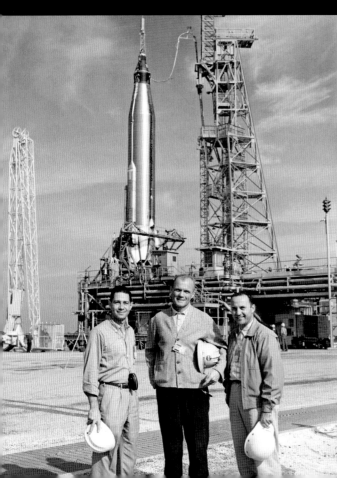